Making Money from
PHOTOGRAPHY
IN EVERY CONCEIVABLE WAY

Making Money from
PHOTOGRAPHY
IN EVERY CONCEIVABLE WAY

STEVE BAVISTER

D&C
David and Charles

THIS BOOK IS FOR AMANDA

ACKNOWLEDGEMENTS

I would like to thank Neil Baber for his unflagging patience and the rest of the David & Charles team for their unfailing professionalism.

PICTURE CREDITS

All pictures are © Steve Bavister, except the following, which are published with thanks. All copyright acknowledged.

p7 David MacDonald (bridal couple); p8 Tony Sheffield (interior), Marek Czarnecki (shoes), Paul Cooper (garlic); p9 Keeley Stone (model with boots), David MacDonald (woman); p12–13 courtesy of Lastolite (lighting and paper roll images); p24 Tony Sheffield (interior); p33 Karen Parker (dog); p45 Paul Wenham-Clarke (boy with tin can); p47 Steve Allen; p60 Paul Wenham-Clarke (storm in a tea cup); p64–5 Steve Allen; p66 Simon Oswin (couple); p66 Karen Parker (young girl); p67 David MacDonald (portrait); p68 GlenMacDonald; p69–70 Martin Campbell; p71 Gordon McGowan; p72–73 Glen MacDonald; p75 Jean-Pierre Barakat; p76 Henk van Kooten; p77–78 Martin Campbell; p79 Simon John; p80 Glen MacDonald (piggy back), Mark Seymour (high voltage); p81 David MacDonald; p82 Gordon McGowan; p83 Martin Campbell; p84 Andrew Spencer; p85 Hossain Mahdavi; p86 Anna Wiskin; p87–89 Hossain Mahdavi; p91 Elliott Franks; p92 Andrew Spencer; p93 Simon John; p95 David MacDonald; p96–97 Tamara Peel; p99 Tracey Clements; p100 Marek Czarnecki; p101–102 Len Dance; p103 Peter O'Keefe; p104 Gerry O'Leary; p110 Alan Stone; p111 Paul Wenham-Clarke; p112 Alan Stone (bottles), Marek Czarnecki (bed); p113 Marek Czarnecki; p114–115 Paul Cooper; p116–117 and p119 Len Dance; p121–122 Gerry O'Leary; p124 Marek Czarnecki (panorama), Len Dance (cathedral); p125 Simon Winson; p127 Paul Wenham-Clarke (astronomer), Ray Lowe (close crop); p128–9 Rob Cook, Crown Copyright, courtesy of CSL; p131 Tim Vernon/St James University Hospital Leeds; p134 Tamara Peel (leaf); p135–137 Martyn Goddard; p138 Neil Warner; p139 Steve Howdle; p140–143 Richard Campbell; p147 Pang Piow Kan; p148 Robert Anderson; p150 Nick House.

A DAVID & CHARLES BOOK
Copyright © David & Charles Limited 2006

David & Charles is an F+W Publications Inc. company
4700 East Galbraith Road
Cincinnati, OH 45236

First published in the UK in 2006
Reprinted 2007
First US paperback edition 2006
Reprinted 2006
First UK paperback edition 2007

Text and photography copyright © Steve Bavister 2006

Steve Bavister has asserted his right to be identified as author of this work in accordance with the Copyright, Designs and Patents Act, 1988.

A catalogue record for this book is available from the British Library.

ISBN-13: 978-0-7153-1961-2 hardback
ISBN-10: 0-7153-1961-1 hardback

ISBN-13: 978-0-7153-1970-3 paperback
ISBN-10: 0-7153-1970-1 paperback

Printed in China by Shenzhen Donnelley Printing Co., Ltd
for David & Charles
Brunel House, Newton Abbot, Devon

Commissioning Editor: Neil Baber
Assistant Editor: Louise Clark
Project Editor: Nicola Hodgson
Senior Designer: Sarah Underhill
Production Controller: Beverley Richardson

Visit our website at www.davidandcharles.co.uk

David & Charles books are available from all good bookshops; alternatively you can contact our Orderline on 0870 9908222 or write to us at FREEPOST EX2 110, D&C Direct, Newton Abbot, TQ12 4ZZ (no stamp required UK only); US customers call 800-289-0963 and Canadian customers call 800-840-5220.

contents

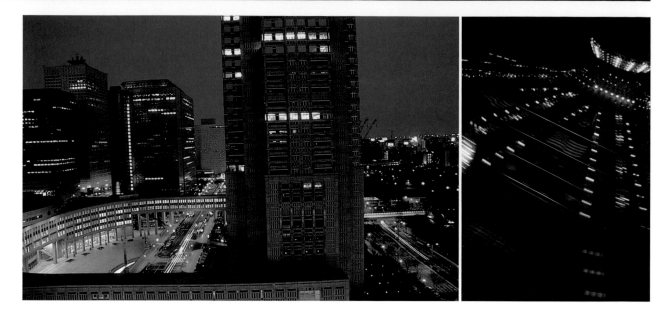

Introduction

Do you ever look at the pictures you see published in books, magazines and calendars and think, 'I could do better than that'? Or stop outside a wedding and portrait studio and say to yourself, 'my pictures are every bit as good'? Or check out the images on an online library and know yours are equally saleable?

Of course you do. It happens to us all. But for many photographers it's just a passing thought. Only a small proportion ever take the next step and start shooting for profit. Sometimes that's because they don't have a clue where to begin – and how to go about making cash with their camera. Or, sometimes they do submit pictures for possible publication, and their dream takes a knock when they get a rejection slip – and they never try again.

But there may have been nothing wrong with their work. Maybe they just sent it to the wrong market – or the right market at the wrong time. The truth is, you don't need to be a world-class photographer to become a successful freelancer, you just need to know what pictures are required, who requires them, and when they're required.

■ What this book covers

And that's where this book comes in. Not only have I been a successful freelance photographer and magazine editor for the last 20 years, I've also interviewed scores of professional and semi-professional photographers. From them I've learned the secrets of:

- selling direct to magazines, calendar publishers, greetings card manufacturers and newspapers
- making it in commercial, industrial and advertising photography
- shooting stock that sells time and again
- moving from amateur to freelance to professional
- succeeding as a wedding and portrait photographer

And I've distilled them down to a number of clear, simple principles that anyone can follow – and which I've detailed in the pages to come. So, yes, you could become a freelance or professional photographer. Why not? You've got your equipment, you can take a decent picture, and all that remains to be sorted out is what are you going to photograph and who is going to buy the pictures.

■ Understanding the different terms

In this book, I'll be using a variety of terms to describe people who take pictures. I will cetainly try my best to be consistent in their use throughout.

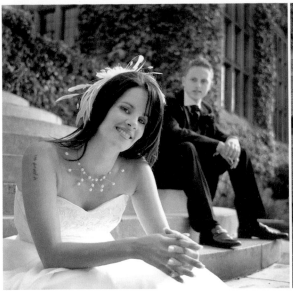

Amateurs take pictures purely for pleasure, with no profit in mind. Often the aim is to capture a moment or record an experience. 'Amateur' is not a judgement of the quality of the work. Amateur does not mean amateurish. I've seen many pictures taken by amateurs that are every bit as good, and as potentially saleable, as those taken by professionals.

Semi-professional photographers earn some of their income from photography and some from the other work they do. Initially, photography may be a small percentage, maybe as little as 1 per cent, but over time that will often grow, and can become a substantial amount each year.

Many photographers stay semi-professional, not wanting – or often not having the courage to go full-time. Some do, though, reach the stage where all their income comes from photography, and they become **Professional**. While some professionals studied photography at college, and moved straight into full-time work, a large proportion of professionals started as amateurs.

Initially, most photographers are **freelance**, working for themselves, rather than employed by someone else. When photography is all they do, or they start to have other people work for them, we say a photographer is **self-employed** or **running their own business.**

By standard definition, **employed** photographers work for other people. If you don't feel you have an entrepreneurial talent, or the idea of running your own business really doesn't appeal, then you might consider working for someone else – perhaps in a High Street studio or on the staff of a manufacturing or service company.

■ Making the transition

Maybe you woke up one morning and decided you wanted to be a photographer. Or perhaps the desire crept up on you over a period of time. What are your options? How do you get started?

Well, simply quitting your job and setting up as a professional photographer is certainly one possibility. And that's what some people do. But think carefully before you hand in your notice. It can take some time to build up a business and you need to be able to pay the bills and feed yourself through that time. If you have family responsibilities, or are cautious by nature, then take it one step at a time.

One option is to start earning money from photography while having another job. Then, when you've built a solid platform and have sufficient business, contacts and potential, quit the 9 to 5. This 'softly softly' approach works in many areas of photography. You can shoot weddings at the weekends, portraits in the evening, and stock and magazine/calendar submissions anytime. However, you're not likely to get commercial, advertising or fashion work as a part-timer.

If you're single, and don't mind taking a few risks, then you might consider 'going for it' – just handing in your notice and devoting yourself full-time to photography.

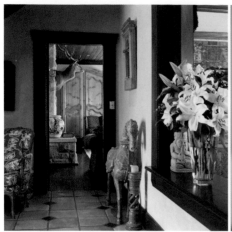

■ Speculative shooting or commissioned work

Getting commissions in the early days can be difficult. No-one will commission you until you've got a portfolio of published work to show them, and the only way you'll ever be able to produce the required tear sheets is if you get commissioned.

So the best way to take the first tentative steps towards building a career as a professional is by shooting speculatively with a view to possible sales in the future. This is the way many freelance photographers work, the great advantage of operating this way is that you can take pictures of what you want, when you want.

This is particularly convenient when you're trying to fit your photography in around other commitments such as a full-time job. Whenever you get some free time you can spend it shooting saleable images. Weekdays, for most employed people, offer little opportunity for picture-taking. By the time you've gone to work and then got home and recovered, it's dark – except for a few weeks in the summer when you might fit in a few frames before dusk. Of course

dedicated souls will get up early or make use of their lunch hour – but there are often other demands on that time. Weekends offer a better prospect, though even then there may be family commitments, such as the weekly shopping trip or providing a taxi service for your children, which sabotages any shooting expeditions.

■ Do you need qualifications?

In most parts of the world, including the UK and America, you don't need any qualifications to become a professional photographer. It's not like being a dentist, solicitor or accountant, where you have to undergo rigorous training, often over a number of years, and belong to a recognized body in order to work in that field. Photography is completely unregulated as a business. You can call yourself professional whatever your level or experience, or indeed ability. There are no barriers to entry whatsoever.

But that doesn't mean there's no value in studying photography or gaining qualifications. Quite the opposite. The more knowledgeable

you are on the subject, and the more training you've undertaken, the better your pictures are likely to be.

Becoming a registered member of a professional organization, such as the Professional Photographers of America (PPA) or British Institute of Professional Photographers (BIPP), has a many advantages. One is that the level of membership is determined by an assessment of submitted work – so if you're accepted you know you're up to professional standard. Another is that being a member means you can use letters after your name, which reassures clients of your abilities and gives them confidence in choosing you.

■ What skills are required?

Professional photographers come in all shapes and sizes, types and temperaments. There's no one set of character traits or skills that suit all areas of the business. It's true that many social photographers are outgoing and bubbly and some commercial photographers are more serious and reserved, but there are plenty of exceptions that 'prove

the rule'. I know some wedding and portrait photographers who are quiet to the point of shyness, while some industrial and advertising photographers of my acquaintance have larger than life personalities. So whatever kind of person you are you have the potential to make it as a professional.

The most important thing is that you are **passionate** about photography, since you'll spend lots of time doing it. That may seem blindingly obvious, but I'm constantly astonished at how many people go into occupations they really don't enjoy.

Given that you are reading this book it's unlikely to be an issue – in fact there's probably nothing you'd enjoy doing more than waking up every morning and taking pictures.

You'll also need to be **self-motivated** if you plan to go freelance or run your own business. When you work for a company you normally have a boss who keeps an eye on you and makes sure things get done. When you work for yourself you need to provide that impetus yourself – setting yourself goals and seeing you achieve them. As someone who

has worked for myself for more than twelve years, I'm often asked how I stay motivated. How come I don't just laze around watching TV all day? It's pretty simple really: If I don't work, I don't eat. That's sufficiently motivating for me.

You need to be **creative** as well, being able to express yourself visually. This is particularly true in the world of commercial and advertising photography, where you might be given a widget and asked to 'make this look interesting'.

You'll find that you also need to be personable, and able to get on with people, both as clients and subjects. **Persistence** is essential, because you'll suffer **rejection** on a regular basis. And you won't get far without self-motivation.

Now you may be wondering why I haven't mentioned **photographic ability**. That's because it's not the most important thing when it comes to success as a professional. Yes, really. A competent photographer with skills in marketing and promotion will earn more than an awesome photographer who's lousy at publicising and selling their own work.

That doesn't mean, of course,

that your pictures can be absolute rubbish. If they are no one is going to buy them – and you'll be endlessly banging your head against a brick wall. That will get you nowhere fast.

What I am saying is that when it comes to making money from photography you only need to be producing professional quality work. You don't need to be a star who's pushing back the boundaries and constantly winning awards – although the more accomplished you are the easier you will be able to negotiate.

■ The life of a pro

To the outsider, photography often sounds like a glamorous profession, because its public perception is shaped by the exploits of high profile snappers like David Bailey, who always seems to be jetting off to the Bahamas with a bevy of beauties on his arm and a million dollar budget to spend.

The life of the average pro is mundane in comparison. You're more likely to be found in a tatty old studio in the back of beyond, taking shots of a spotty kid or the inner workings of a stopcock.

Yet, even at its most routine, photography is a great way to earn a living – and I count myself privileged to have done so for more than 25 years. It has to be said, there are few jobs which allow you to get paid for something you really enjoy doing – and which also give you the opportunity to express yourself creatively.

Whatever path you decide to take, I wish you every success in making money from photography, both now and in the future.

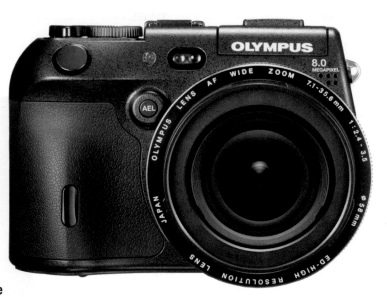

Equipment & Materials

As someone who has been selling pictures in a wide range of markets for more than 20 years, I'm often asked what equipment is required. Back in the days when most photographers were using film it was relatively easy to dispense this kind of advice.

For most kinds of professional photographic work a medium-format camera loaded with 120/220 roll film used to be pretty much essential. The larger negative/transparency sizes – 6 x 4.5cm, 6 x 6cm, 6 x 7cm, 6 x 8cm and 6 x 9cm, depending on the camera used – were capable of producing crisp, detailed, grainless enlargements.

For that reason they were the first choice among social photographers, whose customers often required prints to hang on their walls, stock photographers looking to maximize their sales, commercial photographers whose clients wanted pin-sharp product shots, and publishers of magazines, calendars and posters.

In some areas, such as food photography and architecture, even larger format cameras were required – most commonly 5 x 4in and 10 x 8in view cameras. In addition to the considerably bigger negative/transparency area, these have various 'tilt' and 'shift' movements that provide extensive control over the perspective.

In certain markets 35mm equipment was acceptable – but more often than not it marked the photographer out as a semi-professional. Postcard publishers, magazines and photo libraries would happily consider 35mm, but it was a non-starter as far as commercial photography was concerned, and considered rather 'amateurish' for weddings.

■ Digital advances

Now that most photographers are shooting digitally, the nearest equivalent we have to camera format is resolution. While it's not the only factor – the range of features available is also important – the more pixels a camera is able to capture the more areas of professional photography it can be used in. What resolution is required? Unfortunately there's no definitive answer to that question. It depends on how the image is going to be used – and as technology advances the boundary keeps shifting, with resolution rising steadily with each new wave of equipment that comes on the market.

■ Amateur v professional

This makes it far from easy to say clearly when a camera ceases to be 'amateur' and becomes 'professional' – although some of the old distinctions do seem to be re-asserting themselves as the digital market begins to mature. Most companies producing digital SLRs now have a range of models of different resolutions aimed at the consumer, semi-pro and professional markets. In addition, there are digital backs that can be fitted to medium- and large-

format cameras, which capture images at even higher resolution.

However, the good news is that even a standard digital SLR is capable of producing files sizes large enough to be saleable. That means you can get started without spending a fortune. You may even have such a camera already – since they've been affordable for years now – and have nothing more you need to spend.

The quality you get from a basic DSLR is certainly good enough for portrait and wedding photography, sufficient for magazine work up to full-page reproduction, and fine for things such as postcards and greetings cards where 35mm would previously have been acceptable.

But if you're serious about selling your work it's worth investing in a camera that delivers a significantly bigger file size, so you have the option of submitting images for possible use on calendars, taking on commercial assignment commissions if they come along, and shooting for stock. It's true that some photo libraries will accept pictures taken on budget digital cameras that have been resized to produce a file that's around 50MB, but others do insist on images being that large without interpolation.

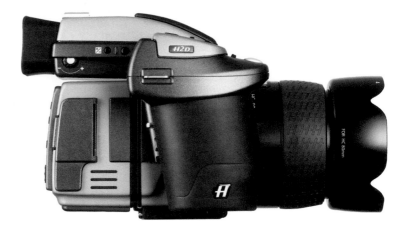

TOP OF THE RANGE
Professional digital cameras like this Hasselblad offer extremely high resolution but are expensive.

■ Is film dead?

But what if you've got a high quality film SLR? Is there no longer a market for transparencies and prints? Well, the secret of success in any business lies in giving your customers exactly what they want – and the majority these days prefer digital. But in social photography, where the end product is a framed portrait or a wedding album, film still has a foothold, with some practitioners – and their customers – preferring it to digital. In most areas, though, including publishing, commercial photography and stock, nobody is interested in film any more.

■ The tools for the job

You may be able to get away with a budget camera if you're interested only in doing a little freelance photography alongside your existing employment. But you'll soon find there's a limit to what you can tackle. You may be able to earn some extra cash, but if you want to go further you'll find that you eventually hit a brick wall.

PRIME LENS
Don't compromise when it comes to lenses: buy the best you can afford.

VERSATILITY
For general freelance and professional work, nothing beats the versatility of a 35mm-style SLR.

To be successful in any profession you need the right tools for the job. Leading tennis players have high specification rackets strung by experts; carpenters use sophisticated power tools that have been designed to get the work done more efficiently, and they are expensive.

Ultimately, anyone who is serious about working professionally as a photographer needs to be willing to invest in a top-end digital camera – along with lenses that are equal to it in quality. There's no point in spending a fortune on the camera body and then skimping when it comes to the optics. That's a false economy.

Depending on the kind of pictures you plan to take, it can also be worth spending more to buy lenses with a fast maximum aperture – such as f/2.8 on a telephoto zoom, rather than the more common f/4 or f/4.5. If you regularly find yourself doing work that requires you to shoot hand-held in poor light – such as during a wedding service in a gloomy church – that extra stop of light-gathering power can make the difference between an image blurred by camera-shake and one that's sharp.

You should also consider, for the same reason, lenses with image stabilization or vibration reduction systems. These typically let you take hand-held shots at shutter speeds around two to three stops slower, allowing a 28–70mm lens to give acceptable results at 1/5 sec and a 600mm to be used successfully at 1/125 sec.

How many lenses do you need? And what focal lengths? Many professionals have three zoom lenses – wide-angle, standard and telephoto – which cover most of their needs. Some, such as sports and wildlife photographers, require a longer focal length, such as 400mm, 500mm or even 600mm, to fill the frame with their subjects, while those shooting landscapes or groups often want an ultra-wide lens – 15mm or less – to fit everything in. In certain areas, specialist equipment

STUDIO SET-UP
If you plan to do studio work, you'll need lights, reflectors and, ideally, an assistant.

is essential: macro lenses in medical or garden photography, or perspective control (PC) lenses in architectural work where a view camera isn't being used.

In addition, you may need a flashgun, a tripod, removable storage cards, a holdall to carry everything in and – if you're setting up a studio – several lights, a background system and a host of accessories.

Many of those looking to earn money from photography will have some equipment already, but upgrading it to a professional specification often requires significant investment. Happily, equipment can often be bought in stages, as and when it is required, especially if you're operating on a part-time freelance basis.

■ Delivering digital images

You've probably got a computer already – most people have – but if not you'll need to budget for that as well, along with a photo-quality printer, high capacity back-up hard drives, and software to 'process' and enhance your images. While there are cheaper programs available, as soon as possible you should invest in Adobe Photoshop, which is pretty much the industry standard and capable of virtually anything you might want and more.

Among other things, Photoshop allows you deliver the files in the way they're required. Typically, publishers, advertising agencies and commercial clients prefer 300dpi TIFFs, along with an index print for reference. Generally you will be delivering them on CD or DVD, though sometimes you'll need to email them to meet a deadline, in which case it's standard practice to send JPEGs compressed at a ratio of 8, 10 or 12, depending on the file size.

CONTROLLING THE ENVIRONMENT
To get soft, attractive light you'll need umbrellas and softboxes, which come in a wide range of sizes.

Background paper rolls come in a variety of colours to suit every need.

When you're sending files to a lab for printing, perhaps for wedding or portrait customers, there's not the same need to be concerned with technicalities, since they will have the expertise to sort things out. So TIFFs and JPEGs will be equally acceptable, at whatever resolution they come out of the camera. Of course, you'll want to work on them first, making sure the exposure, colour balance and cropping are just how you want them.

STORAGE OPTIONS
Removable cards make it possible to capture a large number of images during a shoot.

PHOTOGRAPHY FOR PUBLISHING

One of the biggest markets for photographers who want to shoot speculatively, rather than on a commissioned basis, and who want to market their images direct, rather than through a library, is publishing. This embraces a number of areas – including magazines, calendars, postcards, greetings cards, posters and newspapers – all offering genuine opportunities to make sales.

Buyers are always keen to see good quality work and require new material on a regular weekly, monthly or annual basis, depending upon their publishing schedule. Yes, they have existing contributors – that's how they're able to fill their current publications – but the door is always open to newcomers. So don't feel reticent about making contact. Photographers often feel they're being a nuisance by sending in work, but nothing could be further from the truth. Publishers need contributors as much as contributors need publishers.

Over the years I've spoken to scores of picture buyers, and all but a handful said they were happy to be approached by new photographers.

FACE VALUE
Pictures of people are used in magazines of all kinds. For maximum impact, crop in tight with a telephoto zoom.

MAGAZINES

Magazines form the biggest single market for freelance photographers, with thousands on thousands of titles available. Magazine publishing is also one of the most accessible markets, as most editors are happy to hear from potential new contributors. If you are looking to earn money from photography, this is probably the best place to start. Lots of professionals cut their teeth by selling a few pictures here and there to magazines. With titles covering just about every conceivable subject, hobby, age group and occupation, you're almost certain to be shooting pictures that would be of interest to someone.

FOLLOW YOUR PASSION
If you like gardening, shoot plants. If you enjoy aviation, photograph helicopters. Start with what you know and you'll have the best chance of success.

■ The key to success

In any area of photography the key to success lies in understanding the kind of pictures that your chosen market needs and how they might be used. When it comes to magazines, the principle is simple: the editor needs to have a reason to publish the picture. Rarely, if ever, will editors use an image simply to fill space. The magazine business is too competitive for that, and every page has to work hard to win readers.

Some magazines focus on news, and are interested only in images that have a news angle. Others are more features-oriented, often with a practical emphasis: for example, a sequence on how to plant seeds for a gardening magazine; the effect of fitting a polarizer for a practical photography title; or feeding a baby for a parenting publication. They will also include pictures of products, people, places and anything else that is related to the subject matter – such as fashion in *Vogue*.

■ Stick to what you know

If you are serious about freelancing for magazines, what you must never do is shoot a range of subjects that you know little or nothing about and then try to find a market for them. That's what a lot of freelancers looking to get into magazine work do, and that's why so many of them fail. You go to the coast for a weekend and take lots of pictures of boats and yachts. Reviewing them, you think that maybe a sailing magazine might be interested. Or you visit a county fair and photograph

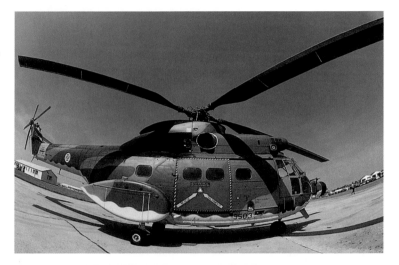

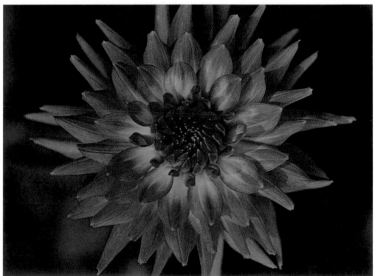

dozens of vintage tractors, imagining that they'll be of interest to a magazine about restoring old vehicles. Well, the images might be just what the magazine is after – but they probably won't be. Unless you really understand the magazine, what it publishes and why, you're just shooting in

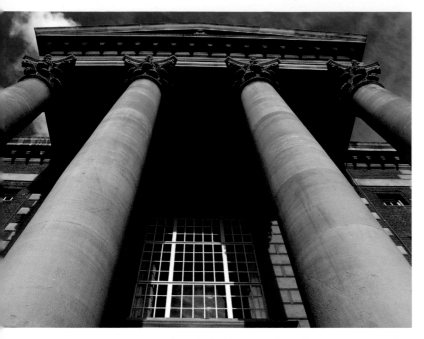

DRAMATIC PERSPECTIVE
Magazine editors want pictures with impact – and if you want to get published you'll need to provide it. Here a wide-angle lens and a low viewpoint have been used to create a dynamic view of a conventional building.

Look at credits for the photographs. Do the same names come up time and again or are they all different? Are they all individuals or are some credited to libraries? Most magazines use a mixture of freelance contributors, picture libraries and commissioned pictures. Some also have staff photographers – check out the panel that lists who works on the magazine. If a staff photographer is mentioned, that can limit your potential for making sales.

■ Guidelines for contributors

Many magazines produce a set of 'Guidelines for Contributors' to assist people interested in writing for them or supplying images. This will tell you about the ideal length for articles, the preferred format for pictures, the fees you can expect to receive and any other relevant information. These guidelines can often be found on the magazine's website, and sometimes come in a printed form that can be posted to you. It is in the interests of the editors to produce them because they will get more material that meets their needs and less that doesn't, and they save time by not having to repeat the information. If the magazine does not have specific guidelines for contributors, you can always ask them to clarify their requirements.

■ Use familiar subjects

The easiest way to get started is by concentrating on magazines that you are already familiar with. If you have a hobby, such as gardening, snowboarding, caravanning or restoring antiques, then you are already halfway there – you will know which titles deal with that subject, and you should have a good idea of the types of pictures they use.

Common sense dictates that you choose a subject that interests you. For one thing, you will spend a lot of time shooting it, and for another, you will produce better and therefore more saleable images if you

the dark. You need to choose your market first and then go out and take pictures for it. Editors spend a lot of time and effort giving their magazines a recognizable character, so you can assume that their requirements can be summed up as 'more of the same'.

■ Analysing requirements

Buying a reference title such as *The Writers' & Artists' Yearbook* or *The Freelance Photographer's Market Handbook* is a good starting point. The entries will help you to avoid obvious mistakes. However, there is no substitute for obtaining a few recent copies of the magazine you wish to submit to and scrutinizing them carefully. Study them feature by feature, and then as a whole. How much importance is given to the photographs? Are they small, medium-sized, or sometimes splashed across a double-page spread? What kind of pictures are they? Very specific or more general? Straightforward record shots, or more arty, creative treatments? Often a magazine will have sections devoted to both approaches to give a sense of pace and rhythm.

MAKING IT SALEABLE
Images with rich, strong colours are always saleable because they can be used to brighten up a page of dull text.

have genuine enthusiasm for what you are photographing. Chances are that you have pictures on file that may be suitable – so you will not have to start from scratch. You may be in a position to pull together a submission from existing material. If not, you know what readers will be interested in seeing and can get going without delay.

When I started freelancing, I had young children whom I regularly photographed. I had hundreds of high-quality shots on file of them doing everything from drawing to eating to sleeping. It occurred to me to target some parenting titles, and I was delighted that two of the pictures from my first submission were used in a leading parenting magazine. I sent in material every couple of months after that, and shots were used regularly. Then I looked for a new market. Realizing that I had lots of pictures of the surrounding area, I submitted some to county magazines – once again with success.

The most important thing is to get your foot in the door. I have found that editors tend to be more receptive to submissions once one of your pictures has been published in their magazine. What subjects and interests fire your enthusiasm? A glance through your pictures will soon tell you. What kind of magazines would be a natural home for the kind of pictures you take? That should tell you where to start.

■ Photography magazines

Photographic magazines such as *Amateur Photographer* and *Popular Photography* can also be an ideal market for your work; they constantly need pictures to illustrate all aspects of technique, from lighting effectively to mastering depth of field. Some photo magazines have a policy of using readers' pictures whenever possible, and go to libraries only when they can't get the material they want from other sources. Features tend to have a seasonal

bias, so if you have back issues go through them and note what appears when. During the dark months of winter, you are likely to find articles on winter landscapes, still lifes, birds, studio lighting, fireworks, indoor portraiture, Christmas and using flash. In spring, the focus shifts outdoors, and there will be features on landscapes, filters, portraits and spring itself – crocuses, rabbits, daffodils, lambs and so on. As the sun climbs higher there are summer subjects, including weddings, holidays, reflectors and travel. After that you have autumn, with writers waxing lyrical about warm light, higher ISO settings, autumn leaves and low-light shooting.

Whenever possible, you should supply 'before' and 'after' shots. And, following the digital revolution, magazines are increasingly interested in sequences of pictures that show digital techniques. When you are enhancing images – even if you are only sharpening them or using curves – keep the original image, any in-between stages, and screengrabs as well.

Quality counts

Of course, you won't be on your own in submitting pictures to your favourite photography magazine – many other readers will have the same idea. Don't let that deter you, however. I have spent many years editing photography magazines, and, in all honesty, most of the images sent in are not suitable for publication. While most submissions these days are correctly exposed, in focus, and otherwise technically competent, most lack impact. Frankly, they're dull. This means that the opportunity is there for anyone who can produce dynamic, eye-catching images of popular subjects that can be used to illustrate technique features. As ever, use the pictures already being published as a guide to what the editor wants, and then shoot and supply more of the same.

Favourite photographic subjects

At any time of year, there are likely to be articles on the following:

- the most popular subjects, including portraits, children, buildings, sport, glamour, travel and still life
- different types of composition
- aspects of lighting
- exposure modes
- metering patterns
- shutter speeds and apertures
- lens choice: wide-angle, telephoto, zoom, specialist lenses.

TECHNIQUE IMAGES
Photo magazines are always looking for images that can be used to illustrate techniques. This picture could be used in a article on composition, shooting at night or architectural details.

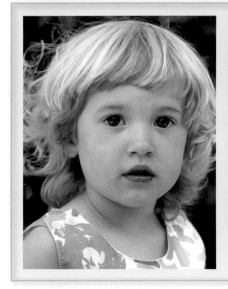

HOW-TO SEQUENCES
Digital imaging magazines are always pleased to receive sequences of pictures that show different techniques – but make sure you include 'screengrabs' of what you've done.

■ Portfolio and gallery sections

As well as individual pictures and comparative sets, many photography magazines publish several images by one photographer, usually over three or four pages with accompanying text, in a 'portfolio' or 'gallery' format. For pictures to be used in this way, they need to have some kind of theme. They might be all landscapes, all taken using long shutter speeds, all in black and white or all composed using diagonals. Whether you specify it or not, any submissions you make will be considered for this kind of slot. So don't just send a random collection of images; take care that they can work cohesively as a set.

It can also be a good idea, particularly in the early days, to narrow down the type of work you send to photography magazines so that you get known for that area. As an editor, I have a mental directory of who takes pictures of what. When I want nature pictures, for instance, I have two or three photographers who come immediately to mind. Not only do I know they have quality work on file, I also know they have lots of it – many thousands of pictures, covering most aspects of the subject – and they almost certainly have what I want. There

may well be many other competent photographers who could supply me with work of an equal quality – but I don't think of them. Once you have become known as a specialist, you can start to branch out, submitting other material – but in addition to the area you are known for.

Photography magazines also run regular competitions, some on a monthly basis, which can provide a decent income. See pages 147–8, 'Winning Competitions' for more details.

■ Local area magazines

Another accessible market is local magazines that cover a particular town, city, area or county. While their freelance budgets are often modest, they are usually delighted to hear from photographers who either have strong local material or are able to shoot to order. They rarely have a staff photographer and are usually run by a small team, with limited resources either to track down the images or to get out and take them specifically.

The geographical area covered by the magazine may not be large, and the subject matter will therefore be 'on your doorstep' – which means that the time and effort involved is often minimal. You

might even be able to build a reasonably comprehensive set of images as you go about your daily business, grabbing a few frames here and there when the weather and light is at its best.

A good starting point, as ever, is to get hold of a copy of your chosen magazine and study it carefully. Does it look as if they use freelance material? Is it the kind you could supply? If so, either give them a call or send them an email saying that you are a local photographer with pictures of the area, and ask if they would be interested in seeing a submission. Most will say yes.

If possible, send a selection of photographs of the subjects most likely to be used in the magazine for them to hold on file. In this kind of publication the focus is normally on people, natural history, and heritage in addition to specific locations. Don't send in anything too arty or unusual, unless you've seen that kind of material published. County and local titles tend to have an older, more conservative readership, so shots that are straightforward in style are more likely to succeed.

If your images are right for the magazine, they will steadily get used over time – with a small but welcome cheque following on each occasion. But don't rest on your laurels. Once you have made your first sale, continue sending material – and if possible get to the stage where it's you the magazine contacts when they need a particular image.

That's what happened to me with a local magazine called *Stamford Living*. I'd had a number of stock images published in it, and had developed a good relationship with the editor, when he rang up and asked me to shoot the Christmas cover – for the following year. With seasonal issues like this, you have to work a year ahead – the Christmas edition needs to be published at the same time as the festive lights go up, so you can't do it the same year. So I spent

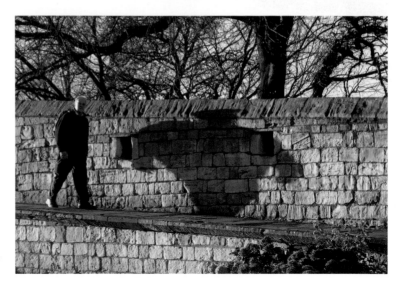

a couple of pleasant, if chilly, evenings at dusk in Stamford's picturesque streets, capturing the scene that was published the following Christmas.

Note that not all local magazines will consider photographs on their own; some only accept complete words-and-pictures packages. Therefore, it's worth learning how to write a simple article (see pages 144–5, 'The Write Stuff' for some tips) to maximize sales in this area.

▇ General-interest magazines

Some magazines are of general interest, not specializing in one particular area. Many have large circulations, often several hundred thousand copies a month or even a week, and are aimed at either a male or female readership. The good news is that general-interest magazines are often extremely profitable, and as a result have a healthy budget to spend on photography. The bad news is that most of the images either come from leading picture libraries or are commissioned from experienced photographers. That doesn't mean there are no opportunities for the freelance, but it does mean there's little point submitting a selection of shots. For a start, what subject would you send? With a fishing magazine, you know they want fishing pictures, but

UNUSUAL SUBJECT MATTER
Quirky images can be sold to a range of publications, so keep your eyes peeled for anything that's out of the ordinary.

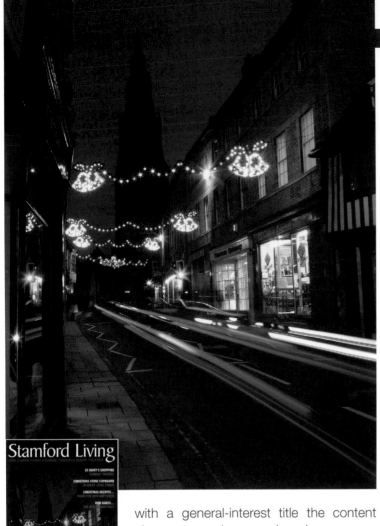

COVERLINE SPACE
When taking pictures for possible use on a cover, make sure you leave enough room for the magazine's masthead and the 'tasters' that describe what's inside.

with a general-interest title the content changes every issue, and you have no way of knowing what will be featured.

However, if you've got to the stage of having tear sheets of published work, and specialize in a particular area that comes around regularly – such as work–life balance in the women's press or health and fitness in the men's press – it is worth getting in touch so the magazine has your name on file.

■ Celebrity magazines

One of the biggest growth areas in recent years has been in the market for celebrity magazines. The shelves are now heaving with titles that show the lifestyles of the rich and famous. Some like to show them at their best, with the pictures perfectly styled, in a sumptuous location such as their own home. These are normally shot by established celebrity photographers,

and it's not easy to join that elite group. One approach might be to research any stars living in your area and approach them to see if they would allow you to take some pictures of them – perhaps offering prints they can use in their portfolio or website in exchange. If you hit lucky and get someone to agree, and the shots you take are good, that could open the door to more celebrity work. But don't expect overnight success. This is an extremely competitive field.

Other magazines are more voyeuristic. They feature the rich and famous caught in an unguarded moment, often accompanied by a 'witty' caption. Sometimes what they're doing is mundane, such as eating a hamburger in the street, and sometimes they're doing something 'wild', such as rolling in the worse for wear after a night on the town. If that appeals to you – and it can be extremely lucrative if you get the right picture – you might want to join the hundreds of paparazzi wannabes who effectively stalk celebrities every minute of the day and night.

A more realistic option for most of us is to keep a camera constantly with us in case an unexpected opportunity comes along while we're out and about. But even then you need to have the 'killer instinct' to do anything about it. I, for one, don't have it. A few years ago I was returning from Nice, and ended up stranded for a few minutes on the tarmac outside the aeroplane. Standing alongside me was an A-list celebrity holding his young daughter in his arms and leaning against his wife who was holding their son. They all looked tired, dishevelled and fed up. It was a picture that would have been easy to take – I had a camera in my pocket – and even easier to sell. But I didn't have the heart. They were clearly on their way home from a holiday and I felt it would have been intrusive to have exploited the situation. Others would not have felt the same and would have grasped the opportunity.

TRADE SECRETS
There are hundreds of 'trade' magazines covering many different kinds of business and industry, all of which have picture requirements.

■ Trade magazines

As well as the 'consumer' magazines I've discussed so far, which you can buy in newsagents anywhere, there are also 'trade' magazines, read by people working in particular industries or professions. You won't find many of them in your local newsagent, or even in high-street outlets. Many are mailed directly, and unless you are in the business yourself, you won't even be aware of their existence. That's when a copy of *The Freelance Photographer's Market Handbook* or *The Photographer's Market* is essential – in these yearbooks you will find lists of many of the titles that are open to submissions from freelance photographers.

There are magazines for just about every trade and business, including medical, oil and gas, engineering, motoring and tobacco. Some are sold on subscription; others are funded entirely from advertising. Many titles focus on news, making them a must-read for those needing to keep abreast of developments in their area – or looking for another job. Often these publications are full of 'situations vacant' advertising, which is part of their appeal.

A typical trade magazine in the UK, for example, is *Local Government News*, which is read by everyone from professional officers in technical departments of local authorities to civil servants in relevant government departments. Like all magazines, it needs photographs to illustrate its stories and to brighten up what might otherwise be slabs of impenetrable text. As such, it has a regular requirement for quality pictures of subjects such as architectural and building projects, road schemes, urban designs and housing projects.

But which ones? And what should they show? Once again, you need to get a copy and look at what is published. Sometimes the requirements are extremely specific, and only 'insiders' will fully understand what is required.

The plus side of shooting for trade titles is that, because they are less well known and generally less glamorous than consumer titles, they don't receive as much unsolicited material, which means that you don't have as much competition.

■ Your first submission

When making your first submission to a magazine, don't send too many images – as the old saying goes, you don't get a second chance to make a first impression. To make sure you make a positive impact, send only top quality pictures. If that means there are only 10 or 20, so be it. Trying to make up numbers by including second-rate material will greatly weaken the submission, and could lead to it being rejected – even if some of the photographs have the potential for publication. It may not seem fair, but that's the way it works. And if the first couple of sets you send in are judged to be poor quality, later submissions may receive only a cursory glance. They'll see your name on the covering letter and not really bother looking at the material.

The most important thing to understand is that your pictures don't necessarily have to be stunning to sell – they just need to meet the requirements of your market. But they must be perfectly exposed, attractively lit, pin-sharp and well composed. This is particularly true when submitting work to photo magazines and leading consumer titles, which naturally tend to have very high standards.

Magazine editors are busy people, and they need to be able to view images as quickly and easily as possible. When sending digital images, always include a hard-copy reference sheet, so there's no need to put the CD in the computer to view the pictures. Use a good-quality inkjet paper and ensure the thumbnails are a reasonable size. Six images to a sheet of A4 paper (210 x 297mm/8¼ x 11½in) is about right. If you go any smaller it's difficult to see the content properly. Include a short covering letter, and make sure that any CDs and images are clearly marked with your name, address, telephone number and email address.

■ Following up

Don't be in too much of a rush to follow up. A busy magazine can receive a large volume of submissions, and if you send yours in during press week – the obligatory panic when the pages of the next issue are being 'put to bed' – nothing will get looked at straight away. It's only when things settle back down that unsolicited contributions tend to get considered.

Magazines vary enormously in how efficient they are in responding. Some will send an acknowledgment immediately, so you know your package got there safely. Others don't reply until they've looked at the material, when you will get something between a curt 'This doesn't meet our requirements' and a satisfying 'We'd like to use some of the images in our next issue.' If you haven't heard anything within

CAPTURE THE MOMENT
Pictures don't have to be stunning to sell, but they do need to be sharp, correctly exposed and capture the subject matter effectively.

a couple of weeks, you could send the editor a friendly email to check whether the images have been received safely and whether they might be of interest.

■ The importance of timing

Rejection is a part of the freelance photographer's life – it happens to the best of us. If you can't handle rejection, it's best not to send pictures to magazines in the first place. Often you won't know why the pictures have been returned, and it's certainly not the responsibility of the editor or picture editor to tell you why they didn't want them. If you ask politely, they may give you some advice and tips on making a successful submission next time, but don't count on it – they've got more important things to do, like producing the next issue. All you can do is look at each rejected submission carefully and try to work out what went wrong.

One possible reason for being rejected is timing. A tremendous amount of planning

INSIDE STORY
Many of the pictures used in magazines about homes are commissioned, but there are still opportunities for speculative freelance submissions.

preferably earlier. Don't send it too early, though, because staff won't be thinking about that feature yet. They will either return your package and ask you to submit it later or suggest putting it on file. The problem is that a couple of months down the line they may have forgotten that it's there and choose other pictures.

Some material, however, is timeless, and you can submit it at any time for the magazine to keep on file. This suits editors, because they will have a stash of material readily available whenever they need it. This can work well for the freelance, with a cheque falling through your letterbox every now and again without you having to do much for it. However, it can also mean that images are sometimes left to gather dust, so it's a good idea to send further submissions if nothing happens for a while.

■ Developing relationships

While there are exceptions, the editors of most specialist and trade magazines, and the features/commissioning/picture editors of glossy, large-circulation titles, are approachable. They need photographers as much as photographers need them, so you shouldn't be afraid of phoning or emailing them to check their needs. It is usually a waste of time asking if they would be interested in seeing your pictures – they don't know until they've seen them. So send them in anyway.

Once you have made a few sales from speculative submissions, you can ask magazine editors for their specific picture requirements. This considerably increases your chance of making sales. However, it's not a good idea to ask what their current 'wants' are before you have developed a relationship with them – you could be from a rival magazine, after all, so they will often be cagey.

Further down the line – once they are publishing your work on a regular basis

and preparation goes into producing a magazine. The editorial process of picture selection, captioning, layout, proofing and passing the pages does not happen overnight. This means that pictures (and articles) are required well ahead of the magazine's publication date. The 'lead time', as it's known, can be just a couple of weeks in the case of a weekly magazine, but is more often a couple of months for a monthly magazine or a quarterly.

Pictures of fireworks, for instance, will typically go in a November-dated issue in the UK, which will be on sale early in October – and that means it will go to the printers at the end of September. Final picture selection will typically be in the first two weeks of September, so you need to have your submission with the magazine by the middle of August at the latest, and

– editors will start contacting you to request material. Can you supply pictures of this, that or the other for our next issue? There may also come a time when they approach you with a commission. When that happens, you really are into a different ball game. You are being asked to deliver a specified set of images by an agreed date – and you must deliver or you won't get asked again. If the commission is to photograph something that can be re-shot if things go wrong, such as a product or a comparative set of pictures with and without polarizers for a photography magazine, there's minimal risk. But if you are contracted to attend an event and photograph it – such as a marathon for a running magazine – you will have just one chance to get the pictures. You will need to feel totally confident in your ability.

■ Fees for magazine work

Once you start selling your work to magazines, you soon discover that there are enormous variations in the rates paid, sometimes with no apparent logic. For example, I have been paid just £20 ($35) for half-page reproduction by one publisher and £100 ($175) for postage-stamp-size use by another.

As a guideline, repro rates are related to the size of reproduction and the prosperity of the publication. However, in a bid to maximize profits, publishing companies are rarely more generous than they need to be. Editors are often squeezed by their publishers, and have an agreed budget to spend on pictures each issue.

Some titles run on a very tight budget; the payments they can offer hardly cover the cost of postage and certainly not the time and effort involved in taking the picture. Some publications are extremely cagey about what they will pay – leading one to the conclusion that it's probably not very much. Others are open about this despite their very low rates, although it's a wonder

they get anyone to contribute when they pay a pittance. Fees are generally higher in the more prosperous world of mass-market publications, such as the women's weekly and monthly titles. But since a high proportion of their pictures come from libraries or commissions, this tends not to help the average freelance. Generally, with magazines, it's a matter of having pictures published at their 'usual rates'. It's a buyers' market, and you have to accept what they're willing to pay or they won't use your work. Expect somewhere between £10 and £50 ($17.50–$87.50) for up to half a page and you won't be far wrong.

KNOW YOUR STUFF
When submitting pictures to specialist magazines you need to be able to supply detailed, accurate captions. With garden photography this means knowing the botanical name of a plant.

NEWSPAPERS

Newspapers offer mixed opportunities for freelance photographers. It's not difficult to get your work published in local newspapers, but it's not easy to get paid for it. National newspapers, on the other hand, pay extremely well, but to get published you need a subject that is particularly original or newsworthy.

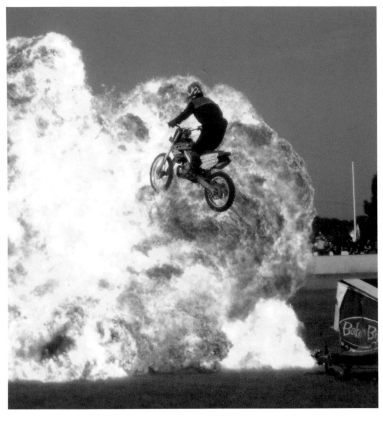

ACTION STATIONS
Dramatic images can have a market at both local and national level, but there's a lot of competition to get published.

Images for inside pages

The inside pages of newspapers are more mixed in content, with news pages at the front gradually giving way to general-interest features before running into the business and sport sections at the back. Unfortunately, the potential for freelancers in all areas is pretty small. Most of the news pictures come from agencies and staffers, and the features tend either to be illustrated with shots from libraries or specifically commissioned. However, newspapers are always interested in offbeat, quirky pictures to brighten their pages. If you take anything of that kind it's work getting in touch, especially if they can be related in some way to a current story.

■ Hold the front page

It would be great to have an image published on the front page of a leading national daily newspaper, so that millions of people around the country – or even the world – could see it. Hopefully you would get a sizeable cheque, too. But unless you happen to be on the scene with your camera when a bomb goes off or someone is kidnapped, you are extremely unlikely ever to take a picture that is sufficiently newsworthy. That is what the nationals are after – dramatic images that capture the attention of a notoriously fickle readership, and persuade them to pick up their paper rather than one of their rivals'.

Most images for newspapers are sourced from staff photographers or international agencies such as Reuters, but occasionally an amateur or freelance strikes it lucky and grabs a once-in-a-lifetime picture that is splashed around the globe. It is always worth having a camera with you – a decent digital compact will do – and keeping alert for anything out of the ordinary. If you do shoot something with front-page potential, don't hang about – call the paper immediately. If they like the sound of what you've got, they will send a bike over straight away, or ask you to email the image to them if you're close to a computer.

Should the newspaper decide that they want to go ahead and publish, they will offer you a fee to sign the rights over

to them. This is the time to keep a clear head and read the small print – don't rush into things. That may be easier said than done, because they will probably put a lot of pressure on you to agree to their terms, especially if they are close to putting the paper to bed. You have to decide whether what you are being offered is enough. It may sound like a temptingly substantial sum, but bear in mind that if the picture is exclusive – no-one else has the image – and in demand, the paper will syndicate it around the world, making serious money in doing so.

What you really need to do, if you can, is to negotiate a percentage of any syndication earnings; that way, your return will be significantly higher. However, if the paper won't budge, you may decide you have to take what you can get.

■ Local newspapers

Another option, albeit a less glamorous one, is your local newspaper. Every town or region in any country boasts at least one, and some have two or more competing titles. By their nature, local papers are focused on news and events within a particular area. Many have a small number of staff photographers, so the good news is that most of them welcome pictures from freelancers, usually accompanied by a short report or caption. The bad news is that many have no budget to pay for freelance contributions, so the best you are likely to get is a credit. Even so, if you want to gain experience and tear sheets, perhaps as a stepping stone to a staff position or to give you credibility in other markets, you may be willing to work on that basis.

Make sure that you retain your copyright in any pictures published, as one of the ways in which local newspapers generate revenue is by selling prints to readers. That is why you see so many photographs of groups published. Leafing through the

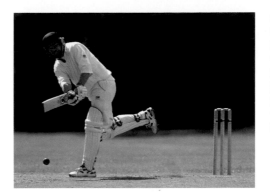

latest issue of my local newspaper, I see a shot of a nursery that has received a glowing report (16 faces); a poet opening a school library (9 faces); a report on a filmmaking project (11 faces); pupils at a grammar school hearing about industry (24 faces in four pictures) – and that's just up to page 9. If you are intent on shooting for local newspapers, therefore, you need to know how to organize and work with groups. If you don't have much experience in this area, simply look at the way the pictures that are currently being published are composed and do the same.

It's the same for other subjects. Photographs in newspapers need to tell the story at a glance and, because they are printed on newsprint – relatively poor quality paper that doesn't reproduce fine detail well – they are also often clichéd in style and content, so they communicate the message quickly and easily. Someone who has just passed an exam may perform a 'jump for joy', while someone whose bicycle has been stolen may be shown sitting with their head in their hands looking despondent. Once you have developed a repertoire of such stock poses, you will find it straightforward enough to produce the right kind of pictures.

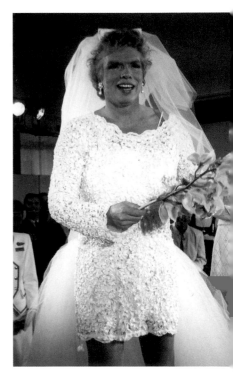

POSTCARDS

Changes in technology can affect markets in different and often unexpected ways. There's no doubt, for example, that the development of quality camera phones has had an impact upon sales of postcards that no-one would have anticipated a decade ago. These days, many people on holiday prefer to text back a picture of themselves relaxing on the beach or living it up in a nightclub – rather than sending an anonymous 'wish you were here'-type postcard.

That doesn't mean the postcard market is dead, however. The sheer number of people going on holiday each year, and the number of times they do so, means that postcards are certain to be around for some time yet. Another reason they continue to sell is the picture quality, which is much better than most amateurs are able to achieve themselves. Usually the light is glorious, the composition attractive and the mood idyllic. If you're looking to get into the postcard market, that is what you need to be shooting, too.

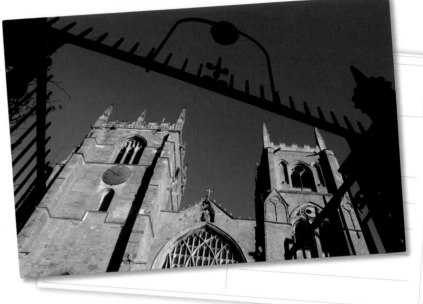

■ Choosing the right subject

The vast majority of postcards are bought by people on holiday, so you need to focus on the right places – coastal resorts, popular inland towns, scenic villages, attractive landscapes, and beautiful gardens and cities that are popular with tourists. You must also select the right view or subject. Postcard publishers are looking for 'definitive' shots of a particular area – pictures that portray its spirit and essence. At almost all locations, there are certain things that you need to include: particular views, well-known buildings or monuments and specific landmarks. By all means take other pictures of the place, but don't expect them to sell for postcards. Paris, for example, has certain iconic views such as the Eiffel Tower and the Arc de Triomphe, and even much smaller towns will typically have a few key landmarks. Not surprisingly, they are by far the most popular postcard subjects.

■ Clichés and original approaches

Successful postcard pictures are often visual clichés that depict the kind of subject matter visitors associate most readily with the place. Think of London, for instance, and you might think of Big Ben, red buses, Nelson's Column, beefeaters, the Tower of London, black taxi cabs – and, sure enough, those are the images on the most popular cards. It's the same in Paris, where visitors typically go for shots of the Eiffel Tower, Sacre Coeur, Notre Dame and Frenchmen wearing berets and strings of onions. Such subjects and treatments may seem corny and stereotyped, but that really is what people buy – because they sum up what tourists think of the location.

That said, postcard companies are constantly looking for new approaches, and in recent years have come up with a range of different treatments in a bid to

GO FOR IMPACT
If postcards are to sell they need to have impact on the stand, so look for ways of making your subject matter stand out.

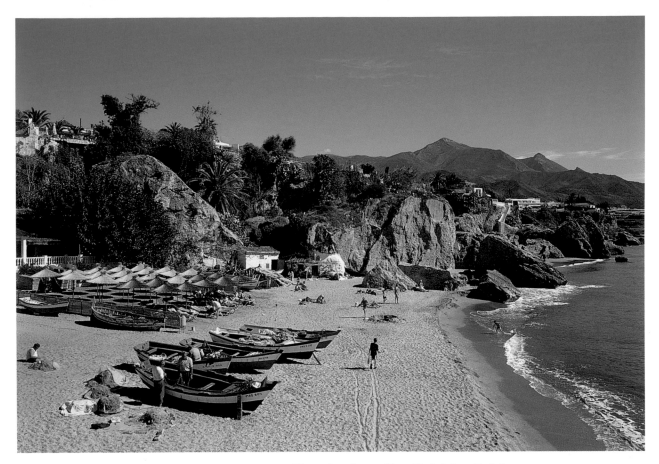

stand out from the crowd. A number of companies, for instance, now publish cut-out postcards, where the card is designed in the shape of the subject depicted in the original photograph: a card of Big Ben will be shaped like Big Ben, for example. This means that the main subject in each picture must be bold and obvious so that it lends itself to this cut-out treatment. Simple compositions with few other elements are required, especially elements that are obstructing the main subject and make a cut-out difficult. Traditional long views won't work. But don't just go for the obvious – they're pretty well covered already. Think laterally and try to come up with more creative pictures. In London, for example, you will see postcards of a pint of beer (shaped like a pint of beer), a red telephone box (shaped like a telephone box), and so on.

Shoot when the light is right

Another thing you need to do is take your pictures at the right time. More often than not, that's during summer, in bright sunlight, when you can feature attractive blue skies. The only exception to this rule are places like the Lake District, the Scottish Highlands, Niagara Falls or the Grand Canyon, which are frequented all year round by people who are interested in more than getting a suntan.

Don't reinvent the wheel

How do you know what the key subjects and treatments are when you have never been to a location before? Just look at the postcards that are already on sale in the place. By definition, their subjects are the things you need to photograph – because they wouldn't have been chosen for postcards if they weren't. Your first port of

BEACH SCENES
The time when most people send postcards is when they're on vacation, and beach scenes are popular sellers – so make sure you shoot them.

call when shooting with the postcard market in mind is the collections of cards currently available. Study them carefully. Even better, become a postcard collector. The great thing about postcards is that they are relatively inexpensive to obtain.

Who wants what

As your collection grows, you will soon develop a sense for what kind of material gets published. You will also notice that the market is dominated by a relatively small number of businesses, whose names you can find printed on the backs of the cards or listed in *The Freelance Photographer's Market Handbook*. If you have some material that you would like to send in, or shoot specifically, it's a good idea to give your target companies a call first, to find out if they are interested. This isn't a particularly glamorous area of publishing, so you won't

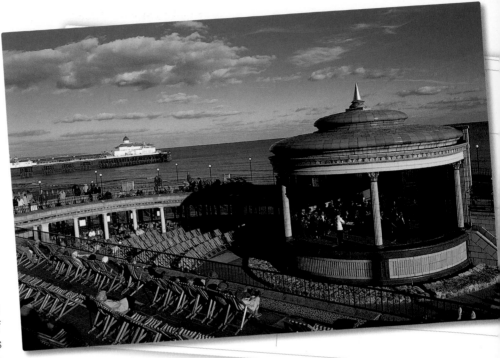

encounter too many people with king-size egos – they are usually approachable and happy to help.

You will find that most are keen to see new material, particularly of locations where cards sell in large numbers. The competition can be fierce, so new cards are added regularly as those that are not selling well are dropped from the range

It's a different story, though, in locations where the volume of sales is lower – such as villages with a small but steady tourist trade. Here the cards are likely to be updated relatively infrequently – sometimes only once every five or ten years – so the demand for new images is considerably less. If you want to earn a reasonable sum from postcard work, it makes sense to focus on the main tourist areas.

Once you have sold a few images to a card company, you will be on their distribution list for specific 'wants' in the future, which will give you an inside track on what to supply. This gives you a much greater chance of success than when you are shooting blind.

TRADITIONAL SUBJECTS
Some subjects have been photographed many times over, but postcard companies are always looking to refresh their ranges.

The magic hour

Many urban locations – cities such as London, Newcastle, Paris and Sydney – look particularly striking when photographed at dusk, when the lights in the streets and buildings have been turned on but there is still some blue in the sky. Rural subjects are often at their most picturesque in the early morning. Whatever the subject, it is a waste of time shooting images when the conditions aren't right. Pictures where the light is as flat as a pancake or the sky is washed out won't get a second look, and aren't worth submitting.

Technical requirements

Since postcards are small – 9.5 x 15cm/6 x 4in is the standard size – an image in virtually any format has the potential to sell if it is technically OK. Most publishers will accept transparencies from 35mm upwards and digital files, but will rarely take photographic or inkjet prints.

Fees

The postcard market is not the most lucrative, but it can generate a useful income if you get it right. In my experience, the range of payments for postcard rights is from £50–£120 ($80–$200) per image. Some cards are multi-image, and that means you end up with a higher fee.

Self-publishing

Why not consider publishing your own postcards? If you have a collection of attractive pictures of your local area, you could have some postcards printed and sell them without too much trouble at a useful profit. There are a number of companies that specialize in printing postcards, but most general printers can help, too. It doesn't cost much to have, say, 2,000 cards printed of each picture, and if they all sell you should at least double your money. The more copies you have printed, the cheaper the unit price gets. Local gift shops, hotels, restaurants, newsagents, museums, galleries and tourist information centres are all potential customers.

This is no way to get rich quickly, but it will spread your name around the area, which could lead to commissions for other work. You can invest the profits in having more cards printed until you end up with a good selection on sale – you could perhaps extend your range to include other locations, though it may be wise to keep things fairly local to simplify distribution.

THE DECISIVE MOMENT
When shooting with postcards in mind, choose the moment carefully, so there are as few distractions and unwanted elements as possible.

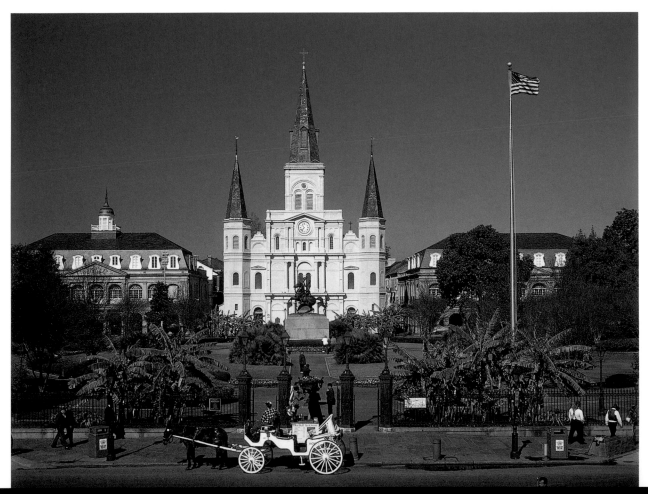

GREETINGS CARDS

The market for greetings cards is booming. People are sending more cards than ever before, and not just for traditional dates such as Christmas, birthdays and Valentine's Day. These days, you can buy 'Hooray! You're Divorced' cards, and there are plenty of 'You're my Friend' blank cards, so you can write your own message. The good news for the freelance is that the proportion of cards featuring photographs rather than paintings and drawings continues to increase – and a number of companies now specialize in photographic greetings cards. The downside is that relatively few new photography cards are published each year and competition to supply the images is fierce, both from photographers submitting material directly and from picture libraries. If you are already shooting the right kind of material, it's worth having a go, but if you're just starting out there are more lucrative avenues that are worth trying first.

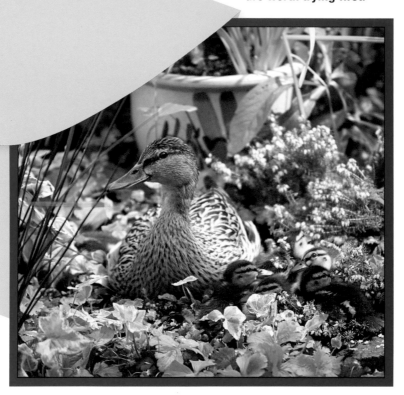

THE 'AHHH' FACTOR
Greetings cards usually have some kind of emotional element, so pictures are required that make buyers say 'Ahhh'.

■ Getting started

The best way of starting is to do some market research. Spend a day visiting as many outlets as you can. As well as large high-street stores, go to smaller locations, such as local shops and post offices. It is also worth dropping into garden centres and DIY stores, which often stock ranges of cards. If you can afford to, buy at least one card from each publisher – remember that you can claim the cost as a legitimate research expense – so you have their name and telephone number. Make notes about what is in each of the ranges. As you study the cards on offer, you will soon notice that the most popular subjects by far are animals and flowers. These represent probably 80 to 90 per cent of the photographic cards on sale.

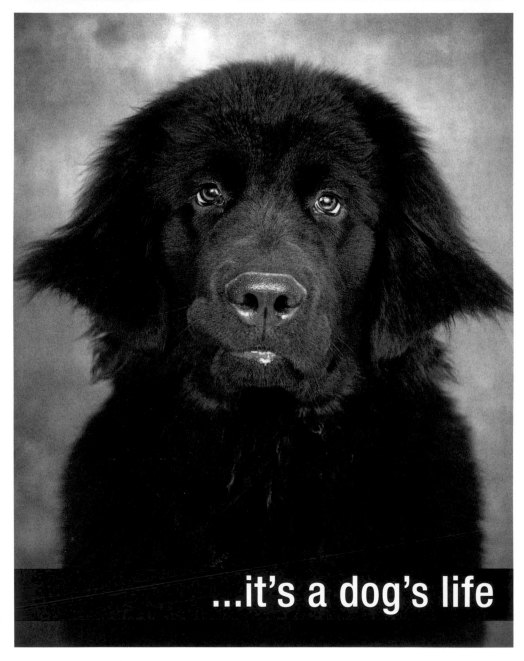

...it's a dog's life

■ Animal magic

The most popular animals are cats, pigs, dogs and – somewhat surprisingly – orang-utans. If you want to get published, those are the best animals to photograph. You can try others, but you would be swimming against the tide of demand, and less likely to be successful.

The market divides into two main areas: cute and humorous. Any picture that makes people go weak at the knees and say 'Ahhh' has the potential for greetings-card use. Think big, ugly boxer dog sniffing tiny, gorgeous kitten, or a fluffy young duckling held in the palm of a hand, and you've got the idea.

Jokey cards are common these days, and many use animals to provide the humour. Sometimes the picture is comical in its own right – a pig with its tongue out

or a monkey parading its bottom – or it becomes funny once a caption is added.

If you have pets of your own, it's worth having a go – but don't be surprised if the results are disappointing. The secret of success lies in finding subjects that are supremely photogenic, and your long-in-the-tooth moggie or mongrel may no longer cut the mustard. If you are serious about shooting to sell, you will need to find a source of winsome kittens or puppies. Perhaps a local pet shop would be willing to help, or someone who breeds cats and dogs. It might be worth suggesting a quid pro quo arrangement – you provide them with images they can use promotionally and you are free to sell them. If they won't go for that then you may have to pay. As long as the fee isn't too high this can make sense financially, especially if you think about shooting for other markets at the same time, such as picture libraries or local magazines.

Farms can also be a good source of subject matter, particularly in the spring,

when you will be able to photograph ducklings, piglets and lambs. At that time of year, some farms have open days, when you can go along for free or for a modest payment. You may find yourself jostling for position with children on a school trip, however, and it is probably better to arrange a private visit, when you will have more control, and are therefore more likely to end up with marketable images.

Providing you have a powerful telephoto lens, it can also be worthwhile spending a day at the zoo. If the weather is good, and the animals active, you should end up with a number of appealing shots, one or two of which might be suitable for greetings cards. You will need a reasonably strong zoom because it is essential to crop in tight, for two reasons. One is that the expression on the animal's face will be crucial in whether you make a sale. The second is that you need to exclude anything that reveals the fact that the creature was in captivity, such as mesh fencing or a glass enclosure.

■ Florals and garden scenes

The other common subject for photographic greetings cards is flowers – or 'florals' as they're often called in the trade. The pictures can be of individual blooms, arranged bouquets or 'country living' still-lifes, which might include props such as jugs, vases and crockery. In other words, everything from a bunch of flowers in a vase to a garden scene to a field of poppies is required. Pastel images with blues and purples, such as delphiniums and foxgloves, are extremely popular, as well as bright images based around primary colours. You can't go wrong with roses, tulips, daffodils and lilies.

It's no good shooting a straightforward record of the subject. There needs to be some kind of emotional component arising from the way the picture is taken. The flowers need to be carefully arranged, beautifully composed, atmospherically

PASTEL COLOURS
Pastel images with blues and purples – such as these bluebells – are extremely popular with buyers.

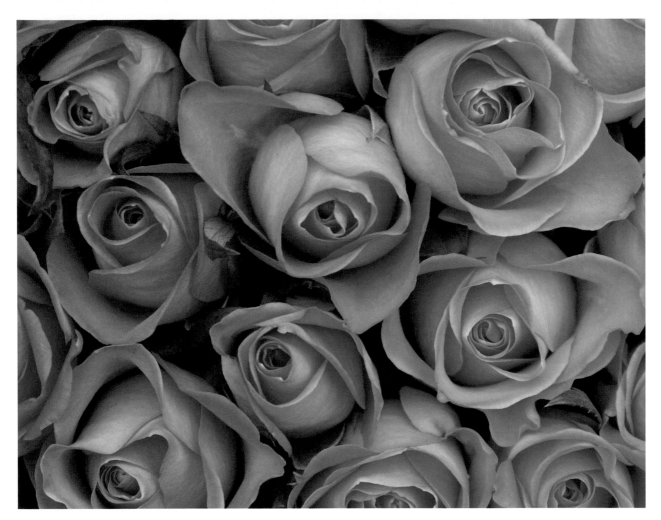

lit and skilfully photographed to stand any chance of success. That doesn't necessarily mean fancy studio lighting, but it does mean you can't just knock the images out quickly. You need to spend time getting things right.

Before having a go yourself, look at what is already available. You'll find that there is a lot of fine stuff out there, so think carefully about how you can match the quality and, ideally, come up with something equally good, but different.

■ Other subjects

The worst thing you can do is to shoot pictures that you think would look good on greetings cards and then submit them to publishers. There is no surer way of getting rejected. Companies already in the market know their business. They know exactly what sells and what doesn't, and they choose their subject material accordingly. It's not enough for an image to be attractive; it must work as a birthday, Easter, Father's Day or general-purpose card.

Keep abreast of what is being published, because the range of subjects and treatments continually changes. Right now, quirky, arty images are popular. These are sometimes just stylish, creative treatments of everyday scenes and situations – often in black and white. You will also see atmospheric landscapes, humorous shots of children, and 'male' subjects, such as cars and still lifes featuring sports equipment, wine and the like.

FLOWER POWER
Pictures of this kind can be used to illustrate cards for Valentine's Day, Mother's Day or birthdays.

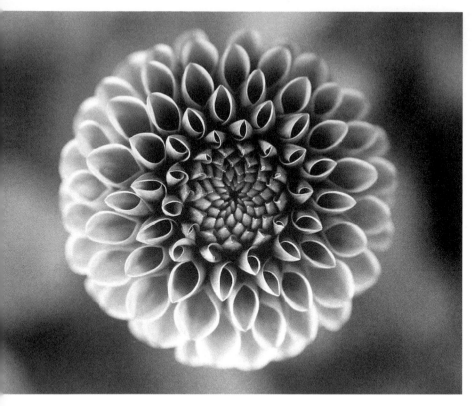

MONO FINE ART
There's currently a trend towards 'fine art' monochrome images.

though not for use on a greetings card during the period for which the agreement is in force. Sometimes this will be limited to a period of time – three years is common – and sometimes will be 'for all time'.

If you have an appealing feline image, for example, that you manage to sell to a greetings card company, you could, therefore, submit it directly to the publisher of a magazine for cat owners or place it with a picture library. But take care: if you do also market your pictures through libraries, it is essential that you let them know when you have already sold a shot for greetings card use. This is because most publishers of cards also source their material from libraries – and you could easily end up with a black mark against your name if the same image were to be published by two rival companies.

■ Fees

Considering how demanding they are in terms of quality and content, greetings card publishers don't pay especially well. Fees can be as low as £75 ($130) and are rarely higher than £200 ($350). A small minority of companies operate on a royalty basis. This can give a regular, though usually modest, income into the future.

Given that most companies typically add just a small number of new photographic cards to their range each year – and occasionally bring out a complete new series – this is not a sector to focus on if you want to get rich quickly. Even if you have some really good material, you are unlikely to make more than a handful of sales each year.

Of course, every sale is welcome, but the return on time and effort is generally not as good as in other markets. That said, the payment is normally for non-exclusive, non-competitive rights. That means that you're free to sell the same picture elsewhere,

■ Image specifications

For many years, greetings card manufacturers were among the most demanding when it came to quality. Quite why that might be, when a card typically measures just 13 x 18cm (5 x 7in), I've never really understood. At one time, many publishers insisted upon roll-film 6 x 7cm or even large-format 5 x 4in transparencies, and wouldn't give 35mm originals a second glance. Happily, some of the companies who have entered the market recently are more relaxed about formats, and will consider all sizes of slides, including 35mm, and high-resolution digital files (normally 20MB+). Even so, pictures have to be of fine quality to succeed.

Most greetings card publishers are happy to receive submissions at any time, with no 'closed' season when they won't consider new material.

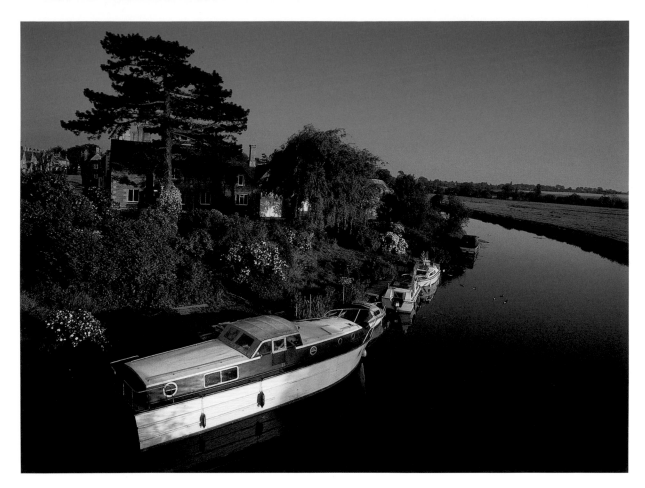

CALENDARS & POSTERS

Many people buy a calendar each year: it's useful to have one in the workplace or around the home so you can check dates and record commitments. Some calendars are simple affairs that just have numbers on them. But most also have pictures to brighten up the room – one for every month of the year. You need only to go into any gift shop or stationery store from August onwards to know that calendars are big business, with millions sold each year. You will see hundreds of different designs featuring every subject under the sun: cats, film stars, country cottages, tranquil scenes, wildfire, artistic black and white... Could you supply some of those images? If you are a competent photographer, almost certainly. Every year, the publishers need a complete new set of pictures, and most are happy to consider submissions from potential new contributors.

THE RIGHT LIGHT
Classic country scenes captured when the light is right will always be welcome in the calendar and poster market.

■ Quality counts

The calendar market is an extremely competitive field – and one where quality counts. Because the pictures are printed relatively large, and will be viewed for an extended period, they need to be technically perfect and have really strong impact. In the days of film, 35mm was rarely countenanced, and only medium-format and sheet film were acceptable. These days, most publishers demand high quality digital images, and will reject anything that falls short of their requirements.

Don't bother submitting material if it is not up to the standard you see already being used. Picture buyers only have to find 12 images for each calendar and are heavily over-subscribed in most subject areas, with many thousands of pictures to choose from.

■ When to submit pictures

As with most areas of publishing, there is a cycle in calendar production that you need to fit in with if you are to have any chance of making a sale. This varies from one company to another, but most seem to focus on picture selection in the first few months of the year. That is generally the best time to make a submission. If you are in doubt, email the company or make a brief phone call to check for the optimum time. Don't ask whether they are interested in seeing images from potential new contributors. The answer will always be yes – they don't want to miss out on the possibility of losing a talented photographer to the opposition just to save a couple of minutes looking at their pictures.

■ Where to send your pictures

The general market for calendars is dominated by a handful of companies, and you'll find these listed in the various handbooks. There are also a number of smaller players that tend to be more specialized in their scope.

The best time to carry out market research is in the months coming up to Christmas, when the widest range is on sale. With postcards, magazines and greetings cards, it doesn't cost much to buy a few samples so you can take them home for detailed study. Calendars, unfortunately, are considerably more expensive. This means that you need to do your research on site, making notes where they're sold. While you might feel a bit self-conscious about doing this, you should have no problems if you choose a large newsagent, department store, garden centre or stationery shop, where you can be reasonably anonymous. If you spend no more than five to ten minutes in each outlet, and move from one to another, you should avoid any hassle or suspicion.

As well as the name, address and telephone number of the publishers, you should look for calendars that use the kind of pictures that you either take at the moment, and have on file, or feel you could take in the future. You also need to pay attention to the kinds of images that each publisher uses. The more information you can record, the better. If necessary, go back on a number of occasions, or visit another town or city if you are worried what staff may say.

QUALITY COUNTS
Quality is paramount when it comes to posters, in particular, as they'll be displayed for long periods of time.

■ Scenic subjects

One of the great things about the calendar market is its diversity. If you like to photograph something, the chances are that someone, somewhere, produces a calendar featuring that subject. That said, the biggest market by far is for scenic pictures – although some other areas, such as domestic pets, are popular as well. Some calendars depict specific towns, cities or counties and regions, while others are more diverse, containing pictures taken from all over a particular country. Such calendars aim to give a strong sense of place with each image, but also provide good geographical coverage, so there's variety over the full 12 months.

As well as the traditional 'blue sky and bright sun' shots, more dramatic or atmospheric lighting will be considered, providing pictures capture the character of the area and depict a specific location well. However, it is mostly traditional 'chocolate box' colour images that are used, depicting landscapes, village scenes, famous monuments, thatched cottages, popular landmarks, harbours, beautiful gardens and tourist sites – although some feature more creative, moody scenic images such as sunsets, mists and stormy weather.

Publishers of scenic calendars are most keen to hear from photographers who have extensive collections of landscapes covering a certain area or country. That is because they prefer, whenever possible, to illustrate a whole calendar, or most of it, with the work of one individual. The benefits are twofold: the calendar has a common style running through it, independent of the different locations, and the logistics are much easier – the picture buyer doesn't have to liaise with 12 different photographers, produce 12 purchase orders, and so forth.

However, don't be put off making a submission if you don't have national coverage. Providing that you have plenty

GONE FISHIN'
Calendars feature a wide range of subject matter to reflect popular hobbies and interests.

of pictures of a particular region or a particular city, it's worth sending them in – because they may be used for a calendar with a narrower focus. Most publishers are not interested, though, in seeing 'bitty' collections of photographs, no matter how good they are.

■ Details matter

One thing you have to be careful about when photographing landscapes with calendars in mind is that the locations appear unspoilt. Make sure you avoid cars, people, telegraph poles, road signs, rubbish bins and anything else that could prevent the scene from looking idyllic. Generally, you'll be using wide-angle lenses to open up the perspective and create a sense of drama, but always check when doing so that stray elements of this kind don't get included. Choose your vantage point carefully, and if necessary use a telephoto lens to exclude anything problematic.

Another thematic approach to the landscape calendar is to choose 12 images that are tranquil or restful in nature – such as sunsets and isolated beaches, waterfalls, ocean scenes, dramatic lighthouses with crashing waves, or calm or moody seascapes. This kind of series might be given a name to point up its theme, such as 'Golden Thoughts'.

Animal subjects

Once you get started in the calendar market, it is reasonably easy to make further sales. But getting your foot in the door can be tricky when it comes to scenics. That's because it is such a popular subject area – what could be more enjoyable than taking pictures in a delightful and photogenic location? – so many other photographers are submitting high quality work.

When it comes to other subjects, the competition isn't so fierce, and publishers are generally delighted to receive material that meets their needs. Animals are probably the second biggest market for calendar images. Domestic pets such as cats, dogs, rabbits and horses are especially popular. As well as 'generic' cat and dog calendars, which include a mixture of breeds, there are also calendars for individual breeds. As with greetings cards, pets need to look cute and appealing for their pictures to be used in a calendar. That means that you can't just take any old snap and send it in hoping it will be published. While there are fewer people submitting photographs of animals, some specialize in the area. Study carefully the pictures that are currently being published in calendars and take the same approach. As with landscapes, you will need to build up a reasonable collection of quality images before making a submission – and it's better to focus on just one animal than to take a more random approach.

Remember that it is not only domestic animals that are popular on calendars. One of the current growth areas is for pictures of wildlife from all around the world – everything from leopards and dolphins to birds of the British Isles. People increasingly want a taste of the exotic on their walls each year, and if you've been on safari, or are an experienced wildlife photographer, you could probably supply it. Pictures should preferably show the animals in their native habitat, looking at the camera, and active in some way. Shots of docile, captive lions or monkeys in a zoo or safari park are unlikely to be successful – unless you are very skilled at making them appear natural.

Other subjects

When it comes to other subjects, research your market carefully and give publishers more of what they're using already. Don't try to persuade a company making classic car calendars that it should move into the market for flower calendars, or vice versa. Use your common sense. Push at open doors and send your classic car pictures to someone who already publishes calendars in that area. You are also more likely to achieve success if you have an interest in the area yourself. That way you are likely to know what will appeal to the kind of person who will buy the calendar.

Rights and fees

When you 'sell' an image to a calendar company, you are assigning them calendar rights for the year in question. Nothing more, nothing less. That means that you are free to sell the same image to another calendar publisher in a future year, or for another, non-competing, use during the same year. What you must never, ever do is sell the same image, or a similar one, to more than one publisher in the same year. If you do you will be in serious trouble. You will certainly be blacklisted, and you might even be sued for compensation. That means you need to take care if you also sell pictures through a library and you have a version of that shot with them. Calendar companies sometimes source images from libraries, so you need to let yours know if they can't sell it for a particular use.

How much can you expect to make? Well, the fees are not especially generous for each picture, but since you are likely to sell several at the same time, it can add up to a useful amount.

MOOD MATTERS
Atmosphere is often as important as content when it comes to calendar and poster photography.

BOOKS

A few years ago it was widely predicted that the Internet would kill the book. The claim was that we would all be having our information needs met via a computer monitor or a handheld PDA. But the web has no more killed the book than television killed radio. Step into your local bookshop and you will find a thriving business, with more books than ever before being published each year.

Although there is little potential for the freelance when it comes to fiction – there is only text inside and the cover is often an illustration – many non-fiction books in popular areas such as gardening, cooking and travel are lavishly illustrated with photographs. How do you get a piece of that action? Well, the honest answer to that is 'not easily'. It can be done, however. Those pictures obviously come from someone, and if you are determined enough, it could be you.

■ Commissioned or stock images

The starting point, as ever, is to be clear about what you are offering. This will determine which publishers you approach. Are you looking to be commissioned to take the pictures for a book, or do you want existing material to be considered for publication?

A travel guide, for instance, might feature the work of just one photographer sent to the location all expenses paid, or it might feature a collection of images gathered from a wide range of sources. Commissions are normally given only to experienced photographers with a track record in the field. Even to be considered, you need plenty of tear sheets and a bulging portfolio. That's because publishers need to feel certain that the photographer will come back with the images required – and they rarely take a risk with a newcomer.

If you have had work featured in lots of magazines, calendars and so on, it could be worth making contact and saying that you are available for commissions. If you don't have much published work, send in a selection along with details of what you have on file. Then, when the publishers produce a title for which you have material, they can get in touch with you. That's one

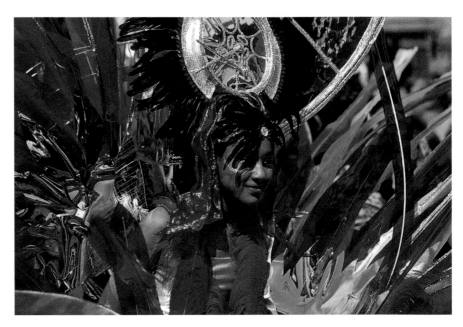

reason why it's a good idea to cover a handful of subjects in detail, rather than have a few shots of many different areas.

If you write to a publisher of gardening books and tell them you have pictures of all common shrubs and trees, they are likely to get in touch when *The Complete Shrub and Tree Handbook* comes along. However, you really must have the material in depth. If they send you a list of 20 shrubs they want and you can supply only four, you can be sure they won't contact you again.

Book picture researchers are sometimes on the staff and sometimes work freelance. Either way, they like to make life easy for themselves by having as few sources for

CARNIVAL TIME
There are books on just about every subject under the sun, so it's worth building up a collection of different images.

Researching publishers' fields of interest

There are three main ways of doing your research: using directories, going to bookshops, and using the Internet.

- Directories such as *The Writers' and Artists' Yearbook* list the major and many of the smaller publishing companies, along with the subject areas in which they publish.

- Bookshops are organized by subject area, and a couple of hours spent browsing some large stores will enable you to find out what's out there already and take down the names of suitable publishers.

- The Internet is also valuable. Go to Amazon, or one of the other online bookstores, and type in the subjects for which you have lots of images. In seconds you will have a comprehensive list of titles, along with the names of the publishers and the ISBN numbers.

the photographs as possible. If they can get the 300 images they want from just three photographers and one specialist library, the logistics are much more straightforward to manage than if they use 30 different photographers and five general libraries. That would mean a lot more emails, packages, invoices and so on for them to handle.

■ Doing your research

Researching publishers who produce books in the areas where you have images is the only realistic way of working. During the late 1990s, I produced a fortnightly newsletter for freelance photographers called *Cash From Your Camera*. This listed specific picture requirements for picture libraries, magazines and publishers of postcards, calendars and books. There was no problem getting information on the other markets, but the book market proved more difficult. Despite approaches to many publishers, only a couple of picture researchers were willing to provide detailed lists – so you won't get far by emailing book companies and asking them what they want.

ARTIST'S STUDIO
This picture was taken for possible use in a book on artists and their studios.

■ Fees

As with magazines, the fees paid by book publishers vary enormously. Educational publishing – books for schools, colleges and businesses – tends to pay worst. Popular consumer titles that sell in high volume generally pay best. Normally you receive a one-off fee, and for that you may have to agree to the pictures being used internationally. The economics of publishing mean that co-editions are often produced with a translation of the text for a number of different countries. However, unless you assign the copyright to the publisher – in which case you should expect a much higher fee – it will stay with you.

When the photography is commissioned, rather than existing pictures used, an all-in fee is agreed. Obviously, this needs to cover the time and effort involved, along with any expenses. Sometimes publishers will insist upon acquiring the copyright in the images. If the fee is large enough, you might be willing to agree. But if the payment is less than generous, you may feel the only way of making things work financially is to sell the images after publication to magazines or through a library, and you should ask to retain the copyright.

2 | PICTURE LIBRARIES

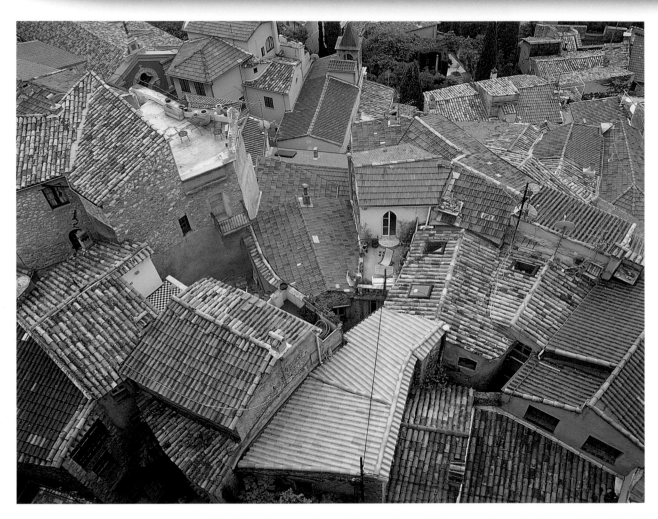

VIEW FROM ABOVE
These rooftops in Roquebrune-Cap-Martin are one of the iconic images of the Provence region of France – and feature in most guide books of the area.

Shooting for a picture library is not the way to get rich quickly. Stock photography should be considered a mid- to long-term investment. It takes a while to build up sufficient images to generate a sizeable income, and even then you need to keep your contributions topped up because pictures date and the market moves on. But if you are looking for an accessible way of profiting from your photography without the hassle of dealing directly with clients, stock photography might be for you. If you take the time to understand the market, treat it as a business, and shoot what people want to buy rather than following your own interests, you should do well.

■ The advantages of picture libraries

Picture libraries house thousands and sometimes millions of images taken by hundreds of photographers, and market them to picture buyers for use in books, magazines, brochures, billboards, calendars, on television, in audiovisual presentations, and other media. The arrangement suits the clients because they can get exactly what they want for a project without the hassle and delay of finding and commissioning a photographer – and often at a significantly lower outlay.

Picture libraries also offer advantages to photographers. Not everyone is cut out for the competitive world of commissioned photography, and some photographers don't even like having to submit images to markets such as magazines, calendars and books. For one thing, it takes a certain amount of confidence to contact editors and picture buyers and sell your own material effectively, and for another it can be extremely time-consuming.

You have to select pictures that are suitable, package them up and send them, chase up a week or two later if you haven't heard anything, submit an invoice when pictures get used – and keep doing that in a regular, ongoing cycle.

That's not a problem when photography is your living. You'll be able to both shoot the pictures and get them out to potential buyers. But if you have another job that you're working around, or family commitments, the number of hours you have available is limited.

If you spend it all on marketing and building relationships with picture buyers, you may not have time to actually take any pictures. For that reason, many part-time, semi-professional photographers prefer to sell their images through picture libraries, leaving them free to concentrate on the part they enjoy most.

■ The changing face of stock photography

Stock photography has grown over the last 20 years to have a dominant position in the marketplace. Over the last decade there has been significant centralization as the two leading players in the field have gobbled up many of the medium-sized libraries. Getty Images and Corbis are now extremely powerful, both playing a major part in defining trends and setting prices. However, there are new photographic libraries being established all the time, so there remains plenty of competition.

Most pictures libraries are now digital. The days are long gone when a member of the library staff would search through sheets of transparencies on the basis of information given by the client about their needs and put a selection of pictures in the post. Searches are now usually carried out online by the buyer him- or herself, making it easier for them to find what they are looking for.

Once a suitable image has been located, a fee is agreed, based on what it is going to be used for, any geographical limitations, and the period for which it can be used. Images are then normally delivered either on CD or, increasingly, via email. Some libraries still send out transparencies, but these are now few and far between. Photographers can supply their digital images to the libraries in the same way.

This means it no longer matters where a library is based. Geography is totally unimportant. In the past, the leading libraries were to be found in centres of population and commerce – London, Paris, New York – but these days they can be anywhere in the world, and often they're out there somewhere in cyberspace.

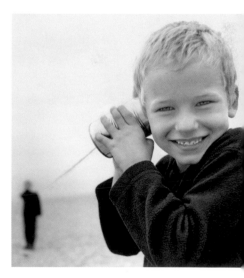

IDEAS MATTER
Ideas are often the most important thing in stock photography. Here the simple prop of a tin can produces an image that illustrates 'communication'.

Rights-managed versus royalty-free images

What kind of pictures sell through libraries? Anything and everything. The most popular subjects are people, business, places, and concepts – but a search through the files of any leading library will reveal an extraordinary range of material covering every subject you can think of.

Another substantial change in recent years has been the emergence of 'royalty-free' stock. Unlike traditional 'rights-managed' images, which are licensed for a specific use and period of time, royalty-free images can, once bought, be used an unlimited number of times. This makes them particularly popular with designers, who can use the same image – of, say, Times Square in New York or a business person talking on the phone – in work for many different clients.

Choosing a library

Despite the increasing centralization of the business, there are still plenty of picture libraries around. Some are global in reach, others are national. Some offer general coverage, whereas others focus on a specific subject area, such as gardening or the military. Should you go with one of the leading libraries? Well, frankly, you may not have the choice. Unless your work is absolutely outstanding you will struggle to get in with Corbis or Getty. These days, they tend to select the photographers they would like to represent, rather than the other way around.

However, if you have strong, saleable material, there are smaller libraries that will be pleased to represent you. This arrangement might work better for you if you plan to shoot part-time and put in contributions only occasionally. With the leading libraries, your work would be competing with that of full-time professionals, and although you would be exposed to a wider range of potential clients, your images might be less likely to sell. It's probably best to be a big fish in a small pond and go with a small- to medium-sized library.

If you take pictures of many different subjects, then you should look to join a general library. But if you concentrate on a particular subject area, such as food or buildings, then a specialist library could offer a better market for your images. You will find libraries covering architecture, botanical photography, business, industry, food and drink, landscape, travel, natural history, personalities and celebrities, sport, transport, and many other subjects.

CAPTURE ATTENTION
Bright, vivid images that capture the mood of a place will always catch the attention of picture buyers.

Royalty-free collections

Royalty-free images are occasionally sold individually, but more often as part of a collection, on a CD entitled something like 100 Backgrounds or 50 Cats & Dogs. Such compilations are usually the work of one photographer, but can sometimes be a combination of pictures by three or four. Buying CDs also brings down the unit cost of the pictures – to just a few pounds or dollars per shot. However, the volume sales that such compilations achieve can make them extremely lucrative.

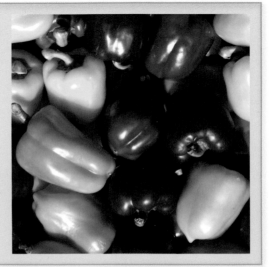

Approaching a library

Having drawn up a shortlist of libraries you feel would be suitable for your work, the next stage is to find out exactly what they require. A good first step is the library's website. There is often a link called something like 'Information for Photographers/Contributors', which will give you the information you need. If this information is not available, send the library an email or give them a call. Most are happy to hear from prospective contributors because they need a constant supply of fresh images to service the needs of their clients. They are, however, extremely busy, and don't have time to give you advice on what to shoot and how to make it saleable.

Most libraries ask to see an initial submission of images so they can gauge the style, quality and saleability of your work. The number they will ask for could vary from as few as 15 to as many as 500. When sending this first set, make sure you include only pictures that are technically perfect and have a lot of impact. You want them saying 'wow' when they look at what you've sent in. Rather than including work that's weak to make up the minimum submission numbers, wait until you've taken some more shots that are strong enough to succeed.

Contracting to a library

Once you've been accepted as a contributor to a library you will normally be expected to sign a contract. This is a legally binding document that often contains an element of exclusivity. Some libraries ask that you place images just with them, that you don't sell your work through any other library – although you are usually allowed to market pictures direct to clients. Other libraries are not so restrictive. They don't mind you placing images with more than one library provided they are not from the same series.

In the past, photographers often signed such documents and then disregarded them. Figuring they would probably never get found out, they put the same pictures with several libraries around the world. However, with virtually everything up on the Internet these days, and some libraries distributing pictures through other sites, you are a lot more likely to get caught. Think carefully about any documents you sign, and consider whether you can live with any restrictions they impose.

What libraries expect of contributors

Libraries vary in their expectations of contributing photographers. Some libraries, such as Alamy, allow you to upload as many images as you want once you've been accepted as a contributor. Others follow the traditional approach, going through submissions and selecting photographs they think will sell. In either case, you will need to supply detailed captions (see below).

One thing all libraries have in common is the commission that they claim from any sales made. This is typically between 35 and 60 per cent, which may sound quite a lot. But the fact that the libraries have access to markets that you would never otherwise know about or have an opportunity of servicing, and are in a position to negotiate higher fees than you would ever get, more than justifies the commission. Libraries also have a significant investment in websites, marketing and accounting, which you don't have to worry about.

Submitting work to libraries

Most picture libraries prefer submissions to be digital, because that's how files are generally supplied to clients these days, and it means less work for them. Some are still happy to accept transparencies if the quality is good enough – taken on slow stock such as Fujichrome Velvia/

Provia 100 – and the pictures saleable. But increasingly the images are scanned and distributed digitally, with the original kept in the office or returned to the photographer.

Some libraries accept digital submissions only, and that trend looks set to increase. That means you need either to shoot digitally or scan your own transparencies, prints and negatives.

At the time of writing, most libraries request files of around 48–50MB. That's the minimum most buyers will accept, because they want to be able to print them up to A3 in size (297 x 420mm/11¾ x 16½in). However, they vary in how they expect this 48–50MB to be achieved. Some ask that it be the resolution of the camera, which means using a top-end digital SLR or back. They are strict in enforcing this requirement, sometimes insisting upon seeing the original file as verification. Such cameras are expensive, and beyond the means of many amateurs, but if you're serious about stock it may be a worthwhile investment, made affordable by paying for it over one or two years.

Other libraries take a more pragmatic view, believing 48–50MB to be far more than most buyers actually need. They allow contributors to 'res-up' or 'interpolate' their

images to achieve the required resolution. This can be done quickly and easily in standard imaging programs such as Adobe Photoshop, or you can buy specialist programs, which some say do it better, such as Genuine Fractals. In theory, you can start with an image of any resolution, but in practice if the original has fewer than six million pixels, the finished image may not be of acceptable quality.

If you're shooting with film, and scanning the images for submission, you will need to do so at a resolution of at least 3200dpi, and ideally 4000dpi, to gain the maximum quality, particularly with 35mm originals. Because it's easy for dust or marks on a

THINK CREATIVELY
Small details can make all the difference, so think creatively. This image has sold well because the use of a long shutter speed has blurred the people, giving their movement a sense of urgency.

DETAILS MATTER
As you travel around make sure you photograph details, as well as the main sites – such as the heads of these fish being sold in a market.

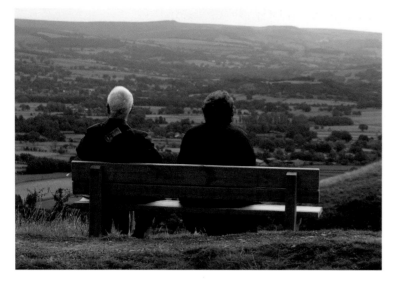

Know your markets

Put yourself in the shoes of a potential buyer. Why do they want a particular image and what is it expected to do? The buyer may be a magazine editor looking to illustrate a feature; a designer producing a brochure; a greetings card manufacturer launching a new series; or a picture editor gathering together photographs for a book. In each case, they will be looking for images that meet specific criteria. The magazine editor, for example, may be looking for a bold, vigorous picture that brings a dull article to life. The designer may require shots that illustrate different aspects of business.

slide or negative to impair the quality of the finished image, some libraries insist you retouch any imperfections, viewing the picture at 100 per cent so nothing gets missed. That's because buyers will return anything that isn't up to the mark.

If you don't have a scanner, or don't feel you could handle the tedium of checking and cleaning up dozens of images, there are companies that offer a scanning and/or retouching service, leaving you free to concentrate on the business of taking the pictures.

■ The benefits of shooting stock digitally

To be honest, I don't know why anyone would shoot stock using film any more, when working digitally has so many benefits. For a start, it doesn't cost you anything. Back in the days when I used to shoot medium-format slides, my film and processing bill was enormous, and I had significant costs to cover

before I started to make a profit. Now that I shoot entirely digitally, each picture is effectively free. This is liberating because I can take a lot more pictures and a lot more risks. In the past, I would often limit myself to just a few shots of some subjects, because I wasn't sure if they would sell. Now I can take them anyway, and if they don't sell it doesn't matter.

I can also take more pictures of subjects that I know will sell, exploring different angles and trying out unusual treatments alongside tried and tested approaches. If they don't turn out to be saleable, there's nothing lost.

Being able to review the picture immediately also means you don't waste time trying out alternative executions unnecessarily. This is especially valuable when you are photographing people and you want to capture a particular expression or pose. With film, you can't be certain that you've got it until the image has been processed. With digital, you can tell straight away whether you have succeeded, and then move on.

■ A numbers game

Digital offers a major advantage because the name of the game in stock photography is generating as many saleable images as possible. It's a matter of numbers. Only a small percentage of the images you put into a library will actually sell – perhaps only one in every 100. The problem is knowing which one it's going to be. It's really hard to tell. Sometimes you shoot what looks a sure-fire winner and you never sell it, and sometimes a picture that doesn't seem very special sells time after time.

So, given that it's a numbers game, you need to get as many shots into stock as possible. Some professional photographers have as many as 50,000 images placed with libraries, and if you take photographs regularly, you'll soon see the numbers of your pictures mount up.

■ Subject matter

Of course, it's not just a case of how many images you have with a library. Subject matter and treatment are also important. You can't just send in the snaps you took while on a weekend break by the coast and wait for the cash to come pouring in. You need to know what sells, so you know what to shoot. Otherwise you will waste time taking pictures with little potential.

One simple way to research the market is to go to some picture library websites and see what's there. If you specialize in one or more subjects, do a search for the kind of images you shoot. If you're a generalist, try a few different areas, such as people, travel and products. How do your pictures compare? Are they as good? Better? Or worse? Be objective. Be honest. You will only succeed in stock photography if your work is up to the mark. Buyers have plenty of images to choose from, and yours will simply be passed over if they don't make the grade.

■ Shooting images that sell again and again

The Holy Grail of stock photography is producing pictures that sell and sell and sell. But it's not easy. If you could do it to order, you'd get rich very quickly and be able to live off the income for many years to come. The problem is that just about anything you can think of photographing has already been photographed, with hundreds of pictures already on the library files around the world.

What you shoot does not have to be more original (although that can sometimes help), but it does need to be definitive – a shot that absolutely sums up what it's trying to say. A good example of this is an image I've seen published in many different magazines and newspapers. It's of two people on a rollercoaster, screaming with excitement, their hands held high. It's a great picture, deserving all the success that

it's achieved, and it must have generated a significant income for the photographer. Even mundane shots can be substantial sellers; one photographer told me that a picture that he'd taken of the sky from the window of an aeroplane had sold several hundred times.

■ Combining stock photography with other work

One of the advantages of stock photography is that you can do it alongside, and sometimes as part of, other picture-taking projects. You might be shooting in a scenic part of the country with an outdoor magazine in mind, but some of those shots could be suitable for the picture library too. It's the same if your target market is a travel brochure, a publisher of postcards or a local newspaper. In each case, you should be thinking about submitting the pictures you take for stock use as well.

That's fine if you're a freelance, shooting on a speculative basis, but what if you do mainly commissioned work? Many of the photos you take would make great stock images, but doesn't the fact that a client has paid you to take them mean they can't be used in that way? Well, yes and no; it all depends upon the agreement you made when the work was commissioned. One option is to give your client exclusive rights to an image for a specified period of time – say three years – after which you are free to market it. Some clients won't agree to that, and you risk losing work if you insist. But others

ILLUSTRATING CONCEPTS
This is one of my best selling pictures, not because many buyers are looking for pictures of fireworks, but because it can be used to illustrate the concept of celebration.

LIFESTYLE MAGIC
There's a huge demand from users of photo libraries for pictures of people – from simple, graphic headshots to lifestyle images.

won't be concerned, knowing that after that time they wouldn't use the image again anyway. This could provide you with a lucrative source of income from pictures that you've already taken. You must have this agreement in writing, however. Consider including a 'stock' option in your standard terms and conditions, putting the onus on clients to say if they are not happy with the arrangement.

■ What if you're a social photographer?

That arrangement is fine if you are a commercial photographer, but it is not really an option if you shoot portraits and weddings. Your customers would be annoyed if they saw pictures of themselves and their family in a magazine or an advertisement without their permission. Even if you asked them, most would be unwilling to consent, because such images are so personal.

However, there is another way. When you get clients who are attractive, and who you think would make good stock subjects, ask them if they would be willing to model for you on that basis. Many will be flattered and keen to earn some extra money. Some may even be willing to do it in return for an extra print or two.

■ Model release

Whenever you photograph people, it is essential to have them sign a model release form. Once pictures leave you and are with the picture library, you have no idea how they are going to be used – in fact, you have no control over how they might be used. It's normally at least a few months after a sale has been made that you know about it, when it appears on your statement. By then, it's too late to say that you didn't want the image published in the way it was, and the damage is done. A perfectly innocent picture of an adult and child could be published as part of

an article on incest. Similarly, a shot of a person holding a glass of wine taken at a friend's party might be used to accompany a report on alcohol abuse. Sometimes a publication will say 'posed by models'; sometimes it won't.

Often when you start out shooting stock, you use people you know as models – your partner, family, colleagues and friends. In your eagerness to build up the number of pictures, you submit them without asking permission from the subject. But images can be used in many ways, not all of them flattering. Imagine how embarrassed you'd be to have your brother or neighbour say how upset they are at how a picture of them has been used. An old work colleague you haven't seen for years might be so irritated that he or she decides to sue you for libel.

For all these reasons, you can't rely on an 'understanding'; you must obtain a signed model release form every time, even when the subject is your partner, child, parent or close friend. Couples split up; relationships end; friends move away. In those situations, you should seek to get images back from the library if you can, but that may not always be possible. If you have a signed model release, there can be no comeback – you are fully protected.

A typical model release form is reproduced here. This allows you to use the image in any way you like. Some people will sign it without a thought; they may not even read it. Others will balk at some of the conditions. If you find people are refusing to sign, you could narrow the range of uses – which will limit the picture's sales potential. If an image is not fully released, you need to indicate that when submitting it to the library – for example, 'released for editorial use only'.

Using this sample text as a starting point, get some models forms printed or print them on your own computer. After each session, ask your models to sign them. Don't wait a few days or months; ask

Sample model release form

The following sample text can be adapted as necessary, but in its present form it meets the needs of most circumstances.

To: _____
(photographer's name and address)

From: _____
(model's name and address)

In consideration of having received a payment of _____ from the above named photographer for posing for photographs

on _____ at _____

I hereby assign you full copyright on those photographs and give you the right to use those photographs for publishing, advertising, publicity, exhibition, illustration, trade or any other use in any medium for all time. I also give you the right to allow any other person to use those photographs with your permission for any use in any medium for all time.

I agree that the photographs and any reproductions shall be deemed to represent an imaginary person, and agree that any wording used with the photographs shall not be considered to be attributed to me unless my name is used.

I also agree not to prosecute, institute proceedings, or make claims or demands against you or your agents in respect of any usage of the photographs by you or them at any point in the future.

I have read this model release form and understand its meanings and implications.

Signed _____ Date _____

If you are under 18 years of age a parent or guardian must sign

Parent/Guardian _____ _____ Date _____

them to sign straight away. When you're travelling, have some forms in your bag, and ask anyone who features prominently in your pictures to sign. Some will, some won't. In the case of minors (children under the age of 18), a parent or moral guardian must sign the release.

Because of the international nature of stock photography, and the increasingly litigious climate around the world, these days you may also need to obtain a signed release when photographing certain buildings, such as country cottages and personal residences.

KEEP IT SIMPLE
Travel pictures don't need to be complicated or clever. Often it's a simple image of the key sights that sells.

■ Photographic restrictions

Certain things are copyrighted, and if you photograph them you're not allowed to publish the pictures. Examples include the London Underground sign, the lights on the Eiffel Tower at night, and the Hollywood sign in Los Angeles. Generally, picture libraries are aware of these restrictions, but the number of sites protected in this way continues to grow, so be alert for signs as you are going round with your camera, and respect them if you see them.

■ Shooting landscape and travel subjects

Probably the most popular stock subjects with photographers are landscape and travel – not least because you get paid to visit interesting places. Ideally, you will want to go away for a week or two and dedicate yourself to taking pictures, but if you are supplying picture libraries around work and family commitments that may not be possible.

Nonetheless, at least once a year you should get the chance to drag your nose away from the grindstone, and head off to some sun-kissed beach for a while. With plenty of time on your hands, and a stimulating environment all around you, chances are that your photographic juices will start to flow.

Stock photographers who, like police officers, are always on duty, will find that the annual vacation provides the opportunity to take some saleable images. Over many years I've made money from images taken while I was on holiday, whether it was a couple of days away in the UK, or a week in the Mediterranean sun. The idea of going on holiday without some kind of freelance element built in is inconceivable to me. Having packed the photographic gear, I then see if there's room for any other luggage.

If you travel on your own, there's no problem. You can go where you want,

when you want. But if you have a partner, however supportive he or she is about your photography, it can be a lot trickier. If you have children, then you may end up having trouble juggling your commitments. It's crucial that you get the ground rules established before you go, or the trip will consist of one long argument. Is it a holiday during which some pictures will be taken, or a stock shoot at a holiday destination? You need to decide. For most of us, it's the former – but with a little ingenuity, and a bit of give and take, all parties can be satisfied.

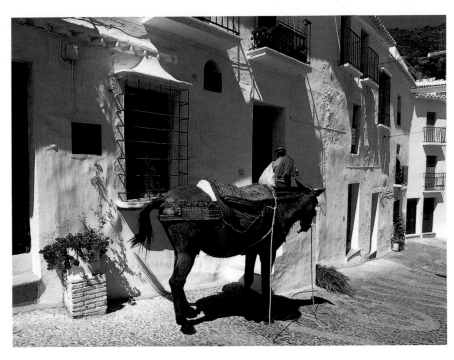

ADDING INTEREST
Empty streets result in travel shots that lack interest, so keep your eyes peeled for elements – such as this donkey in Spain – that bring pictures to life.

■ Shoot when the light is right

The most saleable pictures can often be taken at the beginning of the day, when the light is at its best. The photographer of the family could steal out at dawn, satisfy their craving to capture some images, and then set aside the middle of the day, when the sun is too high and too intense for serious shooting, for family fun. As the sun starts to drop, and the children start to flag, so the camera can come out again, to capture the warm glow of the evening light.

That doesn't mean, of course, that you can't take pictures during the day, if something catches your eye. It's just that on such occasions, the photography must fit around the holiday, not the other way around. You might stop and take two or three quick frames, but you wouldn't erect your tripod and stand somewhere for 20 minutes taking pictures.

It is a good idea to take a tripod on holiday when you can. It is easy, when you are intoxicated by the holiday spirit, to lapse into snapshot mode – and snapshots, however good quality they are, will not sell. Working on a tripod will slow you down,

and keep you tuned into the fact that you are meant to be taking your photography seriously. If you have two cameras, you might like to load one up with print film for shooting family souvenirs, and the other with slow, high quality, slide film for your serious work.

Take care over your exposure when on holiday. The three S's – sea, sand and sky – can send your meter haywire, and there is no market whatsoever for poorly exposed pictures.

What subjects sell? Anything and everything. To find out what the big-selling subjects are where you're going, look through guidebooks and holiday brochures before you go. When you arrive, head for the postcard racks. These will confirm not only which are the most important locations, but where it is best to photograph them from, and which is the best time of day.

Try to think not only in terms of locations, but also in terms of the feel of a picture. Look for subjects that seem to sum up the spirit of the place, such as flamenco dancers in Spain. If you are at a resort,

capture some generic holiday pictures of people swimming in the pool, sunbathing, or eating and drinking. Make sure you get signed model release forms, though, if you plan to get them published.

Whenever possible, try to be a bit more adventurous, and be prepared to hop on a bus or hire a car and head off to investigate the area where you're staying.

■ Get the generic picture

Magazine publishers and advertising agencies often need to find a single image to illustrate a specific location. They're after a picture that tells the reader what the place is at a glance. For India, it's the Taj Mahal; for Germany, it's the Brandenberg Gate in Berlin; for the Caribbean, it's a palm tree on a tropical beach. If you shoot travel and want to maximize your sales, you must capture generic images of this kind whenever possible.

Many photographers shy away from such subjects because they feel there's no point, but in fact there is insatiable demand for the classics, while the more obscure shots that many photographers take instead are never called for. Sometimes, as in the examples above, it's obvious what you need to shoot. But with other locations it's not immediately obvious – and then you need to do some homework. Before setting out, I consider the images used in guidebooks, especially on the cover, and when I'm away I check out the most popular postcards.

When I was planning a trip to the Nice/ Provence region in the South of France, for instance, it became apparent that the most-

GENERIC IMAGES
In most locations you visit there will be one or more iconic images that everyone knows – such as this cowboy, 'Vegas Vic', in Las Vegas.

used picture was of the orange/red roofs of buildings at a small place up the coast called Roquebrune-Cap-Martin. Although it involved the best part of a day trip, and being away from the area where I really wanted to be, it was a price worth paying to capture the image I was after. Having stopped briefly at Monte Carlo on the way, I didn't arrive at Roquebrune until 1.30pm. This proved lucky, as access to the vantage point I needed was through a ruined castle that didn't open to the public until 2pm.

When researching Las Vegas, I came across lots of different images. The most popular seemed to be of the cowboy with the word 'casino' underneath, so I made it a priority to search that out when I was over there. You never know how things will be when you turn up – whether you will need a wide-angle, standard or telephoto lens, for example – so you need to go equipped for all possibilities. To get the shot of the neon cowboy, I needed a telephoto zoom to crop precisely and a tripod to avoid camera shake while shooting at night.

The white towns of Andalucia in Spain are one of my favourite locations. Often, these are represented by a shot of one of the more attractive towns perched precariously on a hilltop – and I had already built a useful collection of such images. But they are also sometimes illustrated by photographs taken inside a white town, ideally with the addition of some 'local colour' in the shape of crafts or people. On my most recent trip to southern Spain, I detoured for a day to the town of Frigiliana, which proved to be a photographer's paradise. The weather was kind, and I was able to add a number of saleable images to my files.

Next time you plan a trip, do your homework first, and know which images are worth shooting and which are not. If you are represented by a picture library, seek their advice – they know exactly what is saleable.

■ Shots of local people

Having got the essential images in the bag, look around for other, more interesting, ways of conveying a sense of place. I always look out for opportunities to include people, from the lace sellers outside the Giralda Tower in Granada to the street entertainers in London's Covent Garden.

I used to hang back and try to shoot candids with a long lens, but the results were far from satisfactory. Now, having got over my nervousness, I tend to go in close with a standard lens or more often a wide-angle. Generally, I ask if it's OK to take pictures – by means of sign language if there is a language barrier. More often than not, I'm given the go-ahead. Having already planned in my mind the compositions I want, I work quickly so as not to outstay my welcome.

In places where English is spoken, I try to engage the person in conversation, passing a few pleasant minutes asking them about their life and the area. Then, if it seems appropriate, I will ask to take some pictures – although often the subject of photography will have come up naturally, as I always make sure my camera is on view. This may sound like a cynical ploy, but it would probably fail if it was. In fact, I'm intensely curious about people, and enjoy finding out what makes even complete strangers tick.

Sometimes the relationships you strike up can become surprisingly close in just a few minutes. A while back, I was in New Orleans for five days, and wandering back from photographing Jackson Square I encountered an immensely photogenic man playing saxophone on a boardwalk on the banks of the Mississippi. I listened

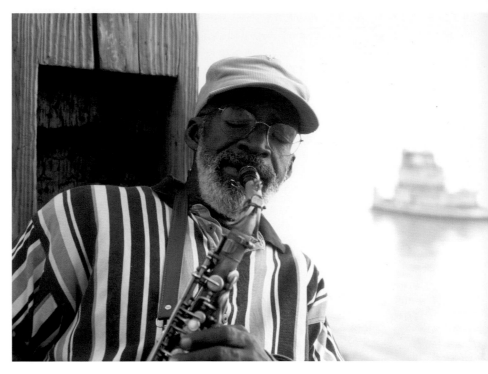

for a few moments, tossed some coins into his case, and asked him how things were going. Over the next 30 minutes, he told me his life story – a fascinating tale – and played me some of his favourite tunes. He also asked me about the camera slung over my shoulder, which, in due course, was my cue to ask him if he would pose for some shots. He was more than co-operative while I rattled off 20 or so frames. We parted with a handshake and a pleasant memory. So don't be shy. All it takes to add variety to your travel pictures is a willingness to approach people. They won't bite your head off; the worst they will do is ask you not to take pictures.

■ Head shots

Ask virtually any picture library what kind of images they need most and they will tell you they looking for pictures of people. What kind of pictures? What kind of people? All kinds. All ages. You have only to turn the pages of a magazine, check out the packaging in a supermarket, or sift through the junk mail that comes through

SAY IT WITH PEOPLE
When shooting travel for stock, don't just concentrate on the scenery. Including people often gives a better sense of the place.

your letterbox every day to realize how big is the demand for people photography.

You could get in on that action. While some of the shots are sophisticated studio set-ups featuring specialist props, many are just simple head-and-shoulder shots of the type that anyone could take with a telephoto zoom, a large aperture to throw backgrounds out of focus and a reflector to soften any shadows. You don't need to worry about paying people to pose, either. In time you might want to, but initially you can work with family and friends, provided they are happy for you to offer the pictures for publication and sign the necessary model release forms. There has been a big shift away from using professional models in stock, because the pictures often look cheesy and contrived, and towards real people in real-life situations. These could be as ordinary as shopping in a supermarket or watching television.

Individuals of all ages are required, from babies to seniors, as well as couples and groups. With an ageing population in many parts of the world, there's a particular need for images of middle-aged, mature people looking happy and active. If you don't know people who would make suitable subjects, try putting an advertisement in your local post office or corner shop. Offering some kind of payment, however modest, may be sufficient to persuade a few people to contact you.

Schedule a shoot of around three hours, and you should be able to produce several sets of pictures in different locations, with a change of clothes and hairstyle for a little variety. Setting up just one session of this kind every week would soon give you a solid collection of saleable shots to put into stock.

Lifestyle

What most libraries are interested in seeing are 'lifestyle' images of people. Advertising companies and magazine publishers have an insatiable demand for images of this kind. Because of how and where they're used, rates tend to be higher than standard head shots.

This kind of picture includes couples paddling on the beach, someone meditating on a bed, groups of friends out drinking in a bar, someone listening to music on headphones, and children jumping on trampolines. What all these pictures have in common is that the people are having fun – and their pleasure and joy is evident in their expressions and body language.

Capturing – indeed creating – such emotion in a way that looks spontaneous isn't easy, which is why skilled lifestyle photographers are in great demand. If you can turn your hand to this kind of work you will find picture libraries biting your hand off. People featured in lifestyle images aren't generally your girl- or boy-next-door types. Almost without exception, they're the 'beautiful people' – slim, fit and attractive – and that generally means using professional models, unless you're lucky enough to have friends who fit that description. It can be a worthwhile investment; the cost of hiring a model for half a day is not excessive, and there is every chance that you'll recoup your money with the first picture that sells.

Business and commerce

One of the biggest areas of stock photography is business. In the past, picture libraries produced glossy catalogues full of images showing people in meetings, at computers, shaking hands, using mobile phones, signing documents, counting out money and a whole lot more. The fact is: work sells.

But you have to get it right. Don't bother asking a friend to pose with your tatty old mobile – it won't sell. Every element has to be just right: the models have to be credible as business people; any equipment featured needs to be bang up to date;

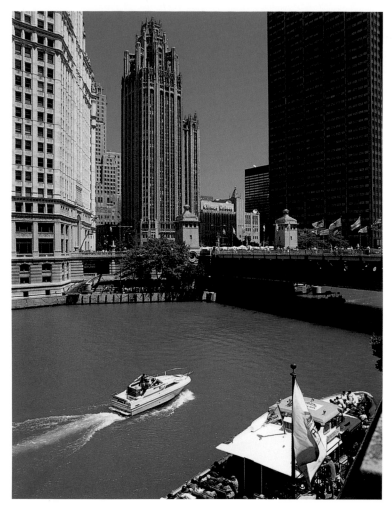

briefly. Or it may be worthwhile contacting the manufacturers directly. They may be willing to loan you equipment if they know that pictures featuring their products will be used in magazines.

Then there's the matter of finding suitable locations. Start by trying to find somewhere you could use for free, by asking friends and relatives if they know of anywhere with the right look.

To stand out from the crowd, business images need to be dynamic and eye-catching. Use your camera at maximum aperture to restrict the zone of focus, tilt it so the subject is tilted, or shoot in black and white to give a gritty, graphic effect.

■ Industry

Another substantial area of stock photography is industry, not least because it covers such a sprawling range of subjects: manufacturing, science, medicine, education, retail, transport, power, construction, technology and shipping. But despite its size, this market isn't one I recommend you target, because unless you know the industry in question you're going to make a lot of mistakes – and you're going to have a lot of hassle gaining access to the subject matter.

Say you decided to try shooting some stock relating to the communications business – where would you start? One radio dish or length of cable looks pretty much the same as another to me. And since I have no idea what people who request bio-medical images are after, I wouldn't even try to photograph them. Of course, if you have a background in a particular industry you will understand the needs of the magazines and journals that cover it, and be able to produce material they could publish. But if you are an outsider, you are likely to be wasting your time. If you are serious about making money from stock, go with what you know.

and the locations should be inspiring and contemporary. Get these elements right, though, and you could do well, as the demand is enormous and existing images soon go out of date as hair and clothing styles change and technology is updated.

If you know people who look sharp in a suit then they could serve as models, but you may have to book a professional via an agency to get what you need.

Accessing the latest equipment may prove more problematic. If you don't regularly buy the latest gear, or have friends or colleagues who do, then you'll have to find some way of borrowing or hiring it. Try making friends with a local store, perhaps offering them prints to promote the products in return for borrowing them

BUSINESS FOCUS
Business is a big and lucrative area of stock photography, including everything from the financial districts of large cities to people in meetings.

Concepts, ideas and symbols

Picture buyers often want to illustrate a particular idea, and are looking for an image that can bring it to life in a conceptual or symbolic way. Producing such images requires some lateral thinking, but it's worthwhile as they can be regular sellers with timeless appeal. Here are a few popular concepts to get your creative juices going, along with some suggestions as to how they might be illustrated:

- Celebration: fireworks, cork shooting out of a bottle
- Chance: roulette wheel, dice being rolled, poker hand
- Speed: traffic trails, blurred people walking
- Time: sundial, clock with hands blurred, stopwatch
- Innovation: light bulb, chess pieces on a board
- Partnership/teamwork: links in a chain, bees in a hive, shaking hands, knots in rope
- Systems: interlocking cogs, a line of dominoes falling down
- Social issues: someone with their head in hands (depression), someone sleeping on the street (homelessness).

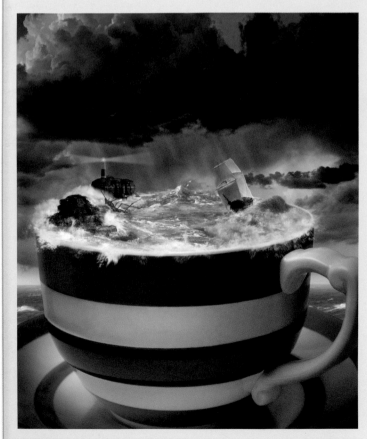

■ Sport

If you are a sports enthusiast, and enjoy taking pictures as well as participating, there is potential for making excellent sales in this area. Some of these may be news-oriented – such as a shot of the winner of a Formula 1 race to go on the sports pages of a newspaper – but more usually, such images are used symbolically. Climbers struggling to reach the top of a peak might be pictured on a workplace poster that promotes the values of endeavour or teamwork. Sometimes it is the sense of energy or movement in the picture that is important – an exhausted runner breasting a tape, or a jet-ski leaping out of the water, for example.

With such subjects, you need to fill the frame with action and colour. Often you will need powerful telephoto lenses that will take you right to the heart of things. Fast shutter speeds can be used to freeze action, but long shutter speeds often work better, blurring the subject to give a greater impression of speed.

■ Natural history

Another area with potential is natural history. Some buyers want to show a specific plant or animal, complete with its Latin name, but often they want images that create a certain mood or feeling.

Both wild animals and domestic pets are always in demand, so whether you photograph big cats out on safari or your own pet cat on the sofa your shots will be welcomed. Be aware, though, that competition in this area is particularly tough. It is relatively hard to make a living as a natural history photographer – you don't win commissions often, perhaps occasionally for a book – and many leading practitioners earn their money by marketing their work through libraries. You are pitched against the world's best, but that doesn't mean you can't succeed if you are interested and dedicated.

Textures and backgrounds

Keep your eyes open for subjects with interesting textures and patterns. While they may seem pedestrian, and hardly worth photographing, they can prove surprisingly lucrative. There are times when a designer requires a simple texture as a background just to brighten up a page.

Backgrounds couldn't be easier to shoot. The natural and manmade world is full of readymade backgrounds, and all you have to do is crop in on them tightly. Just make sure you keep the camera square to the subject matter, and set a small to medium aperture – f/8 to f/16 – to keep it sharp across the frame.

Once you start looking for texture pictures, you will see them everywhere – stonework, carpets and curtains, water droplets and metal sheeting are just a few. Alternatively, you can easily set up a simple still life. A visit to your local supermarket or hardware store will yield dozens of ideas. You could fill a bowl or box with things like pasta, nails, screws, rice and pulses and illuminate it either with daylight or with a couple of studio lights.

Everyday subjects

When it comes to stock, it is difficult to list anything that is not worth photographing. If you have seen a subject featured in a book, magazine, brochure or website then it's worth shooting and submitting to a library, because another picture buyer will want it as well.

When we think about shooting some images, it is the more glamorous subjects that naturally come to mind, but in fact many of the requests libraries receive are for mundane subjects such as car parks, someone writing a thank-you note, paper clips, a 'For Sale' sign outside a house, lipstick, or people standing in a queue. Take pictures of anything and everything – but try to be creative and don't just do a simple record shot.

SHOOT 'EM ALL
Libraries get requests for all sorts of images – so be prepared to photograph anything and everything.

Accurate captioning and keywording

Most searches for images are carried out online, with prospective buyers keying in words to help them find what they're looking for – in the same way that you use a search engine. Sometimes, with more than a million images on a library's website, this can be like looking for the proverbial needle in a haystack.

To ensure that your images are found when people search the library's site, you need to caption them fully, using every search term you could imagine using that would be relevant to the picture. If you take a picture of Big Ben, for instance, the keywords you would attach to it would include: Big Ben, Houses of Parliament, Westminster, London, clock, time, South Bank, England, Great Britain, tourist attraction. Others that could also be added are Charles Barry, Edward Dent, Sir Edmund Beckett (the architects and designers), timepiece, hands, and face.

You need to caption your pictures accurately because buyers order them in good faith, based on keyword searches – and you could be in big trouble if you get the information wrong. If a newspaper buys a picture that is supposedly of Seville and it turns out to be of Granada, there will be hell to pay when hundreds of readers email in to point out the error.

You are not likely to have problems of this kind when you're on your home turf, but you need to be scrupulous when you are travelling. Don't think that you can spend a couple of weeks driving around southern Spain and then sort the pictures out afterwards. When you get back, one 'white town' looks pretty much like another, so keep detailed, accurate notes.

Running your own picture library

If you like the idea of being your own boss, one option worth considering is to start your own library. The big advantage is that you get 100 per cent of the fees. The downside is that you have to do all the marketing, selling, invoicing and paperwork yourself. To be successful, you will need to specialize, perhaps concentrating on one geographical area, or an interest you have, such as Christian living, dahlias, steam trains or scuba diving. That way people will get to know what you have, and come to you when they need it. There's no point in starting a general library because you won't be able to compete with the multinationals in terms of range. But if you pick a small area and cover it in depth, you will appeal to buyers who want to deal with someone who is an expert in the subject. Over time you can expand what you offer – perhaps adding fuchsias as well as dahlias or religions in general as well as Christianity – but it's important to maintain a clear focus.

Make sure that you can manage both the photography and the business side. Unless you do only studio work, you can't be in the office and taking pictures at the same time. Buyers have become used to obtaining images more or less instantly, and if you are not there you will need to employ an assistant to handle business in your absence. Photographers do set up their own libraries – many of them successfully – but you need to be good at business as well as photography to make it.

Log the file numbers for each place, and keep a journal that lists when and where you went. If you set the date and time on a digital camera this is relatively foolproof. If the journal shows you were in Granada from 5 to 7 June, and the digital file is dated 6 June, it must be of Granada.

■ Leaving 'air' can increase sales

Many freelance photographers started out as amateurs, and cut their picture-taking teeth shooting anything and everything – learning from photographic magazines on the way. There's a lot to be said for this, but it can lead to one or two problems, especially when it come to compositions.

Photo magazines generally encourage photographers to fill the frame with the subject, thus maximizing impact and appeal. But when shooting professionally, this is not always the best approach. You have to remember that pictures are used in many different ways, so it is useful to give designers as many options as possible.

One way of doing this, and increasing your sales, is to leave more 'air' around your subject than you would normally. This is especially important where the picture is suitable or intended for cover use. If the picture is used full bleed (filling the cover) you need to leave room for the masthead (title) at the top and tasters (describing the content) down one or both sides.

It's the same with pictures that might be used inside a magazine, or in advertisements and posters. Designers often like to run headlines or text over part of the picture – and are actively looking for images that allow them to do so.

A sensible approach that many freelancers take is to photograph the most saleable subjects both tightly cropped and with more air around them – perhaps by taking a step or two backwards or pulling out with a zoom lens. That way you have the best of both worlds.

■ How much you can earn

Making money from stock photography is relatively easy. If you shoot interesting pictures of sufficient quality you should have no problem getting taken on by a library. The pictures will sell, and you will get a regular payment. Whether you will be able to make a living from stock photography is another matter. I know a few people who do, but they are the exception rather than the rule. It isn't easy, and it's becoming more difficult. There is a lot of competition these days, with both amateurs and professionals becoming contributors each day, adding to the enormous volume of material already in circulation.

But don't let that put you off. On a more positive note, the global reach of most libraries means that you can find a particular image selling many times over – perhaps even 100 times or more in a year. Even if the fee for each sale is modest, it quickly adds up. Produce several pictures like that, and you are on the way to generating a full-time income. Put in lots of new images and you may be able to sustain it.

■ Respond to trends

One of the keys to keeping sales high is to know what the trends are in the marketplace and, whenever possible, to be ahead of them. So make sure you listen to the news and read the papers. Most libraries publish a 'wants' list of material that is being requested, which they circulate to contributors. This is a potential gold mine, because it allows you to target your picture-taking on areas where there is likely to be maximum payback. Go through the list carefully and identify what subjects you would like to take, and do so as quickly as possible. The more you respond to trends, the more income you are likely to generate.

OBVIOUS SUBJECTS
I once spent a month or so photographing the front of as many shops and bars as possible, and those shots have been steady sellers.

LEAVING AIR
Don't crop in tight on everything. Sometimes it's better to leave 'air' around the subject for text to be dropped in.

PROFESSIONAL PROFILE: Steve Allen

RIO DE JANEIRO
Many of the places you visit will have 'iconic' features – such as this statue in Rio de Janeiro.

For nearly 30 years, Steve Allen was a commercial/industrial photographer, but he's always done stock photography to some extent. When he moved to North Yorkshire in northern England from Manchester in 2000 he experienced a large drop in turnover, which was expected. It was at this point that he started to submit work to image libraries more seriously. At that time it was mainly Getty. Then, at the end of 2001, he became involved with a company called Brand X Pictures in Los Angeles, who produce royalty-free CDs.

Since then Steve has built up a collection of CDs: currently there are 21 on sale, with another two in production. Those CDs are now earning him around $80,000 (£46,000) a quarter. As you can see, there's serious money to be made.

The business really started to skyrocket when Brand X extended its distribution network. Now, as well as featuring on their own website, Steve's images can be viewed on another 30 sites, including those of Corbis, Getty and Alamy. Of course, Brand X Pictures don't just sell full CD collections; they also sell individual images, which like CD's, can be highly profitable.

'I did a trip around the world earlier this year to shoot a CD with the working title World Destinations 2,' says Steve. 'I did World Destinations 1 about two years ago. That is my number three best-seller, so it seemed wise to do another one. The one I'm working on at the moment is North American Destinations 2 – because about 18 months ago I did North American Destinations 1. And that is my number one best-seller. I've been doing of a lot of travel this year, including South Africa, Australia (Perth, Ayers Rock, Great Barrier Reef, Sydney, Melbourne), New Zealand (North and South Islands), Tahiti, Easter Island, Santiago, Brazil, Prague, Berlin, Rome, Moscow, St Petersburg, Canada (Montreal, Vancouver), and in the USA to Chicago, New York, Washington DC, Los Angeles, Seattle, San Francisco. Basically, the shots I'm taking are the kind you see in travel brochures.

'When you do a trip around the world, you have to plan it so you visit the majority of the places at the best time of year. You can't expect to go on a trip like that and get the best time of the year from all of them. It's a bit of a compromise at times. But what I did was shoot everything in the southern hemisphere on the first trip, and the weather in most of the places was fine. When I went round Europe it was early May, and the weather was good everywhere apart from Moscow, which was a bit grey.

'I tend to be in most places for three days, and if things aren't great I concentrate on night shots if I'm in a city. Night shots can look good in bad weather – even if it's raining, with streetlights and lots of water on the road.

'Brand X accounts for about 90 per cent of my turnover. The other 10 per cent is between Getty Images, with whom I now have 200 images, from which I get about $25,000 (£14,000) a year, and Alamy, who at the moment have about 1,280 images, which gives me about $20,000 (£11,500) a year.

'I really do enjoy doing travel photography, but it can get tiring after a long trip. I can't say I enjoy sitting in airport lounges – but that's a necessary evil.'

CANADA COMPOSITE
Taking several images of a location and combining them produces a representative composite picture.

NIGHT BRIDGE
Cities take on a different quality at night, which is often the best time to photograph them.

3 SOCIAL PHOTOGRAPHY

Photographers who specialize in taking pictures of people are known as 'social' photographers. The two main areas of activity are weddings and portraiture. People commission photographs of themselves, their family or their children for a number of reasons. Sometimes it's for a special occasion, such as a birthday, anniversary, engagement, graduation or coming of age, and sometimes they just want an attractive portrait to put in a frame or hang on the wall. Since most people own cameras, they are looking for a picture that goes beyond what they could do themselves: a portrait that is professionally lit and posed, and that captures something of the sitter's personality.

HEAD SHOTS
Portrait photography is as much about getting on with people as it is about taking pictures.

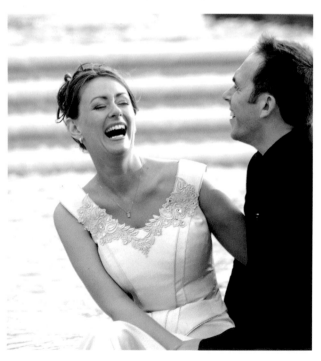

WEDDING DAYS
Despite the fact that fewer couples are saying 'I do', wedding photography can be a lucrative business – but there's plenty of competition.

■ The advantages of social photography

Social photography can be a lucrative business, especially for those who find a niche at the premium end of the market. It is also easy to get into. Anyone can set themselves up as a wedding or portrait photographer, and many professionals start out as amateurs, shooting part-time in the evening or at weekends. Over time, as their volume of work increases, they make the transition into working full-time. Only when you feel confident that you can pay the bills from photography should you leave your current job.

Social photography is a safe and relatively secure way of becoming a professional, and you can do it with a minimum of overheads. At one time, many social photographers had a studio in the high street, to attract the interest of passing trade. However, increasing rents and rates mean that many now work from home, either shooting entirely on location or converting one or more rooms so they are suitable for meeting clients and/or taking pictures. Others buy houses that have annexes or outbuildings specifically so they have a space dedicated to photography.

Working as a social photographer can be extremely satisfying. Over a period of time you will become well known in the community and, if you're a good photographer, highly respected.

■ The skills involved

While portrait and wedding photography might look relatively easy, do not underestimate the skill involved in doing it to a professional standard. Since much of the job involves taking pictures of people, interpersonal skills are crucial. You will meet all sorts of individuals, from many different classes, creeds and cultures, and you need to be able to put them at ease quickly if you are to obtain relaxed results. This is extremely important. If you feel shy or awkward around people, this will probably not be the right area of photography for you. While you don't have to be extrovert and chatty – which many successful portrait and wedding photographers are – having a warm, likable personality goes a long way.

You need to be able to pose and light individuals and groups so they look their best, minimizing any weaknesses and accentuating the positive. This can be a challenge, especially when it comes to hyperactive toddlers and camera-shy teenagers, who are not always willing to cooperate with you.

You will also need to be able to attract customers, which means you have to be competent at marketing. People rarely have portraits taken more than once a year, and may get married two or three times at most in their lives, so regular clients are few and far between. That means you constantly have to find new clients, and may spend more time drumming up business than you do behind the camera.

A lot of custom is generated by word of mouth, and the more successful you are in satisfying the needs of your existing customers, the more likely you are to attract new ones. The bride's sister might get married one day, while your portrait-sitter's neighbour might want a picture of his son on his graduation day.

Finally, you need to be good at selling if you are to earn a good living. Simply showing the pictures to your clients and taking their orders won't get you far. You need to present the images so they have maximum appeal so the spend from each person is as high as possible.

A DISTINCTIVE STYLE
These days customers are looking for different and distinctive approaches to photography.

WEDDING PHOTOGRAPHY

Despite the fact that more couples are deciding to cohabit, and two out of every three marriages end in divorce, thousands of brides walk up the aisle each year to say 'I do' to the groom. This means that there is a steady demand for skilled wedding photographers, and you could be one of them. There are few areas of professional photography that are as easy to get into as weddings. Everything is done on location, so you don't need a studio or premises; most weddings are at weekends, so you can do them alongside a Monday-to-Friday job; and you can get started with relatively affordable equipment.

■ Getting started

If you are a decent snapper, someone you know may already have asked you to photograph their wedding, either as a favour because they are short of money, or on a paid basis. That happens quite often, and is how many professionals get started. Maybe you turned down the request, because you realized that wedding photography is much more difficult than it looks, and you didn't feel confident in your ability to do the job, but are interested in getting to the stage where you can become involved. Or perhaps you agreed to try it, with no guarantees, and already have a certain amount of experience.

Either way, you've got some way to go. You must remember that wedding photography is an extremely serious business. There can be no reshoots and no second chances. You are photographing an unrepeatable, once-in-a-lifetime event, and have a responsibility to everyone involved to produce high quality images that really capture the day. You can't just go out and start snapping.

With some areas of photography, you can learn by trial and error. If the photographs you take of a building don't work out, there's no harm done – you can always go back another day. That is not an option with weddings. You have to get it right first time, every time.

SOMETHING DIFFERENT
There's a lot of competition in wedding photography, and to stand out from the crowd you need to offer something different.

■ Developing skills

Some people have a natural talent for wedding photography. From their very first wedding, they find it easy to handle the pressure, and even enjoy it. Others find that it doesn't come so easily, and they need to proceed more cautiously.

The good news is that you can learn many of the skills of wedding photography by going on a training course. This reduces the risk of you making a major mistake when you start taking commissions. The best of these courses last several months, giving you time to build up your skills – there's only so much you can pick up in a single session.

However, the best way to start learning is to assist an experienced wedding photographer for a season or more. This will give you an insider's view, and you will pick up invaluable tricks of the trade on dealing with different situations. But finding someone to show you the ropes is not always easy. Local photographers may not be keen to help, because you are likely to be in competition with them one you have completed your 'apprenticeship', so you might have to look further afield.

■ Building on experience

Eventually, the day will come when you do your first wedding. It will probably be a baptism of fire. There is a lot to think about, the pressure is enormous, and the stakes are high. However, most photographers survive, and learn an enormous amount

BRIDAL POSE
Wedding photography is an extremely skilled business, and not something you can pick up overnight.

CAPTURE THE MOMENT
A carefully constructed wedding image will preserve the couple's special day and last a lifetime.

in the process. Little by little, usually by word of mouth, you get asked to cover other weddings, and get some experience under your belt. What then?

Well, you can continue as you are, doing a few weddings here and there, in addition to your day job. This will give you a useful extra income (though you must, of course, declare it for tax and insurance purposes). But once they have got a taste, many wedding photographers yearn to break free of the nine-to-five life and go full-time. If you have the talent, wedding photography can be an extremely lucrative profession – and immensely satisfying.

You need to be cut out for running your own business, which means handling everything yourself. You have to attract clients on a regular basis, sell them your service, take down all their details, discuss their needs, work out the costings, deliver the finished pictures, and make sure that you are paid for your work.

If you like the idea of wedding photography, but are not really interested in becoming self-employed, another option is to become an operator for a studio, where you photograph the wedding for a fixed

fee. The attraction of this approach is that there's no hassle. You turn up with your own equipment, take the shots and then let the studio have them. Then, assuming everything is OK, you move straight on to the next job.

◼ Creating a portfolio
Completing your first wedding commission successfully is important for several reasons. As well as giving you confidence in your ability to do another job, it gives you a set of pictures that can be shown to prospective clients. While your friends and family members might book you on the basis of your reputation, a complete stranger will want to see the quality of your finished results.

What do you do if nobody you know asks you to photograph their wedding and you want to join the profession? One of the best ways is to stage a small wedding yourself, so you have a set of pictures to show people. Hire a dress and morning suit and ask some attractive friends to act as the bride and groom, with other friends and family members to act as the rest of the guests. Then take lots of pictures, across a range of styles, in a variety of locations.

If possible, repeat this process with at least two more couples, so it doesn't look as if you have worked on only one wedding. Your aim is not to deceive prospective clients – you have taken the pictures, after all – but to show them what you are capable of doing.

◼ Setting up a website
As well as creating a portfolio of prints to show potential customers, you will need to set up a website as soon as possible. Yes, this is another expense, but it enables you to direct people to your base on the Internet in any advertising you do. You need to do some kind of promotion, otherwise potential customers won't be able to find you.

INTERACTION
Don't just have people looking at the camera – get them to interact with each other.

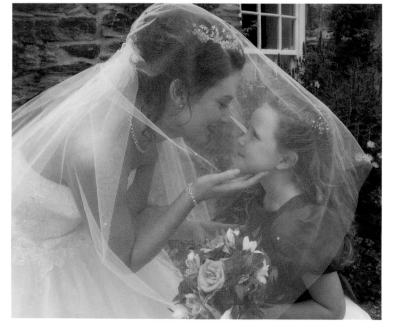

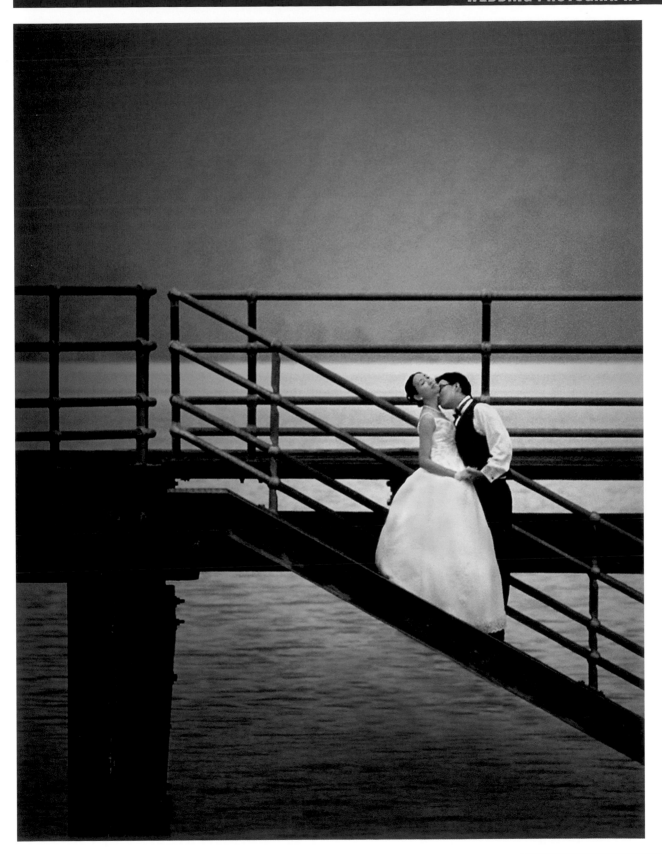

ACTING UP
Wedding photographs don't have to be serious. Encourage the couple to act up for the camera, and you'll produce a wide range of saleable shots.

Initially, a relatively basic website that shows some examples of your photography, describes how you work, and gives contact details will be sufficient. Don't give out too much information; you want people to get on the phone to you. Cost-effective ways of publicizing your services include producing flyers that you can give to bridal shops, putting up posters in local newsagents or health clubs

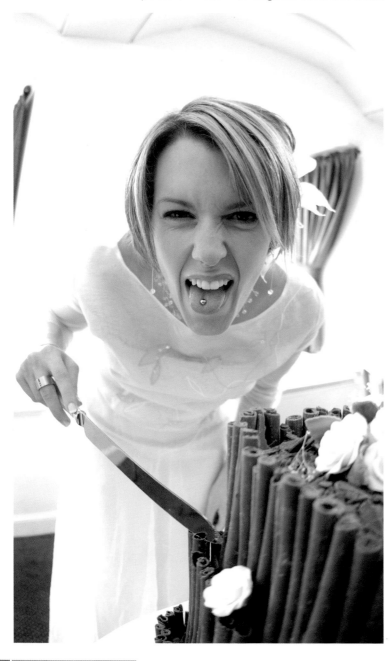

and attending bridal fairs. Ultimately, you will want to place an advertisement in the local telephone directory, which is still the first port of call for many couples seeking a wedding photographer. Although the rates are reasonable considering the return you are likely to get, it may be an expense you don't feel you can justify in the early stages of your new career.

Wedding photography skills

Success in the wedding market is as much about organizing and managing the day as it is about actually taking the pictures, and you need to combine discipline and diplomacy. You have a limited period of time to capture all the key events, and you need to do so quickly and efficiently, often under the gaze of an impatient group of guests. So don't consider wedding photography as a career if you are no good at working under pressure.

You need to be good at handling people as well as taking great pictures. You should be capable of coaxing, charming and cajoling the couple into natural, vibrant expressions when they are feeling the strain, too. Many successful wedding photographers are lively extroverts who lead from the front, acting like ringmasters at a circus or MCs at a show. They often have a ready supply of banter and bags of confidence. But don't worry if you are slightly more restrained. There are many successful wedding professionals who are shy and retiring in real life, but who have learned to turn it on when 'performing' in front of all the guests.

Planning ahead

The adage 'Not to prepare is to prepare for failure' is as true of wedding photography as of any other field. The more you plan ahead, the more successful you are likely to be, and that process begins when you first speak to the couple. Try to learn as much as you can about the day, and write

it all down. When you are doing only one wedding at a time, it is easy to remember everything, but when you have several on the go at the same time you need comprehensive notes so you know what you are doing and when. Is it a religious or a civil wedding? Will the bride be leaving from home or somewhere else? How many guests will there be? What time is the service? Where is the reception? When do the guests need to sit down to eat? It is up to you to fit around the timing structure, not try to adapt it to suit you.

It's a good idea to go to the church or registry office and reception venue before the day, so you know the layout. You can work out which are the best spots to take the pictures, and consider options for different weather conditions.

After a while, you will get to know the most popular venues in your area, and will have a store of ideas you can return to time and again. It's also worth building up a repertoire of locations you can take couples to for a short time if the reception is being held in a grotty bar or restaurant and the church is surrounded by unphotogenic brick walls. Whatever the surroundings, you will be expected to come up with attractive shots, so a local park could be a lifesaver. I once saw a wedding photographer taking pictures on a partially wooded roundabout on the outskirts of a large city – so keep your eyes open for opportunities.

Over time, you will get to know the ministers in your area and what their rules are; they can vary considerably. Since you need them on your side – they can make life difficult for you if they take a dislike to you – it's good to get the relationship off on the right footing. Some vicars, for instance, forbid photography in church entirely, except for the signing of the register, which is always recorded, while others allow pictures to be taken using available light. Rarely do they allow flash to be used during the ceremony. Make it a

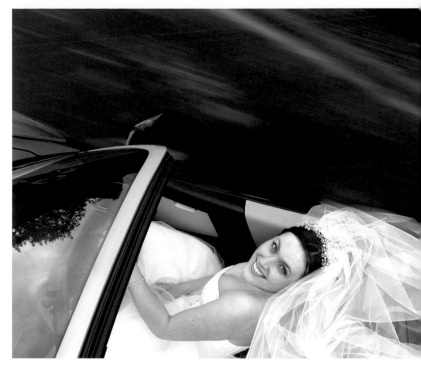

policy each time you go to a new church to ring the vicar ahead of time. Some also have rules about throwing confetti in the church grounds. When it rains, it goes soggy and looks unsightly. Woe betide you if you encourage guests to distribute confetti where it's forbidden.

It's also a good idea to learn about different cultural approaches to weddings, so you know what to do if approached to tackle, say, a Jewish or a Sikh ceremony. Find out what pictures must be taken and whether there is anything that is considered inappropriate to photograph.

■ Wedding photography gear

Most weddings are now shot digitally, although some practitioners still prefer to use a medium-format roll-film camera such as a Hasselblad because of the quality it delivers, and because they have greater control over the highlights. One thing is certain: if you want to be credible as a wedding professional, you need to have better equipment than most of the guests. A mid-priced digital compact really

DRIVING FORCE
The only limits to how interesting your wedding pictures can be are your imagination and the willingness of your subjects to join in.

Wedding picture checklist

These are the main pictures taken during complete coverage of a church wedding - but always check with the couple to see whether they have any specific requirements.

- **Before the ceremony – at the bride's home**
 Bride getting ready; having her hair and make-up done; leaving the house; details of flowers, shoes, dress. Avoid flash and shoot using available light, if necessary using a high ISO setting/film.

- **At the church before the service**
 Guests arriving; groom and best man arriving; bride and father getting out of the car; bride and father entering the church.

- **During the service (if allowed)**
 Church interior from rear gallery; couple and minister hearing vows/exchanging rings (normally without flash); signing the register (normally allowed, with flash); couple leaving the church; confetti being thrown (sometimes not allowed in church grounds).

- **After the service – in the church grounds or at the reception**
 As many groups as specified by the couple – start with the bride and groom and build groups from there; bride alone; bride alone showing the dress; groom alone; bride and groom; bride and groom kissing; bride and groom – hands showing rings; bride and bridesmaids; groom and best man; best man and bridesmaids; bride and groom plus bride's family, and then groom's family; bride with her parents; groom with his parents; football shot of everyone present, so all the faces can be seen.

- **At the reception**
 The speeches; the cutting of the cake (stage it beforehand if possible); the first dance; guests; food; details such as bouquets.

won't inspire confidence. Every now and again, you will encounter an affluent guest with a flashy camera trying to show off. Do not get into competition with them. The best approach is to flatter their ego by recognizing their obvious skills and enlisting them as an unofficial assistant – asking them to hold reflectors and so forth – thus turning a potential rival into a useful ally.

The most important issue regarding equipment is that you need to be able to produce quality images to the maximum size your clients might request – a minimum of 50 x 75cm (20 x 30in) and ideally 100 x 125cm (40 x 50in). One of the latest high-megapixel digital models will give you that, whereas an old 35mm silver-halide machine won't deliver quality at that size.

The totally reliable camera has yet to be made, so you will need a back-up. Go to a wedding with just one body and you'll be asking for trouble. If you can't afford two top-of-the-range pro models, choose as your back-up a camera designed for advanced amateur use. It will cost significantly less, but will still produce professional-quality images should an emergency arise.

Don't familiarize yourself with equipment during a real wedding. Spend time getting to know your camera inside out, so you can operate it blindfold in a force-ten gale – which is what the pressure of shooting a wedding can sometimes feel like.

Most cameras these days are useless without battery power, so it is imperative that you carry two spare sets of batteries, fully charged if they're rechargeable, or fresh from the pack if they're not. You will also need spare batteries for the flashgun if you are using one.

Your equipment needs to be in perfect working order every time you shoot a wedding. Have it serviced regularly (the best time is during the winter, when fewer people get married) and always check it thoroughly on the day. With a digital camera, this is a straightforward business

– you can see at a glance whether everything is as it should be by firing off a few shots and then deleting them. It is also sensible to take an image and view it on a computer screen, to make sure that no muck has got on to the CCD – or you could end up doing hours of painstaking retouching to remove the marks caused by a stray hair.

If you are using a film camera, make sure that the shutter and aperture are working correctly, and that the meter is giving a realistic reading. Check that your flashgun is firing correctly, and examine all of your lenses carefully, polishing the front and back elements with a clean cloth until they are spotless.

■ Lens choice

When photographing a wedding, the last thing you want is to be endlessly swapping lenses. Ideally you want a zoom that goes from wide-angle to short or medium telephoto, so you can switch from a group shot to a single portrait without changing position. Lenses with a fast maximum aperture, f/2.8 or better, let you shoot at the ceremony without flash or too high an ISO setting. Going in close with a wide-angle lens gives a sense of being at the heart of the action, rather than a detached observer – though a telephoto zoom means you can crop in close on details and throw backgrounds out of focus.

LENS OPTIONS
It's useful to have a full range of lenses so that you can frame the subject perfectly.

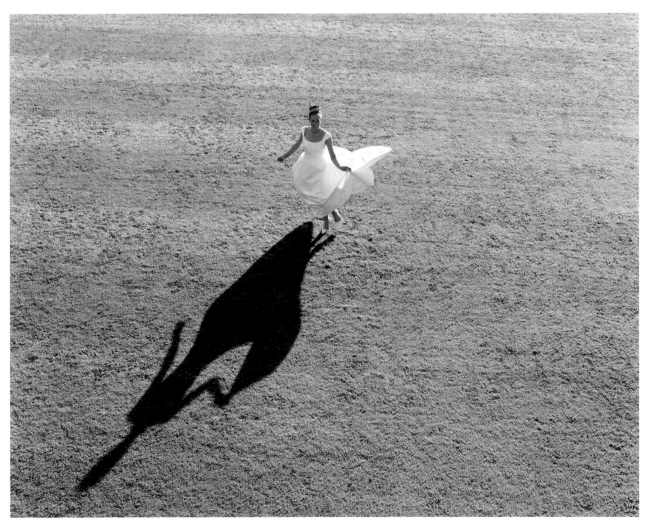

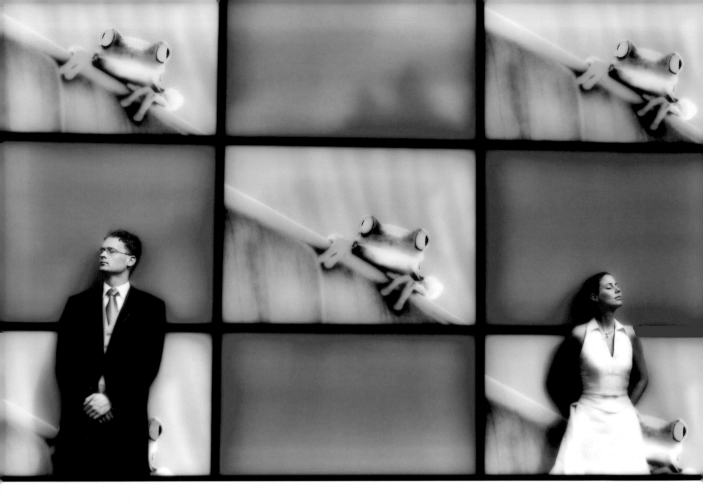

Top tips

- Do only one wedding per day, even if the timings seem to allow for two. You need to be relaxed and focused to produce work of the highest quality, and running from one wedding to another increases the pressure.

- Carry a small waterproof ground sheet that the bride can sit on to avoid getting the dress dirty – but make sure it can't be seen by the camera.

- When photographing confetti being thrown, take a series of shots because you often get a piece of confetti in front of the eye, nose or mouth of the bride or groom.

- Position the flowers carefully, not just dangling down. They can also be used to brighten 'dead' areas, such as the groom's dark suit.

- Make sure you have a back-up plan should you be taken ill. Develop a network of other photographers that you can call upon at short notice to fill in for you. You must never be in a position where you let a client down.

▪ Metering

One thing you need to take great care over when shooting weddings is metering. If you follow the built-in meter and simply fire away, you may encounter problems. Can you imagine scenes more likely to cause your camera's meter to have a brainstorm than white dresses in front of foliage in shade and dark morning suits in front of pale stonework? Or, worse, both together on bright days, when shadows are deep and hard, particularly around the middle of the day when the sun is high in the sky. The contrast range is well beyond what both film and digital cameras are capable of capturing. The couple will have spent a small fortune on the wedding dress, and will expect to see every detail in the finished pictures. This means you must take great care not to allow the camera to overexpose, because you will never get the highlight detail back.

One option when shooting digitally is to reduce exposure by around a stop – but then you end up having to tweak each picture in the computer, which makes the job much more time-consuming. The easiest solution, whenever possible, is not to place your subjects in direct sun. Position them instead under a tree, which cuts out much of the ugly top light, or in the shade of a wall or building. If no such location is readily available, another option is to shoot towards the light, so the faces and clothing of the guests are not lit directly.

Care needs to be taken with regard to exposure, and you need to make sure that the sun doesn't hit the front lens element and cause flare. It is worth investing in a separate hand-held light meter to ensure accurate exposure in tricky situations.

Some photographers like to use fill-in flash to brighten faces and put a sparkle in the eye when shooting *contre-jour*, but take care not to overdo it, or the pictures will look unnatural. Most external flashguns have power control settings; these allow you to give half or quarter of the usual output, which is much more subtle. However, many wedding professionals use flash only when they absolutely have to – for the cutting of the cake, for example – and would never use flash outdoors.

A better alternative when photographing individuals or couples is a reflector, positioned just out of sight of the camera. White is probably best for weddings – silver or gold can be too strong and produce hotspots. Handling a reflector while concentrating on your photography isn't always easy, even if you use a reflector with a handle, so it is really useful to have an assistant to hold it in just the right position. This could be your partner, a friend, or someone interested in getting into weddings themselves. An assistant can also watch your bag while you are working, get equipment ready for you, and help organize the guests.

■ Weather conditions

While sunny days tend to put everyone in a good mood, slightly overcast days when the light is softer tend to be better for weddings, because you don't have to worry about heavy shadows and people squinting. However, you can't do anything about the weather, except watch the forecast the night before so you have some idea what you will be working with. As a wedding photographer, you will encounter everything from torrential rain to blistering heat – and it's up to you to come up with great pictures no matter what the conditions.

When it's cold or wet, things tend to happen quickly. The bride won't linger outside the church as she might in warm, sunny weather; she'll come in immediately. You won't have as much time and will need to be ready to respond quickly to rapidly changing situations. After the ceremony, you may have limited time to shoot any groups because people will want to get indoors. If the wedding really is washed out, you can use umbrellas as props

BACKGROUND STORY
Backgrounds don't have to be dull and boring. Using this billboard as a backdrop creates a wedding picture with a difference.

INCLUDING ELEMENTS
The couple may have paid significant amounts for things such as cars, flowers and clothes, so make sure you include photographs of them.

to produce some amusing images that sum up the day. It's worth keeping some umbrellas in your car, but make sure that they're free of logos.

Whenever awful weather is forecast, you should have a back-up plan for taking some of the pictures indoors – by windowlight if that's possible, or by portable studio lighting if you have it.

CANDID CAMERA
Candid, reportage wedding photography is extremely popular, with people captured naturally rather than posed formally.

■ Styles of wedding photography

Wedding photography has undergone a significant change of style in recent years. Most couples still want some pictures taken in the classical style – with the photographer exercising full control over the posing and lighting – but many now also want 'reportage' shots that are unposed and more informal.

Some photographers specialize in one style or the other, and attract clients who favour that style. But if you want to maximize your potential, it is a good idea to offer both, emphasizing on the day whichever approach the couple prefers. Sometimes you will be leading from the front, setting shots up. At other times – such as in the morning when the bride is getting ready – you will be invisible, or at least unobtrusive.

In the reportage style, you photograph the same events, but without arranging them, capturing the action as it unfolds so the images have a relaxed and spontaneous feel to them. However, you need to take care when shooting candids that your pictures don't end up looking like snapshots that the guests could have taken themselves. Many of the best 'reportage' wedding pictures that you see winning competitions have often been partially set up. The photographer might, for instance, place all the bridesmaids in a particular location and then ask them to chat, photographing them unobtrusively as they interact with each other rather than looking at the camera.

Increasingly popular are 'storybook weddings', which catalogue and capture every moment of the day. The ideal arrangement is for a husband-and-wife team, where both are photographers, to work together – though it would be possible for male and female photographers working separately to join forces whenever necessary to cover a wedding in this style, splitting the fee. The man starts the day with the groom and the woman with the bride, each documenting what happens in a reportage style – such as putting on the make-up or going to the pub for

some Dutch courage. Then everyone comes together at the ceremony. One person then concentrates on groups while the other shoots candids. Clearly with two people involved the charge made is going to be higher, but couples who want comprehensive coverage of this kind are normally happy to pay for it.

You can keep up to date with wedding photography styles by reading the various wedding magazines on the market. Generally, couples are looking for a mix of traditional shots and more creative treatments. Some wedding professionals see themselves first and foremost as artists, and command high fees for the stylish images they create. Often it's the bride who will take the greatest interest in the pictures – and the style of the wedding overall – and be concerned about how they look. She may want to be reassured that you can capture what she hopes will be a fairytale wedding. It is your responsibility, therefore, to make the wedding look better than it actually was. To achieve that, you need to be alert to capture images that show moments of drama and intimacy, such as the first glance that the couple exchange when they meet in church, a veil suddenly blowing over the bride's face, or the expressions of guests during the best man's speech. To do this, you need to create a spirit of cooperation in which you and the couple work together to produce the best possible images.

■ Handling guests

You need to be able to work effectively with the guests, who can, at times, be a pain to deal with. If you lose their goodwill, you can soon find yourself with a mutiny on your hands. The first issue is organizing groups. You need to be able to do this quickly and efficiently – guests soon become impatient if the process is dragged out. This is particularly true if the group pictures are being taken at the church, where there's

nothing to do but get bored. At least if the photography is being done at the reception, guests can find somewhere to sit and grab a drink.

Unless the couple insists, don't try to photograph every family combination – and if they do insist, try to talk them out of it. Suggest doing a maximum of eight groups – the bride's immediate family, the groom's immediate family, the best man and bridesmaids and so on – with one big group at the end that includes everyone attending the wedding. Taking a commercial perspective, people rarely buy the shots you're missing out anyway.

Try not to spend more than 15 minutes photographing the groups, with 20 minutes being the absolute maximum. To minimize delays, get details from the couple in advance about who should be included, and about any complicated family

FUN AND GAMES
There's no reason why you can't produce stylized wedding photographs where the emphasis is on fun.

arrangements or politics you might need to handle sensitively. Ask the couple to nominate someone who knows everyone to help you assemble the groups, so that when the bride's mother goes missing she can be found quickly and proceedings are not held up.

If you have visited the various locations ahead of time you will know exactly where you want to take the pictures, perhaps taking account of natural features such as steps to stagger the members of the group, ensuring that all faces are visible. One of the easiest ways of photographing everyone is from an upstairs window with them looking up at you.

DANGER
High voltage

■ Dealing with other photographers

One thing you have to get used to is other photographers taking pictures alongside you. Some wedding professionals find this annoying, but there's really no point; it comes with the territory. It shouldn't be a problem because your shots will be better than theirs due to your skills in handling light, composing creatively and so on. However, you need to make it clear from the outset that you are running the show. Tell guests that you are happy for them to take pictures, but would prefer them to wait until you have taken yours. Set up your shot, commit it to card or film, and then invite guests to take theirs. Be pleasant and courteous at all times. Most wedding bookings are made via personal recommendation, and the way you conduct yourself may affect the amount of business you get in the future.

Most people become self-conscious when a camera is pointed in their direction. You need to be able to chat to the guests so they relax and you capture their natural expressions. Keep the mood light, particularly when dealing with children, and encourage them rather than ordering them around. Even though you want to work quickly, make sure the groups are well arranged. Pay attention to details, such as angling feet attractively, having ties straight, and arranging the dress so it can be seen at its best.

At some point you will want to take the couple away from the masses for some intimate portraits. These are the pictures that often sell best because no-one else has them. It is important that you go somewhere quiet and get the couple on their own so they are not self-conscious as they would be in front of a crowd. You

HIGH VOLTAGE
Explore the area where you're taking
the photographs for any locations that
seem particularly interesting.

should try to capture the tenderness, warmth and love they feel for each other, so you want them embracing, holding hands, kissing, and with their heads together. Encourage them to lose themselves in each other and record what happens. You should also take pictures of the bride by herself and the groom by himself.

Don't just pay attention to the subjects – think about the backgrounds as well, and the direction of the light. And that means shooting from the best vantage point.

■ Be creative

Wedding photography is an extremely competitive business, so you can never rest on your laurels. Always be on the lookout for ways to improve your pictures. Study the work of leading professionals to see what they are doing; read articles and books and attend training courses. Take some risks by using long shutter speeds with flash to show movement, or use depth-of-field techniques to create interest, perhaps by having the bride at the front of the picture in focus and the groom behind her out of focus. Photograph personal details, such as invitations and flowers, which the couple will have chosen carefully. In recent years, there has been a renaissance in black and white wedding photography, which is easy to do when shooting digitally.

■ The business side

Your first contact with a prospective client is likely to be over the phone or via email. They will have heard about you from a friend, seen your website or advertisement, or looked in your shop window, and will either want to make a booking or know more about your work.

Increasingly, couples are searching the Internet for a photographer whose style they like, and then telephoning to find out whether they are available on the date they have planned. Less often – unless the

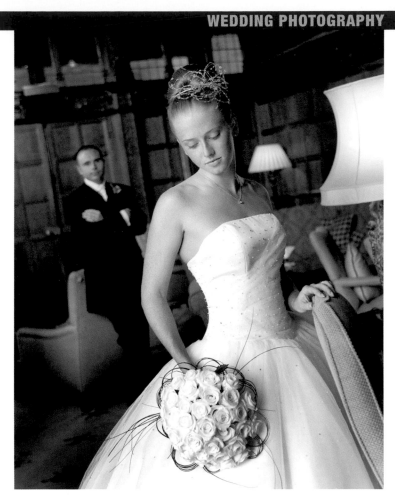

photographer has a shop – do the couple pay a visit in person to look at prints and albums before making a decision, although that does still sometimes happen.

One of the key issues for potential clients is cost. That's not true of everyone – some will pay whatever it takes to get the pictures they want – but most couples have a limited budget from which they have allocated a certain amount for photography. Knowing how much to charge, especially when you are just starting out, is one of the most difficult decisions to make. The easiest way to get a sense of the market rate for your area is to ring some wedding photographers in your local telephone directory. There is likely to be a range, and you might be tempted to pitch your price towards the bottom end, or even lower, on the basis that you are just trying to become established. That could be a mistake, and

EXCLUSIVE
Whenever possible, take the couple away for a few private minutes so you can shoot some pictures that no-one else has.

USE THE VENUE
If the reception is being held somewhere photogenic, make full use of the surroundings.

could cheapen your service in the eyes of your customers. They might think the reason you're cheap is because you're not very good. But equally, you are not likely to succeed if you set a price at the top of the market – unless you are extremely talented. Begin by pitching yourself somewhere in the middle and observe the response of customers when you announce the price. If they don't flinch, and they do book, you're in the right vicinity. If everyone books without comment, your prices are probably too low. If no-one books, they're too high. You certainly need to charge a realistic rate, though – one that covers your costs and allows you to put food on the table and meet your bills.

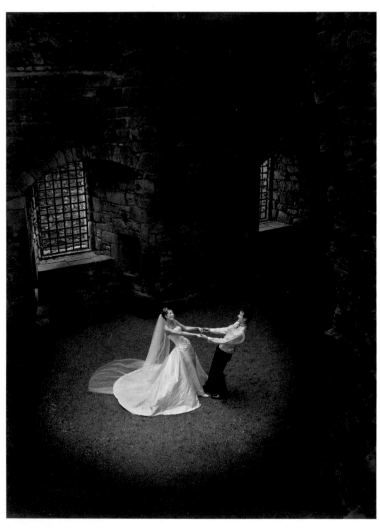

Wedding packages

Most wedding photographers offer packages, so the customer knows broadly how much they are going to pay. The cost is determined by a number of factors, including the number of pictures taken; how many prints of what size are supplied; the extent of the coverage (whether it includes time with the bride before the ceremony or pictures at the reception afterwards, for example); whether there is an album and, if so, what kind; and the position of the photographer in the marketplace.

Most couples pay between £750 and £2,000 ($1000–8000 in the USA) for coverage of the wedding and an album of high quality prints – typically thirty 8 x 6in prints. At the lower end of the market, there are photographers charging around £300 ($600) for basic coverage and a simple album, while at the prestige end you can pay £8,000+ ($15,000+) for a sumptuous album full of creative images. While these figures are obviously not all profit – you need to advertise, invest in equipment, make prints, provide an album, and so on – there is a healthy margin in the profession, and it is possible to earn a handsome living as a wedding photographer.

Why will someone pay ten times as much for a blouse in a boutique as in a high-street store? Because they believe that it is better, or has more style. It's the same with wedding photography. The higher you pitch the price, the fewer weddings you need to do to earn the same income. But your pictures, and the quality of your photography overall, must reflect the amount that you are asking.

Generating additional sales

Whatever your position in the market, there is a limit to the number of weddings you can do in the course of a year – for many self-employed photographers the number is between 40 and 80 – so you need to maximize your earnings from each one.

One way of doing that is by generating additional sales in the form of mini-albums for parents or grandparents, framed 'wall' portraits for the couple, and single images for guests. There are also special 'wedding books', such as those made by GraphiStudio, which cost significantly more than a standard album, and allow a great margin for the photographer. Whenever possible you should 'pre-sell' such value-added items to the couple when you agree the booking.

Unless the couple lives some distance away, in which case you will need to correspond by phone or email, it is important to meet them in person to discuss all aspects of the wedding. You need to find out what kind of images they want, show them exactly what they will get for their money in terms of prints and albums, talk them through your terms and conditions (including cancellation charges), and answer any questions they might have about the photography.

If it's all acceptable, ask for a deposit to secure your services. That makes it less likely that they will change their mind and cancel further down the line. Don't consider the booking to be confirmed until you have received a deposit. At this meeting you should also gauge whether the chemistry is right between you and the couple. If you have any doubt about whether you will be able to work with them, it's a good idea to discover that you already have a booking on the day they want you.

■ Proofing the work

At one time, couples were given an album of proof images to take away and choose the ones they would like to have in the album. This system was open to abuse, with illegal copies sometimes being made before the album was returned. These days, images are normally either projected on a computer screen, often to the accompaniment of music, or posted on

Get insurance

Once you start taking pictures professionally – and that means taking payment, even if it's just a Saturday every now and again – you need to make sure that you are adequately insured, or you could end up with an enormous legal bill that could bankrupt you. Professional indemnity insurance is a must, and covers you in the event of a customer suing you for what they perceive to be a sub-standard service. You should also have public liability insurance, so that if a member of the public trips over your bag or tripod and ends up in hospital you don't have to foot the bill personally. While these policies may seem like an expense you can do without in the early days, they are really not an option – you must have them if you are to trade safely.

SHOOT TO SELL
The more pictures you take the more you are likely to sell, so add as much variety as you can in the time available.

a website. The latter arrangement means that all the guests can view them, no matter where in the world they are, and there is usually an automated ordering system, payable by credit card, with prints then delivered by post. Couples sometimes come back for prints many years after the wedding was photographed – perhaps because they are renewing their vows – so make sure that you store and archive all the images safely and securely.

PORTRAITURE AND CHILDREN

Think of portrait photography and you probably think first of the high-street studios in most cities and sizeable towns. Gaze in the window and you'll see pictures of couples, babies and families in a range of settings. You may have used the service of such a studio in the past when you had a special occasion to commemorate or simply wanted a family portrait. If so, you may have come away thinking: 'I could do that.' Most amateurs take pictures of people, and it's potentially just a small step from shooting for pleasure to shooting for profit. When you settled the bill, you may have had a second thought: 'That's a lot more than I'm earning!'

GO FOR IMPACT
If you can take pictures of children that are as appealing as this you'll have no problem making money as a social photographer.

◼ Getting started

If the idea of getting into portrait photography appeals, you have a number of options available. Which you choose depends on whether you just want to earn some money alongside your day job or whether you want to go into this full-time. If you're looking simply to supplement your existing income, you can start slowly and build steadily, working from home, and fitting it around existing commitments. A good way to begin is by telling your family, friends and people at work that you are taking portraits professionally, and give them some business cards or a brochure to hand out to people they know.

Personal recommendation is easily the best way to build a portrait business, but it is also worth mounting an inexpensive promotional campaign by putting up posters at local post offices and shops in your area. Whenever possible, include an example or two of your work, so that prospective customers know what you're

offering. It is also worth setting up a basic website featuring a wider range of your images, along with contact details and some idea of what you charge.

The great advantage of working from home is that you don't have any overheads, so there's no pressure on you to achieve a certain level of business. But the problem with part-time working is that you can take pictures only in the evenings, at weekends or on days off. That is not an issue when you are shooting only one or two sessions a week, but if the number grows it can be a challenge fitting them in.

Some amateurs will be satisfied with earning a little extra, and have no desire to turn professional, while others will see it as a stepping stone to working full-time in photography – which is how many of those at the top of the profession got where they are. Others won't be prepared to wait that long. Maybe they hate their current job, or have been made redundant, or simply harbour a burning desire to work as a

portrait photographer. In that case, there are more options to consider – including working from home, shooting entirely on location, renting business premises, buying an existing portrait photography company or taking on a franchise. Let's consider each of these options in turn.

Working from home

For the full-time portrait photographer working from home is perfectly viable providing they have enough space. In practice, this means having at least one room that can be used as a studio and ideally another that can function as an office. While it helps if the studio is permanent, and ready for use at a moment's notice, there are some photographers who set things up as and when they need them, and then pack them away afterwards.

Options for your studio include an unused reception room, a converted garage, or a spare bedroom. Sometimes, people have a purpose-designed extension built on to the side of the house.

Other advantages of working from home are that you can make a claim for using it against your income and you don't have the cost of travelling to and from a separate studio.

Shooting on location

What if you don't have anywhere you can shoot portraits, or you have young children or pets that could be disruptive? Why not make a virtue out of a necessity and offer a service where you shoot entirely on location, either in the homes and gardens of your customers or in appealing and interesting public areas such as parks and woodland? You might even be able to charge a premium rate, since you do all the travelling. Indoors, you can harness the many moods of daylight, using inexpensive reflectors to balance the light if necessary. If the house isn't especially attractive, you can just shoot against plain walls or take

along some paper background rolls. If the house has some interesting features – such as a stylish fireplace or elegant panelling – make use of them. That way the pictures will seem more personal. It's the same when you shoot in the grounds of the house. If they are well landscaped, and the building looks good from the outside, consider incorporating it, perhaps rendered slightly out of focus by using a large to medium aperture to restrict depth of field. When working outdoors, the lighting can be controlled effectively by means of large white reflectors to bounce light back in and black to subtract light.

CONTEMPORARY PORTRAITURE
Many portrait photographers these days have their own personal style, which attracts clients from a wide geographical area.

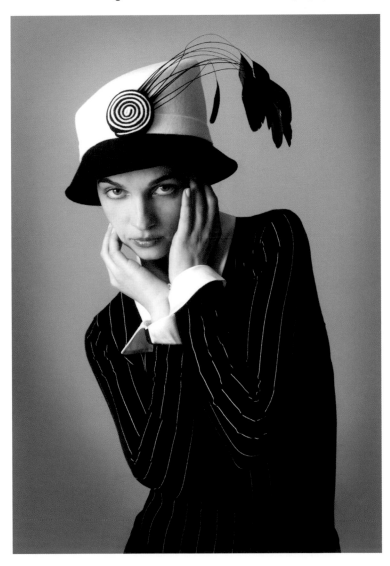

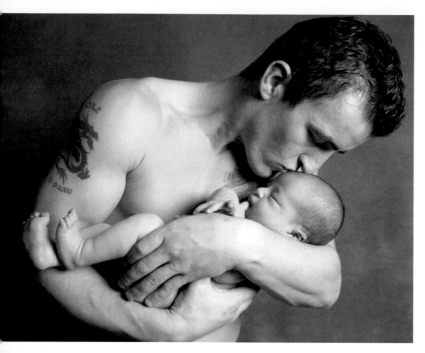

BABY STEPS
Having a new baby in the family is often the reason families ask to have some studio portraits taken.

■ Buying an existing studio

If you have never worked in a studio before, starting one from scratch is a potentially risky move. You will have no idea how many people will come or how much they will spend. You will have money going out every month but no guaranteed income. Another option worth considering is to buy an existing portrait studio – one perhaps where the owner is retiring. Because it is already a going concern, you can check the books and see how viable it might be. Inevitably, there will be a larger investment, because you will also be buying the 'goodwill' of the business, but you can be reasonably assured of money coming in from the first day. Although the risk is ultimately all down to you, it is unlikely that you will get a loan from a bank if they consider the idea to be unviable.

■ Renting business premises

Another option is to rent business premises and set up your own studio. This might be in a high-street setting or, if the rates are too high, slightly away from the centre of town. But bear in mind that you will get more passing trade in a prime location, which might justify the greater expenditure. A shop window on a busy street will give you a perfect display space for examples of your work, so before they step inside customers will know that they find your style of photography appealing. Avoid premises that are too remote, although they may be cheaper, as you will need to spend proportionately more on advertising if customers are to come to you.

As well as paying three months' rent in advance, you will need to budget for refitting, signage, interior decoration and much more. Before embarking on such a course of action, you need to produce a detailed business plan – and you will need one if you intend to borrow money to start things off. Remember that you will have regular ongoing costs such as business rates, lighting and heating.

■ A portrait franchise

Another option worth considering is taking out a franchise. If you have never worked in the business before, the advantage is that you will get full training as part of the package, along with national advertising and being part of a recognized brand. The downside is that the investment can be considerable, and sometimes there are stringent legal constraints should you want to get out or move on. Another issue common to many franchise operations is that you have to do things their way. You don't have the creative freedom you have when you run your own business.

Creative freedom can be important – particularly to photographers for whom portraiture is about more than making money. For many, it is also a form of self-expression in which they harness their creative ability to produce artistic images. The days are long gone when most pictures of people were taken in the studio against a painted 'old masters' background. These days the public expects a more contemporary, lifestyle approach, reflecting

the kinds of photographs that are published in magazines. Many professionals have their own style, ranging from crisp advertising or fashion-type shots against a clean, white background to relaxed, informal studies in natural surroundings.

■ Equipment for portraiture

You need to be able to produce professional quality pictures. For portraiture, that means images should be capable of enlargement to at least 50 x 40cm (20 x 16in), ideally 50 x 75cm (20 x 30in), and if possible 75 x 100cm (30 x 40in) and beyond. There are two principal reasons for this. One is that many customers want to commission a portrait they can hang on the wall, and they won't buy it if it is not sharp. The second reason is that the mark-up is significantly higher on the larger sizes, so you want to sell as many as you can.

What that means in practice is that you need a digital SLR with a reasonably high resolution (you can always throw pixels away, but you can't add them without some loss of definition), or, if you're shooting on film, a medium-format model. The main lenses you will use for portraits range from moderate wide-angle to short telephoto – 24–105mm in 35mm-format terms. You could probably get away with just one zoom covering that range, although on occasions you may want something a little wider and longer.

As with any branch of photography, you need to have back-up equipment should your frontline gear fail. That means having at least one spare camera body and lens.

■ Equipping a studio

Some professionals use only ambient, available lighting, but they are very much in the minority. While it is natural, and to a degree versatile, it has a number of

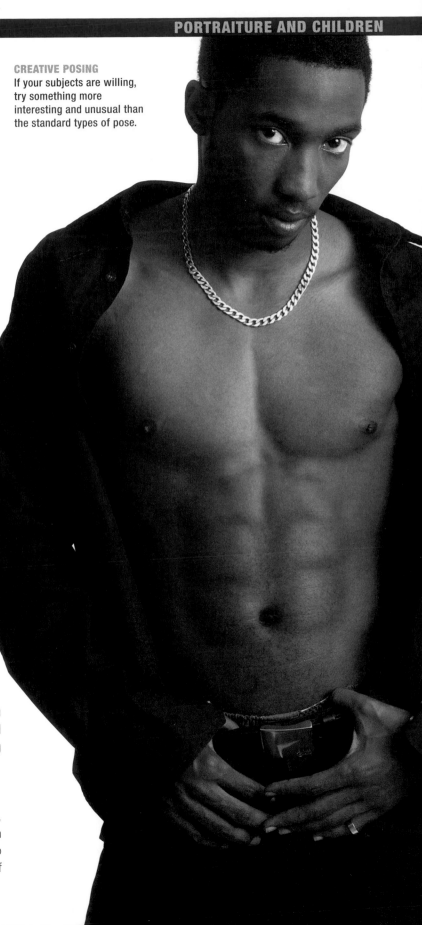

CREATIVE POSING
If your subjects are willing, try something more interesting and unusual than the standard types of pose.

FLIRTY EYES
If you're looking to sell a portrait, it must have an appealing expression.

because the pictures look overlit and unnatural.

For simplicity, there is nothing to beat one light to the right or left of the camera. There is only one sun, and restricting yourself to a single source avoids multiple shadows that can ruin a shot. One of the most popular two-light set-ups is to place a head each side of the camera, at 45 degrees to the subject, one producing slightly more light than the other. To create more of a fashion feel, place one below the camera and one above it.

There are lots of different ways of lighting portraits, and no right or wrong way. But it is useful to learn the principles of lighting, especially how to work out ratios – the relative strength of the different lights used – so you feel confident in what you are doing.

It is also considered valuable to understand the difference between 'narrow' and 'broad' lighting. Narrow lighting is more flattering; the light comes from the side where there is the shortest distance between the bridge of the nose and the side of the face. Because of the shadow on the near cheek, more shape is given to the face and it looks thinner. Broad lighting, which lights the side of the face turned towards the camera, is less flattering.

significant limitations – including the fact that you can't take pictures after about 4pm in winter. Most portrait photographers, therefore, also use studio lighting, and some rely upon it entirely. Studio flash is what most go for, though a few prefer continuous tungsten lighting. Hardly any, though, use accessory flashguns that fit on the camera for anything other than fill-in outside on excessively bright or dull days and as a main source when they are covering events. Most portrait professionals have between two and four flash heads. Rarely does anyone use more these days,

In addition to the studio heads, you will need various accessories to modify the light. Umbrellas, into which the head is fired to diffuse the light, are great if you have a small studio or work on location a lot because they don't take up much space and can be set up and packed away quickly. If you have more space or time,

you will get softer, more flattering results by fitting large softboxes, which spread the light even more. As a result, you get a consistent light over a larger area, covering groups more evenly and allowing subjects to move around more freely. Sometimes, though, you'll want it more focused, for dramatic, stylized effects. In that case, you'll need a snoot, which narrows the beam of light.

Other items of equipment you might need are a number of reflectors to provide fill-in light; a flash/exposure meter, for the 100 per cent accuracy that no camera can deliver; and a tripod, so you can set the camera up and then chat to your subjects to put them at their ease.

■ Dealing with enquiries

Working on your own as a portrait photographer presents a number of logistical problems, such as how you deal with prospective customers, both over the phone and, if you have premises open to the public, in person, when you're busy taking pictures. The answer, of course, is that you can't. You will have to find someone else to do that for you, otherwise you'll quickly lose a lot of prospective business.

Many married photographers deal with this issue by having their partner deal with enquiries and bookings – and they often do the accounts and general duties as well. The most common arrangement used to be that the photographer was a man and the admin person was his partner, but times have changed and sometimes the roles are reversed. The business is run as a partnership, and in practice the two jobs are equally important. If you don't have someone who can look after things while you are shooting, you will need to make other arrangements.

If you have a studio that people drop into without appointments, you may have to employ someone. If you only take bookings and make appointments over

IN PROFILE
Don't always have the subject staring straight at the camera – try some shots where they're looking away or in profile.

the phone, it might be possible to employ a 'virtual' secretary – someone who looks after a number of clients – to handle the calls for you.

However you organize things, that person needs to have an excellent manner when dealing with customers, because their perception will start to be shaped from the moment they first make contact with you – and first impressions, as the saying goes, can often be lasting impressions.

Don't have a studio? Shoot natural-looking portraits at your subjects' home or in a public area.

TALKING HEADS
When photographing two people together get them to interact so the picture doesn't end up looking static.

Practical matters

How long should a sitting be? How many should you do in a day? That varies enormously. Some photographers at the top of the market do just a couple of sessions each day, one in the morning and one in the afternoon, while studios at the 'volume' end can sometimes do one every half an hour or so all through the day. Most are somewhere in between – and are often busier on Saturdays and early evenings, when the whole family can make it, than during the week. For that reason, some studios schedule 'makeover' sessions from Monday to Friday, to generate business when things can often be quiet.

In an ideal world, you should have a discussion with each customer in advance of their session, so it can be tailored to their specific requirements. That may not be an option in a busy studio, however. If you are photographing a dozen or more sittings a day, as can sometimes be the case at peak times, you are not going to be able to personalize your service as much as someone doing just a few sessions a day. Sometimes the best you'll be able to manage is a brief chat just before you begin shooting.

Pricing services

This is probably one of the hardest considerations for someone just starting out. Set your prices too high and you won't get much business; set them too low and you'll be working frantically but not earning much. A good starting point is to get someone you know to ring round the studios in your area and find out what they are charging. Establish the range. What is the cheapest? What is the most expensive? Where are most of your rivals?

Getting qualified

One thing that can help at the enquiry stage, and when people are looking through their local telephone directory to find a photographer, is to be a member of a recognized professional body, such as the BIPP (British Institute of Professional Photography) or PPA (Professional Photographers of America). It gives prospective customers confidence to know that you are a qualified photographer whose work has been assessed by a professional body. For that reason, it's an excellent idea to join up as soon as possible. There is usually an annual charge, and you may have to pay a fee to have your work assessed.

Ask them to send brochures, so you can study their pricing structure in detail.

Most studios these days offer free sittings – that is, they don't charge for taking the pictures, only for prints actually bought. This encourages custom because people know they won't have to pay anything if they don't like the pictures. Some studios have a notional fee for their sittings, which they offer 'free' in promotions – 'All portrait sessions free during May!' On some occasions, the free sitting may be tied to a minimum purchase – 'Free sitting when you buy a 10 x 8 print!'

There are those who say that not charging for the photography devalues it, but the practice is so common these days, and the whole market so promotionally driven, that you may have no choice but to follow suit. Only a small number of studios, typically at the pricier end of the market, get away with charging a sitting fee.

The main element of your price list will be the cost for each print. Normally this is based on size, starting at 13 x 10cm (5 x 4in) or 15 x 10cm (6 x 4in) and going up to 100 x 125cm (40 x 50in). The standard size, though, is 25 x 20cm (10 x 8in), which is what many customers buy. Pictures can be priced on their own, in simple folders, framed or as 'artistic' canvas prints.

Ultimately, you have to make a profit. If you pitch your prices too low in a bid to win custom you may go out of business because you won't cover your costs. You will need to be competitive to start with for sure, but if you are a decent photographer you shouldn't need to undercut your competitors. Once you have more work than you can handle, consider increasing your prices. See what the market will stand. If you run the only studio in a town you may be able to charge more than if you have a number of rivals. Alternatively, if you are particularly skilled, and produce strong, saleable work, you might try to position yourself at the top of the market

to begin with, charging not just a sitting fee but a sizeable amount for each print. There will always be customers who want the best and are willing to pay for it.

■ The ups and downs of portrait photography

One thing you need to be prepared for is the cyclical nature of the portrait photography business. There will be times, such as November and December, when you are rushed off your feet shooting family portraits. But come February, you will almost be able to hear tumbleweed blowing through the ghost town your studio has become. That is why many portrait photographers take a long and well-deserved holiday at that time of year. It can be up and down at any time, though. You have a couple of busy weeks and you start flipping through the Mercedes catalogue. Then no-one phones and the door doesn't open for the next two weeks and you wonder whether you will be able to pay the mortgage that month.

MONO MAGIC
Black and white portraits are extremely popular – and when you shoot digitally you have a choice between colour and mono.

◼ The art of selling

The vagaries of the portrait photography market mean that it is very important to be able to sell effectively. You need to be able to make the most of the customers you get. That's not to suggest you should go for high-pressure selling tactics, getting people to buy pictures that they don't want. That will only rebound on you. You are looking to build long-term repeat business, and you will only achieve that if you are honest and fair. But some photographers are a little reticent about marketing their work.

Some simple techniques can make all the difference. Instead of just giving customers proofs to look at in the corner of a busy studio, sit them down over a cup of coffee or a glass of wine to watch a presentation on a decent-sized computer monitor or plasma screen, with atmospheric music to heighten the mood. Show them different sizes or prints – starting with the biggest, perhaps a 50 x 75cm (20 x 30in), so that when they see the others, such as 40 x 50cm (16 x 20in), they look small in comparison. When a customer orders a print, don't just write 'One' on your pad. Ask 'How many?' You might sometimes be surprised when, after a moment's reflection, they answer: 'Six.'

One way of increasing your order value is to offer a wide range of frames and mounts that match the subject matter – everything from plain wood through to an expensive, ornate gilt finish.

Some photographers don't enjoy selling, and if that's how you feel, consider employing someone to handle that aspect of the business for you. They will more than pay for themselves and will leave you free to concentrate on what you are best at – taking the pictures.

◼ Printing matters

Something else to consider is whether you want to make your own prints. There are various systems available for purchase or lease that allow you to produce high quality prints on the premises. There is no need to process films any more – you can download the images from the camera immediately – so there is nothing to stop you providing a 'prints while you wait' service, and possible gaining a competitive edge. Alternatively, you may prefer to send files away for printing once the orders have been made.

USING PROPS
Some clients prefer a traditional approach, with pastel colours and liberal use of props.

■ Shooting to sell

Once you acknowledge that selling is a central part of your business, you can make life easy for yourself by taking pictures that people want to buy. The most important element by far is the expression on the faces of the people you have photographed. Mostly your clients are looking for smiles, but they have to be natural ones, not forced. That's why it is so important to establish a rapport with your subjects and get them to relax. Just chatting to them about what they do and what their hobbies are is all it takes. Avoid grins, though, and avoid serious expressions – but do take some pensive, thoughtful shots as well if time allows.

It is often women who arrange the session and they will take the lead when it comes to buying the pictures. As a general rule, they prefer pictures of themselves not looking at the camera and of a male partner looking at the camera.

When asked to photograph a group, always take individual pictures as well, and vice versa. With digital shooting it costs nothing, but when the customer sees the pictures they may be tempted to buy them. With teenagers, take stylish, sophisticated images of them for themselves and more traditional shots for their parents.

Vary the location. Try different poses. Go in close for a tight crop. Then zoom out to include the whole person. Shoot black and white as well as colour. Try tilting the camera to make things more interesting. Give your customers plenty of choice, so they're bound to find something they like, and may buy several pictures rather than just one.

MTV GENERATION
Keeping up to date with the latest trends by watching MTV and reading style magazines means you'll attract younger subjects.

WORKING WITH CHILDREN
To get nice pictures of children you need to have an affinity with them. Get down to their level, so they're not straining to look up at you.

▪ Maximizing the positive

When shooting to sell, you need to make your customers look their best, accentuating the positive and minimizing the negative. There are plenty of good books on the subject, including my own *Take Better Family Photos* (published by David & Charles), but here's a brief summary of how to deal with different issues:

• The best way to deal with sagging, double chins is to get people to lean forward and push their jaw out slightly,

and shoot from above.
• Don't take head-on pictures of people with big ears – choose a three-quarters pose, so one ear is hidden.
• Receding hairlines aren't so obvious if you shoot from below.
• You can make anyone look thinner by positioning them at three-quarters to the camera rather than square-on.

▪ Poses

The need to make people look their best has to be balanced against producing images that look natural. Many customers these days don't want pictures that look too posed. This is as true when photographing couples and group portraits as when working with individuals.

Try out different poses and positions. Have people leaning, sitting or lying down as well as standing. But don't allow the picture to be too static. Get people interacting with each other so there is a sense of something happening in the picture, rather than having everyone staring blankly at the camera.

▪ Working with children

Children are a crucial part of the portrait market, and can provide regular work over a number of years as parents bring them in for another birthday picture. You need to be skilled in dealing with them. Some photographers who specialize in children's photography do extremely well. The secret, with younger children in particular, is to take it slowly. If you have time, allow them to come to you, rather than going to them. Sit down at their level and start doing something, such as sorting out some toys. Don't be in a rush to get your cameras out. Give them a chance to get comfortable. Ask them about their friends and what they like doing. Learn some silly 'knock knock' jokes and have a laugh.

If you don't get children on your side they simply won't cooperate, and you

will end up with miserable expressions and pictures that won't sell. Make the experience enjoyable and encourage them to have fun. Stimulate their imagination, get them to act out a story and then record what's happening, rather than asking them to do something. If possible, set things up so they can roam around freely and capture their expressions as they explore. Should parents stay in the room? Ideally not. Children are more likely to be self-conscious, so it is better to have the parents wait in the next room. Leave the door open, however, so parents have the reassurance of hearing what is being said. If younger children are concerned about mum and dad being absent, get them to leave a coat or bag in the room, so they know they will be returning.

Babies

When photographing babies, it's better to have the parents there all the time, otherwise they can soon become fractious. Babies under six months need careful handling. Make sure that they are fully supported at all times, particularly in the neck region. You can now buy specially designed

baby-posing devices from companies such as Lastolite. These are normally adjustable, so you can photograph the child resting on its front looking over the top as well as lying on its back.

What you're looking to do with babies is create an 'Ahhh' response to your pictures, so always be on the lookout for cute, lively, saleable expressions. Get the parents to stand behind you, making noises and waving a favourite toy or rattle, rather than to the side, so the baby is looking towards the camera.

Keeping up to date

One of the secrets of success in the portrait photography market is keeping up to date with trends. You need to produce fresh, contemporary images relevant to people's lives, not the sort of pictures their parents had taken. Right now, successful studios are drawing inspiration from MTV and style magazines. Images have a relaxed, fashion feel, in black and white as well as colour, and are not just rectangular in format; they are sometimes long and thin or square.

EXPERIMENT!
These days people want portraits to look real, so be relaxed and natural in your approach and style.

PROFESSIONAL PROFILE:
Tamara Peel

Tamara Peel is one of Britain's most skilled and sought-after portrait photographers, who has developed her own personal style and won a string of awards along the way. Thanks to her engaging manner and infectious enthusiasm, photographing people comes naturally to her, and she has a particular talent for connecting with children. Able to produce stunning pictures in even the most ordinary situations, she is always looking to capture images that delight and inspire her clients.

'I usually spend about an hour and a half on a portrait session with children because of their limited attention span. I have a minimal studio, featuring white walls and a pine floor, with two Prolinca studio lights fitted with translucent brollies. These I normally place behind me to give a nice even light on the subject.

'The lights aren't in the way at all. I think that's important with children, as the equipment can often look a bit daunting and it intrudes on the shoot. I work very simply, with one camera – a Canon EOS-1D 35mm digital body with one or two lenses. My favourite is a 28–105mm, which gives a good working range in the studio I use.

'I sit cross-legged in the corner of the room and observe and talk to the children as I work. I have a floor-to-ceiling window that looks on to fields and I work around that, asking the children what they can see and what they enjoy doing, all the time mixing the window light with the flash.

'My approach is clear-cut. You have got to cover the reason the family has come to you in the first place, and that's essentially to secure some nice, expressive pictures of their children. And they need to be smiling! But equally, and because of my reputation for my fine-art images, which is the reason the client has come to me in the first place, I make sure that I capture quiet moments too – moments of contemplation. That means moments when the subjects are more subdued – concentrating on a puzzle, for example.

TILT AND ANGLE
Tilting a camera so the person is angled across the diagonal is a quick and simple way of making a shot more dynamic.

'I start off with very simple compositions and go for the big-eyes-looking-into-camera type of shot. If the child feels awkward with their mum or dad watching, there is a small anteroom outside of the studio the parents can wait in. This seems to work well, as the kids still have the security of having parents close by, but they also have the freedom to clown around a bit, which I always encourage!

'I ask the children to bring a change of clothes and often take them outdoors with their parents into the countryside around the studio (an old barn conversion) where I work. The real shooting begins when you get to this stage. I love the unpredictability of working outdoors, and I don't care if it rains. I work in all

PLAYING AROUND
Acting like a court jester means that children laugh and have a great time when Tamara photographs them.

BACKGROUND STORY
Unusual backgrounds add interest to pictures of children – and you can even get them to dress up to fit in.

circumstances because as soon as that camera is in front of me, I'm like a different person. I'm like a court jester. I lead the party and the people around me respond to that, especially the children.

'I work really quickly, using the motor-drive on the camera to continuously shoot a particular activity or movement. I work very intuitively too, and rarely plan a shoot. I much prefer to feel my way through a session.

'I can shoot up to 250 images at a portrait sitting. After the client has gone, I transfer all the images I've taken in the session on to a CD and edit them down through Photoshop to about 80 really strong images from which the parents can then make their choice.'

PHOTOGRAPHING PETS

Never work with animals and children – that's what W.C. Fields once famously said. But while that may be good advice when it comes to acting, it's certainly not true of photography. Both can be profitable areas of photography if you have the temperament to take them on. Pets in particular offer plenty of potential, since it's not an area many photographers cover. And with Fido and Whiskers increasingly thought of as part of the family, the number of owners looking to have a lasting memory of their pet continues to rise.

That's why, if you like animals and have an affinity with them, you might consider specializing in the field. The size of the market may be smaller, but there's a lot less competition. Some GP and social photographers include pet photography in the range of services they offer, but not many do it 100 per cent of the time.

Focusing exclusively on a niche area such as pets means you develop a reputation that will draw customers to you. They tend to prefer someone who's an expert, rather than a jack-of-all-trades. Getting known as a skilled animal photographer can allow you to charge a premium rate for your services – which means you don't have to do as many sessions to earn the same money. Of course, where you live will determine whether there's enough of a market for you to be able to specialize in this way.

NATURAL ORDER
Some subjects benefit from a 'natural' treatment using available light rather than a flash.

■ Which animals?

You're most likely to get asked to photograph dogs, but a photographer working in this field could get asked to take pictures of everything from cats to canaries and horses to hamsters. But since exotic pets are becoming much more the norm these days, you find yourself dealing with geckos, eagles or tarantulas as well.

■ Studio or location?

Another advantage of pet photography for someone planning to enter the area who has a job already and is looking to work freelance alongside is that you don't need a studio. It's a lot easier for a number of reasons to shoot on location. Most pets – like humans – will feel more relaxed on their own territory. And there may be logistical issues with moving larger animals, such as horses, around.

However, working on location doesn't mean you'll shoot everything using ambient light. Sometimes it will give a natural looking picture, which is what your customer wants, but sometimes you'll need to set up a makeshift studio on their premises. This

can normally be done in 10–15 minutes, and gives you full control over the lighting of the shot. If you're taking pictures on a winter evening you may have no choice but to set up a light, since there won't be enough available naturally.

In time, though – or even initially if you're serious about getting into pet photography – you might prefer to establish your own studio, either at home or in rented premises. The advantage of doing this is that you're not having to travel so much. Customers come to you, and the lights are all set up ready, so you can fit in more sessions during the day – which means you make more money.

■ The skills required

As well as being an animal lover – which is pretty much essential if you're going to succeed in this field – you'll need lots of patience. When you photograph people you can tell them where to stand and how to pose, but it's not like that with most pets. Unless they're extremely well trained – and some dogs are – they're likely to put up and wander off just as you're about to take the picture. So you need to be willing to work with them, and re-position them several times if necessary.

■ Promotion

As with all areas of social photography, you also need to be able to bring in a regular stream of new customers, and that means promoting yourself effectively. One good way is to get a notice up if possible at your local pet store or veterinary practice – places where people with animals will inevitably go.

■ Take care

The vast majority of the animals you'll photograph will be tame and perfectly safe. Handle them carefully and you'll have no problems. But some will feel nervous around you, and may even be frightened by the studio environment, so it always pays to take care. Obviously the risk is greater with larger animals, such as dogs and horses, around which you should always be wary, even if the owner is present. Dogs in particular can unpredictably turn nasty, so avoid making sudden, quick movements or looking them straight in the eye, especially if you're down at the same level as them. This can be interpreted as a hostile gesture. I know an experienced, specialist animal photographer who was bitten on the face in such a situation.

HAVING FUN
The clever way the border has been incorporated gives this pet portrait a sense of fun.

4 COMMERCIAL & INDUSTRIAL PHOTOGRAPHY

Commercial and industrial photographers take pictures for commerce and industry. Their clients are businesses and the work is usually commissioned. Common subject areas include products, buildings, people, concepts and presentations. The pictures are used for advertising, brochures, exhibitions, websites, newsletters, annual reports and mailshots. If the idea of shooting speculatively seems too uncertain – as you can never know whether a picture will sell as stock or to a publisher – commercial photography could be for you. It can be a more reliable way of earning a living – as long as you can get the commissions in the first place. Once you have quoted a price and the job has been booked, you know you are going to be paid, providing you deliver what was requested.

■ The challenges of commercial photography

The challenge for anyone thinking of becoming a commercial and industrial photographer is that it is an extremely competitive market, with too many practitioners chasing too little work. Matters have worsened with the advent of digital photography. Taking pictures on film was a relatively skilled business, and you could not be sure that you had got what you wanted until the picture was processed. But these days, most companies, and most of the individuals who work for them, have easy-to-use digital cameras that allow them to check the captured image. As a result, they are now taking a lot of pictures themselves that they would previously have commissioned from a professional photographer.

If they can't take an image themselves, and a generic image is required rather than one specific to the company, they might get the picture they want from a photo library as it will probably cost less than a commissioned photograph. Only if that doesn't give them what they want will they have a picture shot to order.

For these reasons, the commercial and industrial sector is experiencing a tough time. Some practitioners have started doing social photography and shooting stock as well, while others have closed down their studios and quit the profession. However, it's not all bad news. Businesses will always need images, and there's a limit to what they can take themselves. There may be fewer commercial photographers now than there were a decade ago, but many of those who remain are doing reasonably well. So it is still a career choice worth considering if you have the skills required. A safer, and potentially more successful, option for those starting from scratch is to become a 'GP' (general practitioner) – a photographer who takes pictures of pretty much anything.

■ Working from home

One of the challenges facing commercial photographers is that one week can be frantic, and they can be working from dawn to dusk, while the next week is dead, with not a single commission. It's also possible for it to be quiet for a whole month – and that can be scary. For that reason, an increasing number of commercial and industrial photographers now work from home rather than renting a studio, as most did in the past. The last thing you want when there's little or no money coming in is to have crippling overheads that you can't afford to pay. When your income doesn't cover your outgoings, you have a problem – so in the beginning, I urge you to tread carefully.

To be able to work from home, you need to have space in your house, and if every

SKILLED WORK
Producing high quality images like this is beyond the capabilities of most industrial companies – but that doesn't always stop them trying, and coming up with something inferior.

DIVERSE SUBJECTS
Commercial and industrial photographers are called upon to cover a wide range of subjects, including architecture.

corner is occupied that's not going to be an option. However, if you are determined to get into commercial photography, you could concentrate on subjects that can be shot on location – such as architecture, pictures of people in business, and many kinds of PR work.

If you have a spare room or a garage that you can convert for photographic use, ideally full time, you will be able to tackle a much wider range of subjects. The bigger the space is, the better, because the range of work you will be offered will be limited by what you can fit into the room. You won't win many commissions to photograph motorbikes or bathrooms if you are operating out of a box room. (That said, one leading commercial photographer in England produces top quality pictures of a wide range of subjects from a room just 3m (10ft) wide.) Bear in mind that you will need sufficient space to accommodate your lights and cameras and for you to be able to move around. In particular, you will need enough headroom to have a large overhead light – though you can always place your subjects on the floor if the ceiling is low.

You will also need space to store items that you are waiting to photograph – and if you get into catalogue work, that can be a real issue. You might find yourself taking delivery of dozens of different power tools, which have to be kept clean and in order, so you can find the one you want when you need it. That means your house can easily be cluttered with objects when there is a major shoot going on.

You will also need room for a computer to process images, as well as for storing ancillary equipment such as a photo-quality printer and storage devices.

One complication of working from home is that clients or their representatives often want to come to shoots, so your set-up needs to look professional. Ultimately, it's the quality of your pictures that will determine whether you win business, but looking the part can also be a factor. So make sure that the decor is attractive and contemporary, and arrange everything in an efficient and orderly way.

You also need to make a positive impression when speaking to people on the telephone, as that will be how many clients first make contact with you. Try not to have dogs barking and children wailing in the background – it will create the wrong impression and may lose you business. If there is a domestic crisis going on when a prospective customer rings, let the answer machine take it, and return the call as soon as things settle down. Have a separate business line so you don't have one of the family picking up your calls inadvertently. If in doubt, give your mobile number as the first point of contact and always keep your mobile phone with you.

■ Renting versus hiring

One option with commissions that you can't accommodate at home is to hire a studio when you need it. Studios are available in most cities and reasonably sized towns, and you can normally hire

BE IMAGINATIVE
Can you tell what it is? Being able to come up with interesting and imaginative treatments – this is an iPod by the way – is part and parcel of being a successful advertising photographer.

them by the day, half-day and sometimes by the hour. This potentially gives you the best of both worlds. When money is not coming in reliably, you don't have the burden of maintaining a studio. But when you do have a sizeable commission, you can hire the space and facilities you need.

Over time, as your reputation grows and you acquire regular clients, you may find you have sufficient business to rent a studio on a permanent basis. This will make your working life much easier. Choose somewhere reasonably spacious – perhaps on a business park or industrial

items quicker, easier and more efficient. In commercial and industrial photography, time is money: when you're not shooting, you're not earning.

Ultimately, it would be useful to fit out the studio with an infinity curve, which gives a smooth transition between the walls and the floor. This is not essential initially (you can always eliminate the joins in an image-editing program such as Photoshop), but it's better, and more professional, not to have them there in the first place.

◼ Cameras and lenses

Whether you decide to work from home, rent a studio or shoot entirely on location, the next thing to think about is equipment. Exactly what you need will depend on what kind of pictures you are planning to take and how they will be used.

EVERYDAY SCENES
Not every location you photograph will be exotic. Often you will need to make an ordinary room setting look interesting.

estate – and you will be able to set up different areas for different kinds of shots. This will save you lots of time, and it also gives you the option of leaving something set up for a few days if you want to come back to it.

You might have a dedicated area for small products, with the lights set up ready. If a rush job comes up, you can simply put the item in place and take the picture, with no messing around. Being responsive will get you more business. You will also have space to accommodate much larger items, and may even be able to build complete room sets if necessary. Think also about access when choosing a studio. Ideally, you want doors that open wide enough to drive a car or small lorry in – not only so you have the option of photographing something that size, but also because it makes loading and unloading bulky

Quality tends to be a more significant issue in commercial photography than in other areas. There may be fine detail that has to be reproduced; products and people need to be shown at their best; and it's not unusual for images to end up as posters or published large in magazines.

Traditionally, therefore, photographers taking pictures for business used large- and medium-format cameras – and some still do. The quality you obtain from a 10 x 8in or 5 x 4in sheet-film camera takes some beating – and some product and architectural photographers still shoot transparencies, which they subsequently scan. Part of the reason is the control that such technical cameras offer over the image. Using tilt and shift movements, the perspective can be dramatically altered, allowing the verticals on large buildings to be kept upright even when space is

tight. The depth of field can be extended or reduced to control the sharpness in different planes in product and food photography.

Such cameras are not cheap, and when you add in a range of lenses, you are looking at a considerable outlay for a complete outfit. If you want to leave film behind, you need also to invest in a high-resolution digital back – which can be even more expensive.

Happily, such equipment is not required for every commercial assignment. Many can be tackled with a 35mm-style digital camera, although you may then need to do some work in the computer to counter the relative lack of creative control compared with that of the technical camera. As well as a body, you will require a full complement of lenses, from wide-angle to telephoto. These should ideally be fixed focal length prime lenses for maximum quality – though zooms often give acceptable results if the range is not too great.

Some manufacturers, notably Canon, offer perspective control (PC) lenses that help avoid converging verticals when photographing buildings. These can also be used creatively in the studio. Some commercial photographers will also need to invest in a macro lens designed to give life-size reproduction of tiny objects.

As far as finances allow, lenses should have a fast maximum aperture, allowing you to restrict depth of field for dramatic narrow-focus effects.

■ Other equipment needs

You also need quite a lot of other equipment – more than is required for social, publishing or stock photography. One of the key areas is lighting. Commercial pictures are rarely illuminated only by daylight. Usually, several studio heads are used to produce the effect required. One factor that most distinguishes amateurs from professionals is skill in setting up lighting that is appropriate to the subject. It is not unusual to use four or more heads when photographing a product – and dozens might be required with a larger subject, such as a car or a building.

Few photographers own that many lights; they hire as many as they need for major assignments. When starting out, you may be able to get by with two lights, supplemented by reflectors and mirrors, but as soon as possible you should increase that to four – and consider adding another two as funds allow. If you work mainly in the studio, go for a power-pack flash system, which is more versatile. If you are often out on location, opt for lightweight monobloc heads, as they are considerably more portable. You will also need a range of accessories such as softboxes, honeycombs, snoots and barn doors, which limit the spill of

BIRD'S EYE VIEW
Aerial photography is something that most commercial photographers tackle from time to time – and some specialize in it.

the light and vary its softness. These will allow you to exercise precise control over the way the subject is illuminated. Don't forget to budget for a flash meter to enable you to calculate correct exposure quickly and easily.

There are further items that can make your life easier. One is a dedicated still life/product table. Typically made from transparent Perspex (Plexiglas) and curving up at the back, this is ideal for taking pictures of small items. You can clip different backgrounds to it, and have the option of lighting from underneath. In the same vein, and perfect when you want soft, shadowless illumination, is a small 'cove' – a cave-like construction into which products are placed and illuminated using a softbox overhead.

Most commercial photographers also collect various bits and pieces to use as backgrounds, such as sheets of metal, old pieces of board and slabs of stone.

You will never reach the stage where you have everything you need, and will often have to gather together what's missing. This might involve finding props, hiring models, and renting a special item of equipment – such as an ultra-wide-angle lens or a 360-degree camera.

■ The skills needed

Unless you decide to specialize in one particular area, your life as a commercial and industrial photographer will be full of variety. In any one day, you might find yourself producing a high-tech image for a press release, photographing a group of executives for an annual report, or taking pictures of a building at dusk for a corporate website.

You never know what's going to come up next, and it's often one challenge after another. Initially, there's an enormous learning curve as you work out how to handle a particular subject or situation. But over time, you can draw on the

COMMERCIAL PORTRAITURE
Business people of all kinds require high quality portraits. I took this picture for use on an election mailing.

experience of previous commissions to make assignments run more smoothly.

While the ultimate aim is always to come up with a great picture, the route to achieving that often involves finding a solution to a problem. How do you illustrate the hard-wearing qualities of a non-stick saucepan? make a podgy, balding CEO look young and vibrant? or come up with a picture a trade magazine will want to publish alongside a press release? The key quality a commercial photographer needs is creativity – the ability to keep coming up with original ideas, and to transform what could have been an ordinary record shot into something more interesting.

You will need an eye for composition, too. It's extremely important to ensure that all of the elements within the frame work well together, with the eye going immediately to the most important part of the scene.

You will also need to be knowledgeable about digital manipulation, and be skilled in combining different images to create something exciting and unusual. If you don't already possess these capabilities,

it's a good idea to go to college, at least part-time, to build a solid understanding of the principles of picture-taking, before embarking on a career in commercial photography.

■ Coming up with quotes

When prospective clients contact you – usually by phone, but increasingly by email – you will need to take full details of what they want, as they will generally be asking you to provide a quote. You may get some clients who simply ring you and give you work, but they are very much in the minority. Some big companies have introduced procedures that require three quotes to be requested before a commission can be awarded. It doesn't always go to the lowest, but you will need to make sure you are competitive if you are to win the contract.

To be sure of obtaining as much information as possible, make a list of questions you need to ask and keep it by the phone. You might even want to produce a form on the computer, so you don't miss anything out. Leave gaps to fill in the answers so that you've got a record you can put on file.

Wherever possible, avoid offering a quote there and then. Give yourself a moment to think the job through. Exactly how long do you think it will take? Are there likely to be any hidden expenses? Will you need to hire anything? Then get back to the client as soon as possible, by phone if it's urgent, with an email to follow so that there is a record in writing.

ALL IN A DAY'S WORK
Clients generally want to get as much for their money as possible, and during a full day's commissioned shoot you may be asked to tackle a wide range of different subjects. I took all these pictures, some using supplementary lights indoors and some outside, for use in a variety of the company's publications, including the annual report.

Coping with urgent deadlines

Commercial photographic work is often urgent, with clients saying they want the job done 'yesterday'. Or, worse, they will ring you up for a quote and, three weeks later when you thought you hadn't got the job, they will call and say that they need the work done within 24 hours. This can be extremely frustrating if you have been standing around from Monday to Wednesday afternoon not working, only to get a call for a shot that's needed on Thursday morning – which means you have to work into the evening on Wednesday. That's just the way it is in the world of commercial photography. You could say no, but then you'll lose the work, and the possibility of other work in the future. If you are flexible, you will win business. If you are willing to work only from nine to five, you will probably struggle.

Working with agencies

While some commercial work comes directly from clients who are producing their own promotional material, much of it comes from graphic designers or advertising and marketing agencies who have been commissioned to come up with an advertisement, brochure, catalogue, report, press release or mailshot. The experience in each case is very different.

When companies commission you directly, you are often dealing with people who are not particularly knowledgeable about photography. Unless the company is big enough to have its own marketing department, these people are often not clear about what they actually want. They will generally want you to come up with ideas for them to approve. In smaller companies, your point of contact may be the managing director's assistant. Often there will be no one with you from the company when you are taking the pictures.

Advertising and marketing agencies and graphic designers are experts in illustrating concepts and presenting ideas, so the brief you get will usually be much more specific. They will have talked to the company to discover exactly what it wants and will bring together all the elements needed to complete the project. This might include copywriting, illustration, photography and, if they don't handle it themselves, design. An art director from the agency will often attend the shoot, offering advice and checking on progress.

Fees for commercial photography

Knowing what to charge when you first start out can be difficult. You're obviously not as experienced as other commercial and industrial photographers who have been practising for some time, so it doesn't seem reasonable for your rates to be as high. But if you pitch your fees too low, it may give potential clients the impression that you are not very good.

To find out what the going rate is in your area, try ringing your competitors to find out what they charge – then go 10 to 20 per cent lower. Pricing is usually at an hourly rate, with an overall day or half-day rate that works out a little cheaper. Most photographers shooting for business charge between £40 and £100 an hour in the UK and typically $100–$500 in the US – and some have a minimum charge of two hours when travelling.

When quoting, make sure you include the cost of any materials used, claim mileage at the going rate, and allow for any time you might have to spend on the computer manipulating images. Some photographers even add on a charge for supplying a CD – but not every client will accept extras of that kind.

Supplying proofs

In the old days of film, the photographer would normally deliver the processed transparencies – or occasionally prints – to

the client. These days, most jobs are shot digitally, and there are various ways the images can be supplied. If there are just a few, or they are required urgently, email is probably the easiest way – with the files saved as JPEGs. Another alternative is to upload them to a website. If there's no rush, or the client is nearby, it is better to write the images to CD or DVD and drop them off. That way there is no loss in quality.

Occasionally clients and art directors can't attend shoots because of meetings or other commitments, and you may need to email an image to them at their office as soon as it's taken, to be signed off before you pack everything away.

■ Establishing a business

Once you are established, with a solid client base, you can earn a decent living as a commercial and industrial photographer – though you must bear in mind that you will have all the expenses of buying equipment, possibly renting premises and promoting your business. But if you prefer dealing with companies rather than individuals, this can be an enjoyable and rewarding branch of photography.

Many commercial photographers work on their own, without any kind of assistance. Although they are in regular contact with clients, who may also attend shoots, it can be a solitary life. For that reason, it's a good idea to join a professional organization that holds regular regional and national events at which it is possible to network with other photographers and exchange ideas with them.

THE SPIRIT OF A PLACE
I was commissioned by a property development company to photograph a number of towns and villages for use in their brochures for new housing developments. My aim was to present each of the locations as somewhere appealing to live, so I made sure that the weather was good before starting out and then selected the most interesting and picturesque sights in each area.

PRODUCT AND STILL LIFE PHOTOGRAPHY

All businesses have a product or service that they need to show in press releases, mailshots and brochures, and commercial photographers are regularly called upon to produce these images. Unless the items are large or bulky, or can't leave the company's premises for some reason, they are most often shot in the photographer's studio.

■ Simple pack shots

Often all that is required in a product shoot is a simple pack shot against a plain background. Although some businesses now do these themselves, there is still a steady demand from companies who recognize that it's not as easy as it looks to produce such images.

If you have been able to set up a dedicated pack shot area, using a product table with a scoop at the back and with a studio head fitted with a softbox overhead, you will be able to produce a quality pack shot in a few minutes. Just put the product in place, switch the light on, and fire away. You already know what the exposure is because you've used it before and nothing has changed. You can have the image with the client within another few minutes by email, or on a CD if they want to take it away with them.

The secret with pack shots is to keep it as simple as possible. Choose a suitable background that works well with the subject you are using. You can buy sheets of card from an art or craft shop relatively cheaply, or rolls are available from photographic shops. White is a good choice if the product is dark, and vice versa. Coloured backgrounds can add interest if the subject matter is dull. Avoid graduated backgrounds or the sheets with grids on that were popular in the 1990s: these now look very old-fashioned.

Avoid using props unless they add something to the image – such as putting a credit card alongside an item to indicate how small it is.

Sometimes you need to include several items in a single picture, to show the whole of a range. These need to be arranged in an interesting and logical way. Some people have a natural eye for composition; others need to develop it. Initially, collect catalogues and brochures to see how other photographers have done it. Don't be afraid to copy or adapt existing ideas.

■ More interesting approaches

The product you are photographing may be rather mundane – a pair of shoes, an office fan, a beaker – and the client or creative director may challenge you to make it look more arresting. This is your cue to try something more creative. Study the product carefully and think about what you are trying to convey. Don't just show

LIGHTING FOR INTEREST
These plastic trays could look extremely boring, but thanks to skilful lighting the bright colours have been brought to life.

its features; illustrate its benefits as well. What does it do? Why should anyone buy it? How will it make life better for them?

Advertising often relies upon one big picture and relatively few words. The image, therefore, is crucial. It needs to be eye-catching and either tell the story at a glance or intrigue the viewer and make them want to read the accompanying text to understand what's going on. You also want to create an interest, a mood, a desire for the product.

You may have been supplied with a 'visual' indicating how the shot is to be used, and it's important to follow it exactly or you may have your work rejected. If you have more choice, try out different approaches until you find one that works. Try sitting down with a piece of paper and sketching out ideas first. You might crop in tight, showing only part of the product, shoot from an unusual angle, or try an unusual lighting technique. Sometimes you might even go further, building an elaborate set and bringing in props and accessories.

Always shoot what the client or agency has asked for, but, if you have time, produce some ideas of your own as well and include them in what you supply.

Digital manipulation

As a commercial photographer, you will be expected to have skills in digital manipulation, and be able to merge several images together to produce a unique, original concept. These skills are now crucial to success in this area of photography, and you should make learning to use Photoshop a priority if you want to succeed in this competitive field.

3M 100 Hook & Loop Fastener

When something needs taming

3M *Innovation*

■ Working in the studio

To be a successful product and still-life photographer, you need plenty of patience. It can sometimes take hours or even days to pull everything together and take the picture. You need to be methodical and meticulous, working step by step and paying close attention to detail all the way.

It's often necessary to wire elements of the picture together – such as a cork coming out of a champagne bottle – or Blu-Tack them into position.

The great thing about working in a studio is the complete control you have over all the elements. You can put things precisely where you want them and light them exactly as you choose, leaving nothing to chance. That's the difference between 'making' pictures, which is what most professionals do, and 'taking' pictures, which is what most amateurs do.

Lighting for small products these days tends towards the natural – using just one or two heads – but it's good to break the rules and select a set-up that works for the subject in hand. Where you position the lights is arguably more important than how many you use. Placing them behind the subject brings out any translucent qualities while putting them to the side reveals surface texture.

Softboxes are good for simple pack shots, but more focused, dramatic, contrasty lighting is often better. Using a snoot over a studio head will narrow its focus, or you can block off light using pieces of black card. It's also worth experimenting with putting objects in front of the light, such as blinds or small boxes, to cast atmospheric shadows across the set. Small mirrors and reflectors can be used to put highlights precisely where they are required.

Generally in product photography you will either want to maximize depth of field, using a small aperture to keep everything in focus, or have an extremely narrow zone of focus with a large aperture.

The more variety you can come up with in your shots and your approach to your subjects, and the more you can avoid getting into a rut, the easier you will find it to get new clients and hold on to existing ones. If you keep giving them the same kind of pictures, eventually they will get bored and find someone new.

MAKING IT HAPPEN
The essence of being a commercial and advertising photographer is coming up with exciting ways to photograph products and places.

Bigger subjects and catalogues

Not everything fits on a tabletop. You may find yourself photographing subjects up to the maximum size your studio will accommodate. Anything a company sells needs to be photographed. Often, when dealing with larger items, you will need to build a set – or, more usually, get someone to build it for you – that creates a convincing context. If you are shooting a furniture catalogue, that would mean a room set; if you are photographing power tools for industry, the set could be a workshop or garage.

You may get commissioned to shoot a catalogue or brochure featuring dozens or even hundreds of items. To make a success of it, and avoid going crazy, you will need a proper production system, so you know what has been shot and where everything is. If you don't yet have a full-time assistant, this is the time to hire someone, because it will save you time and money.

◼ Shooting difficult subjects

Some subjects are more difficult to photograph than others. The trickiest are highly reflective, such as metal and glass objects. However you light them, you are going to have 'hot spots', and there's a danger of the whole of the set, including you and the camera, being visible in reflections. One secret is to shoot through a sheet of black card with a hole cut into it the size of the lens. You can also buy 'dulling' spray, which reduces the amount of reflection you get in the first place.

Black subjects can be difficult too: they suck in light and you need to find a way of defining their shape and volume. You can try positioning lights to catch the edge of the objects.

When you are photographing textiles and clothing, it is essential that the colours in the photograph match those of the original fabrics. Careful calibration of the system is essential, along with a meticulous process of careful checking all the way through to make sure there is continuity in the colour matching.

FOOD AND DRINK

Food and drink is one of the most demanding areas of commercial photography. It is not something you should think about if you are not experienced or confident in your skills. While product photographers often work on their own, or with an art director in attendance, food photographers are often part of a larger team that includes a home economist, a stylist and sometimes a chef. Being able to get along with people – especially when things become stressful, as they often do – is essential. There can be a lot of waiting around and then a sudden rush to take the pictures while the food looks its best. You need patience and the ability to keep cool under pressure. There are simple tricks of the trade, though, that make life easier – such as using a 'prep' plate to set things up and then putting the actual food in place at the last minute.

MODERN STYLE
Contemporary food photography has a fresh clean style.

■ Current styles

You need to keep up to date with styles, as they are constantly changing. Make sure you check out the latest books by leading chefs when they hit the shelves. Right now, the emphasis is on making things look natural, rather than heavily lit and stylized as was once the case.

Some photographers use daylight, but many prefer to mimic it with flash to maintain consistency of colour. Companies generally want all the products in a range to be photographed in the same style. The problem with ambient light is that it varies in colour and contrast from one day to another and from dawn through to dusk. Gone are the days when photographers would use a dozen lights for just one shot. Now it's often just one head fitted with either a softbox or honeycomb, or a bare bulb in a reflector fired through a 'trace' screen, or sometimes two, to soften the light. Flash is the most common source, because the heat from tungsten bulbs quickly wilts the food. For the same reason, the modelling lights on flash units are normally kept switched off until they are required.

The position of the lights depends on what is being photographed. With textured subjects, such as biscuits, the

light is generally to the rear, so the texture is revealed. For standard photographs, it may be overhead or close to the camera. With translucent items such as pasta, the light is sometimes placed underneath.

Black card 'scrims' are commonly used to block off light and small reflectors and mirrors to direct light with pin-point precision into specific areas.

What most characterizes modern food photography, though, is an extremely narrow zone of focus. Typically, only a small part of the subject is rendered sharp, with the background, and usually the foreground as well, completely blurred.

Details matter

One of the most important things with food and drink photography is to keep everything clean. It can be helpful to wear cotton gloves when handling shiny objects such as cutlery, to avoid fingerprints. Plates and dishes should be attractive and chosen to complement the subject matter. Care should be taken to use only perfect ingredients: this can mean sifting through ten tins of baked beans to get the five best-looking individual beans.

Even if you're meticulous you can still miss something in the set-up. If you're shooting digitally in the studio, load each of your images on to the computer straight away and examine them at high resolution to make sure there are no blemishes before you pack everything away and move on to the next shot.

Staying within the law

In the past, food and drink photographers used all sorts of tricks to make the products look good – such as cooking turkeys for only a fraction of the time required and then varnishing them, or using lard instead of ice cream. These days, this is not only frowned on, it is also illegal in most countries. You have to make sure that what is shown corresponds to reality.

Companies have been reprimanded by advertising watchdogs for such things as using small plates to make portions appear bigger and placing all the filling at the front of a burger, so it looks as if there is more than there actually is. And if a pack of cereals has only four hazelnuts in a pack, you mustn't show five.

There are things you can legitimately do to make the food look as attractive as possible – such as spraying fruit and vegetables with glycerine mixed with water to give them a fresh, dewy look, or blowing down a straw to selectively melt ice cream.

Areas within food and drink photography

• Food packaging

This is a big growth area. Fewer people now cook raw ingredients and more buy processed meals that they stick in the microwave at the end of a busy day. The manufacturers of such ready meals need appetizing photographs of the dishes to place on their packaging.

• Advertising

With new products regularly coming on to the market, companies need pictures of them to go in newspapers, magazines and fliers so that potential customers know they exist and what they look like.

• Menus

Local restaurants often need photographs of meals to put in menus and posters to go in the window. They may have tried to take pictures themselves and been disappointed with the results. You could be called upon to do a single dish or a whole meal – sometimes with table decorations and all the trimmings.

• Books and magazines

Hundreds of cookery books are published every year, and most of them are lavishly illustrated. In many cases, the pictures are the work of just one photographer who has been specially commissioned. There are also a number of glossy magazines devoted to aspects of food and wine.

• Wine and beer

There is a huge drinks market, covering everything from beer and alcopops to bottles and glasses of wine.

COMMERCIAL LOCATION PHOTOGRAPHY

Not all commercial and industrial commissions are carried out in the studio. There are many subjects that require the photographer to go to the client instead. Some products are too large or heavy to be moved, or may be fixed in position, so you have no choice but to shoot them in situ. You may be asked to photograph the client's factory, office or facility, often with people at work in it. You may need to capture lorries and vans leaving at dawn to make deliveries. Sometimes the assignment will take you to a specific event, such as a conference, dinner or presentation. Companies may want to record the progress of a building project. Often executives are too busy or too important to leave their desk, so you'll have to go to them to take a portrait. Or you may need to travel to a remote location such an oil rig by helicopter.

Such is the life of the commercial and industrial photographer who works on location. It can be exciting at times – you go to all sorts of places, sometimes overseas, and meet lots of different people. It can also mean long hours. You may need to get up early to drive to where the shoot is taking place, stay out late to catch the atmospheric light at the end of the day, and then drive home afterwards.

ADDING COLOUR
One simple way of making an industrial location more interesting is to add colour gels over the lights you use.

■ Equipment matters

When you are working on location, you have to take everything you need with you. That means careful preparation is even more important than usual. If you suddenly discover when you're a long way from home that you have forgotten to pack a flash cable or a particular lens, you have a problem. Make a detailed checklist of what is required when you plan the shoot, and make sure you have packed everything before you leave.

Obviously you will need cameras – and the plural here is important. If a camera fails in the studio, you can quickly grab another one. When you are on location, it is essential to have a spare with you.

Unless there's a good reason not to (say, you're travelling by helicopter or light aircraft and there's a weight restriction), pack a full range of lenses. You may think you will only require wide-angles, because you expect to shoot only large interiors, but when you reach the location you may discover that additional shots have been commissioned – such as pictures of the owner – or the layout isn't quite what you expected. It is crucial to be prepared for as many eventualities as possible.

For the same reasons, you should always bring lighting with you even if you plan to work by daylight. It might suddenly cloud over; the brief could change; or the ambient lighting might not be suitable.

Obviously, you will need a vehicle that can accommodate all this equipment, along with tripods, gadget bags, flashguns, reflectors and anything else you need.

■ Location work in industrial workplaces

There may not be as much industry as there once was, but commercial photographers are often commissioned to take pictures of factories, warehouses, laboratories and distribution centres for use in press releases, annual reports and newsletters.

Such places are primarily practical and functional, and are therefore rarely photogenic. Some are dirty, many are untidy, and others are downright dilapidated. Most of the time you can't just get your camera out and start shooting; you need to make the place look presentable first.

If you have been able to scope the site beforehand – perhaps when you went to discuss the project prior to giving a quote – you may have been able to sort some of the problems out then. Telling the owner or manager that you need the place cleaned and tidied if you're to get decent images may do the trick. They may even be willing to slap on a coat of paint to freshen the place up. But don't expect miracles. When you get to the site, it may still be far from perfect. You will have to use your skills to make it look as attractive as possible. Sometimes that can be achieved by careful use of composition – including only those areas that are OK and excluding others

TIME OF DAY
To be successful you need to be prepared to go the extra mile. That may mean getting up before dawn to capture the light when it's at its best.

that are not so good. Consider shooting from a higher viewpoint, or getting down low and looking up.

Using a standard or telephoto lens in preference to a wide-angle can also help. If necessary, consider moving things around, if that's possible. Placing a fork-lift truck in front of a grotty patch of wall can hide it from view. Letting down blinds can keep a cracked windowpane out of view.

Of course, not all workshops, factories and warehouses are like that. Some companies boast state-of-the-art facilities that are kept spotlessly clean – and those are much easier to photograph. Even so, many are still bland, grey places that are difficult to make look exciting. You will often want to introduce a number of flash or tungsten heads to balance lighting levels, focus attention on a particular area or simply create more interest. Fitting coloured gels over some of the lights can dramatically enhance the picture and make it look more high-tech – but take care not to overdo it, or the effect can detract.

On a more practical note, some of these locations can be extremely cold, especially in winter, so you'll need to be well wrapped up. In particular, pack gloves, scarves and thick-soled footwear.

■ Location photography in offices

Some of the issues relating to factories and warehouses also apply to offices. The typical office desk is covered with paper; there may be boxes stacked up in corners of the room; and tatty posters and notices may decorate the walls. If you are aiming to produce a picture that makes it look like a wonderfully responsive call centre or a switched-on sales office, you've got your work cut out.

Start by establishing which shots you want to take from where. That way you will know which areas demand attention. It's much easier sorting things out when you're

Other locations

You may also be asked to take commercial pictures in other locations, some of them extremely inhospitable – such as a mine that is buried deep in the earth or an oil rig that's being tossed around by huge waves off the coast. Here the challenges can be even greater. If you don't feel confident in your ability, you should decline the commission. If you suffer from claustrophobia or get seasick you're not going to achieve very much. Consider every assignment carefully rather than simply saying yes to whatever comes along.

If you work for international companies, you may be invited to work overseas. This requires even greater planning, an understanding of how to ship equipment to other countries, and knowledge of different cultures and languages. It can be exciting taking on overseas contracts, but you need to do your homework first.

on-site than trying to retouch messy items away later.

Take care when you have computer screens in the picture. Because of their 'refresh rate', they need to be photographed at a shutter speed that's longer than 1/25 sec, or you'll get banding – unattractive lines – across the screen. The same is true of televisions, which you might find in recreation areas.

One solution is to use a long shutter speed – such as 1/15 sec or 1/8 sec – but that can be problematic if you are using daylight in brightly lit areas. Another option is to take two pictures, one at the normal shutter speed and one at the longer speed, and combine them later.

■ Creating a sense of activity

One of the most important things about location shooting is to create a sense of something happening. It's all too easy for pictures to be static. Including people can make a major difference. Instead

INTERACTIVITY
When you include people, get them to interact, rather than looking at the camera.

SKY'S THE LIMIT
To produce this picture the photographer went up in a bucket above the building and used a fish-eye lens to produce the eye-popping perspective.

of just featuring a piece of equipment, have someone operating it. People bring locations to life. They also give a sense of scale in a factory or office. You often can't tell how big or small the building is if there's no human interest.

Take care when you include people that you don't have them standing where they shouldn't be or doing things they shouldn't be doing. If you do, the agency or client will reject the pictures. Check whether they should be wearing goggles, hard hats, or any other kind of safety equipment. This should be at the front of your mind when shooting on location.

Most of the time, it's better not to have people looking at the camera. Have them concentrating on what they're supposed to be doing – such as picking goods from a shelf in a warehouse – or, if there's a group of people, encourage them to interact with each other. If you have even one person looking at the camera, it changes the dynamic completely, and the picture no longer seems natural.

Since most people become self-conscious once a camera is pointed at them, you will have to provide some direction initially, placing them and telling them what to do.

Another way of creating a sense of activity is to include moving items, such as vans or production lines. Going for a long shutter speed – 1 sec or more – will reproduce them as a streak that looks more dynamic than a static interpretation.

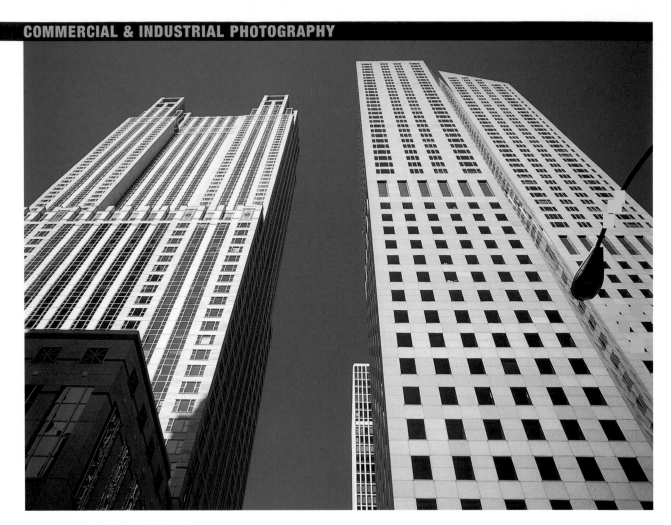

ARCHITECTURE

Some commercial photographers specialize in architectural work, but even those that don't find they regularly take pictures of buildings. These might be for other professionals in the industry, such as surveyors, builders and architects, or for businesses that need images for reports, adverts or websites. Sometimes these are pictures of current, finished buildings, and sometimes 'progress reports' of buildings in the course of construction. Estate agents don't normally commission pictures of the houses they're selling – they're taken by staff. However, you may pick up work at the top end of the market, where the value of the house justifies spending money on a spread of images that will help to sell it.

THE SKY'S THE LIMIT
Weather is one of the primary considerations when photographing buildings – and usually a bright day with blue sky is best.

■ Lighting considerations

The aim of architectural photography is generally to give a positive impression of the structure and form of a building. The key way of achieving that is to shoot when the light is right. Nothing has more effect on the quality of the finished results. This means that weather is a primary consideration when photographing exteriors.

Most buildings – there are exceptions, but relatively few – look their best when the sun is shining. Bright illumination brings to life their construction materials, whether they are stone, metal, wood or concrete. You can often get away with light, fluffy cloud. It may even be an advantage in the middle of the day, when it acts like a giant diffuser that softens the sun's harshness.

When it's overcast, the light doesn't have enough contrast and has a strong blue content. In the resulting pictures, the building looks flat and dull, and the sky ends up burned out.

Architectural photographers need to pay close attention to the weather and plan around it whenever possible. Of course, that may not always be an option. Sometimes you will receive a call from someone frantic to have the picture taken that day, and you will have to go out and shoot it whatever the weather. In situations like that, the client usually understands that you have done the best you can. I often boost the contrast in Photoshop and warm up the colours to obtain the best image I can.

If you are not working to a tight deadline, you have more freedom to choose a day when the weather is ideal. But even then

you can have problems. I once had two weeks to take some photographs of a building not far from my home, and there was unrelenting rain and heavy cloud for the whole of that period. It can be difficult to produce good architectural images during winter, because the weather is often drab, the sky is grey and the days short. And when you are shooting in built-up areas, such as city centres, the fact that the sun doesn't get so high means the building you are photographing can sometimes have an ugly shadow on it from another building for much of the day.

◼ The position of the building

The time when you take your pictures will be partly determined by the position of the building. If it faces south, you know – because the sun rises in the east and sets in the west – that it will be lit most of the day. Best results are usually obtained when the sun is at an angle of 30 to 60 degrees to the building. The 'raking' light you get when the sun is coming from the side emphasizes relief and reveals texture. When the angle is less than 30 degrees, the shadows are often too long. And as it approaches 90 degrees there are no shadows at all, making the building appear flat and uninteresting. If the building faces east, you will need to shoot in the morning. If it faces west, you will have to shoot in the afternoon or evening. Both are good times, when the light can be warm and atmospheric. If the building faces north you have more of a problem, as it won't receive any direct sunlight.

Another option, whichever way the building faces, is to shoot at night – or rather at

STAIRWELL
Consider all perspectives, including looking straight up. For some subjects black and white may be superior to colour.

FRAMED
'Night' pictures are best taken at dusk, when there's still some blue in the sky. Using a foreground frame creates a sense of depth.

dusk, about an hour before it gets dark, when the lights have just gone on. That will give you attractive results, and sometimes blue skies, no matter what the weather was like during the day.

Plan ahead and carry a compass

As should be obvious by now, successful architectural photography involves a lot of planning. You can't just turn up on the day and hope the conditions are going to be right. You need to find out ahead of time which direction the building faces, whether you will have any difficulty in getting a view of it, and deal with any other factor that could affect the shoot. The best way is to go and see for yourself, taking a compass with you to work out where the sun will be and when, making allowances for the different seasons.

If you can't travel to the building easily because it's too far away, try to check it out on a map or ask someone who works in it to answer any queries you have.

Keeping it upright

Many people who commission architectural photography are discerning and knowledgeable, with specific requirements that you have to be able to meet. One is often that the uprights in the building are shown upright in the picture. To achieve this, the back of the camera needs to be perfectly square. This is easier said than done, for a variety of reasons. One of the most common is that it is often impossible to get the whole of a tall building in without tipping the camera back.

That is why architectural photographers often use 'view' cameras, which have a wide range of 'tilt' and 'shift' controls. These make it possible to compensate for the converging verticals that would otherwise result from working in a restricted space.

Some specialists still shoot film and then, if the client requires a digital file, scan the resulting slide – producing an extremely large file. Another alternative would be to fit a digital back, although that wouldn't make financial sense for many commercial photographers who do architectural work only occasionally.

Another option, if you are using a 35mm-style digital SLR, is to buy into a system, such as Canon's, which includes PC (perspective control) lenses. While lacking the full range of movements found on a view camera, they do enable you to compensate for much of the convergence that you will encounter on a daily basis.

Another option is to correct the verticals in an image-editing program. Once you've got the knack, this is a pretty straightforward procedure that takes a few minutes. The secret is to shoot with as wide a lens as you have, leaving plenty of 'air' around the building, because when you make the correction you crop some of the image away.

Creative techniques

Happily, not everyone is obsessed about getting the verticals upright, and many clients will be content to receive a decent record shot of their building. Some will even encourage you to come up with a more creative approach, or be delighted if you do so spontaneously.

So rather than avoiding converging verticals or compensating for them, you could exaggerate them by fitting a wide-angle lens and tipping it right back. Going in close and tilting the camera can also produce a dynamic result.

If you're not careful, there can be a lack of depth in the picture. One way of avoiding that is to include something in the foreground to act as a frame. This might be another architectural feature, such as an arch if there's one conveniently nearby, or the foliage of a tree. If a tree is not readily available, you can always 'cheat' and cut a branch from elsewhere and hold it in front of the camera as you take the picture.

You should also think imaginatively about the shapes of your pictures. Sometimes buildings lend themselves to long, thin panoramic compositions – vertical as well as horizontal.

Whether you are shooting conventionally or digitally, fitting a polarizing filter over the front of the lens can make an enormous difference to the quality of the finished image. It deepens the blue of the sky, increases contrast and – depending on the degree of polarization – reduces the reflections from glass and metal.

Difficult buildings

Some buildings are more difficult to photograph than others. The most challenging, as we have discussed, are those that are tall and where you can't get back to photograph them.

Others have things round them that restrict the view, such as tall hedges or fencing. In those situations you can use a step-ladder, scaffolding or even an extending aerial set-up that lets you shoot over obstacles. This can also help when there are unattractive things in the way, such as cars and vans.

Another difficult kind of building is the long, low design that you often find in industrial parks. It's really hard to make these look interesting. The best approach is to show it in its setting by shooting from a distance.

Photographing interiors

Exteriors are relatively easy to shoot compared to interiors. Once you step inside an office, factory or other kind of building you are often faced with a lighting cocktail of daylight, tungsten and fluorescent. You could just capture things as they are, but the results will often be far from ideal. So you might see what happens when you switch various light sources off. Some mixed lighting is often acceptable, but too much generally looks wrong. Take a test shot to assess the situation – bearing in mind that you can always make some adjustment to the overall balance in your image-editing program.

If you only have daylight and tungsten to contend with, one option is to replace some or all of the tungsten bulbs with daylight-balanced equivalents. These are readily available from most electrical stores in various wattages, allowing you to brighten and darken selected areas.

Fluorescent lighting is more difficult to deal with. It gives everything in a photograph a nasty green cast that you really want

to avoid. It is best to switch fluorescent lighting off entirely if that's possible – but it may not be, since it is such a commonly used light source.

Sometimes you can get away with the lighting that is there already. However, photographing interiors almost always requires extra lights. These can be used either to replace the existing lighting or, more commonly, to supplement it. If the area is small, you may be able to get away

with just a few studio heads. If you have a large space to light, you may need to hire additional lighting to cope.

Position lights creatively, so you 'sculpt' the lighting to give a dramatic effect. Some heads will require softboxes or honeycombs to soften them. Others should be fitted with fresnels or snoots to focus the beams. All the units should, of course, be positioned so they can't be seen.

In some situations, you may want to create the effect of light streaming in through the windows. But what do you do if the sun's not actually shining? Try placing a flash head outside a window or open door, fired into a brolly or through a softbox, to replicate the effect. Fit an orange gel over the head to give a sense of early morning or late evening warmth.

Sometimes, for interior shots that include windows or doorways, you will want to balance the lights indoors with the daylight outside – often the light levels inside are lower, and the exterior view gets burned out. Taking two separate exposures, one for indoors and one for outside, and then combining the shots, can be an effective solution.

WESTMINSTER ABBEY
Make sure you keep the verticals upright in formal interiors.

The life of a PR photographer can sometimes be an interesting one. This picture of the Cutty Sark Tall Ships Race was taken for the developer Berkeley Homes and appeared on the front page of *The Times* newspaper.

PUBLIC RELATIONS PHOTOGRAPHY

Public relations (PR) used to be a reliable source of income for the commercial photographer. Every week clients would want pictures taken to publicize their companies. But many of the simple 'grip and grin' presentation pictures and straightforward product shots are now handled in-house, and as a result there is not as much PR work around as there once was. But most companies are aware of their limitations, and although they would like to do it all themselves, they know they can't. That's when they call in a professional. Or, more often than not, their PR company commissions the work and provides you with a brief.

■ The scope of the work

Sometimes the company wants a picture taken to support a press release that has been written. They want a shot of a member of staff leaving or joining the company, the launch of their latest widget, the opening of a new factory or office building, the company winning an award, the visit of a prominent person or celebrity or, most popular of all, someone holding a giant cheque. Most of these pictures are taken on location, though some may be done in the studio, such as product shots and the occasional portrait. On other occasions, the photographer may attend an event, such as a meeting or conference, and take some pictures around which a press release is subsequently written.

CORPORATE NEWS
PR photographers are often called upon to take this kind of picture, recording an event or presentation and making sure the company's logos and identities are included.

■ Getting the image published

The aim of the brief is to get the material published in a newspaper or magazine, whether it is a consumer or a trade publication, or on a website, so the images need to be planned with the target market in mind. What kind of shots do they use?

GROUP SHOTS
Being able to photograph large groups so that everyone can be seen is a key skill.

How do they use them? If you don't know, find out before you take the pictures, or you could end up with something that has no chance of being used because it doesn't meet the requirements. Plan ahead and prepare carefully.

Some trade publications use PR pictures on their covers, and if you have that in mind you need to remember to leave space for the masthead and any cover tasters. Look at the established style of the magazine and follow it.

As a general rule, PR pictures need to tell the story at a glance. But they also need to be creative. News editors receive a lot of very dull images, and they are always looking for something eye-catching that will bring their pages to life. If you can provide such images, they will be published, your client will be happy, and you will get more work. If your pictures regularly get 'spiked' (not used), your clients will quickly stop using you.

■ Creative treatments

With these requirements in mind, you need to look for an original treatment. You might, for instance, lie on your back with a fish-eye lens with four people who've just won an award leaning over you in a 'rugby scrum' style. Or you could show an intriguing abstract detail of the company's latest widget.

Since the whole point of the exercise is to publicize your clients, you need to include in the picture whenever possible something that represents them. This could be their logo, one of their products, the front of their building including the company name, or their details on a cheque or t-shirt.

PR pictures are rarely used at large sizes, and they often need to be taken quickly on location, so a standard 35mm-style digital SLR will do just fine. Often you'll want to use a wide-angle lens to get in close and create impact.

COMMERCIAL PORTRAITURE

It is not just social photographers who get asked to take pictures of people – companies need them too. Institutions from doctor's surgeries to fitness centres to conference facilities have pictures of their staff on the wall. Over the years, I have been commissioned to shoot commercial portraits for a wide range of uses, from annual reports to political literature. Some companies now shoot their own images using inexpensive digital cameras, but the results are often horrendous.

USING PROPS
Don't settle for simple head shots – use relevant props to bring commercial portraits to life.

■ Working quickly

Sometimes people will come to you in the studio, but you will usually be expected to go to them. Often you won't have much time to take the pictures – sometimes I've had just a few minutes. The best approach is to go in, decide where you want to shoot, and set everything up. Bring the executives in only when you are ready to take the picture. As you may not have very long, building rapport quickly is an important skill if you're to capture relaxed expressions, rather than forced grins.

When it comes to posing, the approach you take depends largely on the kind of pictures you want. Annual reports usually show the chairman and/or board in a formal setting – sitting at a desk or arranged in the boardroom. But times are changing and styles loosening. Instead of stiff and formal poses, with the person staring at the camera, executives are increasingly being shown in a more natural way.

Keep things simple with lighting. Use just one flash head into a brolly, or, if there are large windows, consider using daylight. Then work fast. You may be able to get only a handful of photos, so make them count.

People further down the food chain tend to have more time, and quite like getting away from their routine to have their picture taken – so things are rarely as rushed. If it's just a head-and-shoulders shot that's required, setting up two heads either side of you at 45 degrees will produce a flattering result.

CROP TIGHT
Crop in close to get pictures of people that are full of impact.

5 EVERY OTHER WAY
OF MAKING MONEY FROM PHOTOGRAPHY

As well as the main areas of photography – publishing, picture libraries, social photography and commercial work, which we've covered in some depth – there are many specialist areas of the profession. Some, such as natural history, fine art, theatre, sport, and documentary, can be tackled on a freelance basis. For others, such as forensic, medical and in-plant photography, you would normally be employed by a government department or commercial organization. Specialist areas like this make it possible to follow your passion, and photograph what really interests you. If you're really into cars, ballet, horse racing or big cats, it may be possible to focus on that and make a living out of photographing it. Some photographers may prefer to combine their interest in picture taking with a vocation, by becoming, for instance, a police or military photographer. And even if you don't think you are cut out to be a photographer, you could be an agent or work in a camera shop or photo lab. There are many ways of earning a living from the profession.

GREEN BOTTLES
In-plant and scientific photographers will often be called upon to produce stylish and interesting images for a wide range of uses.

EMPLOYED PHOTOGRAPHY

The life of a freelance or self-employed photographer isn't for everyone. Some people prefer the security of working for a company and picking up a regular paycheque each month. If that sounds like you, what options are available? Here are some that you might like to consider.

■ Working for a photographic studio

While some photographic businesses are 'one man bands', others are larger operations. It's not unusual for busy portrait and GP studios to employ several photographers, and the same is true to a lesser extent of successful commercial studios. If you want to work as a photographer, but don't want to have to worry about running a business, there's no better place to start. Contact studios in your area to find out if they have any vacancies – or any national chains if you're prepared to relocate. You won't be the only one applying, though. Many people consider photography to be a glamorous profession, so there's plenty of competition for each position. You'll need to demonstrate you have the right skills and attitude, as well as a decent portfolio of images. Pay is usually reasonable, but there may be some unsociable hours in a social studio, where clients are more likely to make appointments in the evenings or at weekends.

■ Staff photographer

While there's an increasing trend for companies to outsource their photographic requirements – commissioning images as and when they need them – many still retain an in-house photographic department, which in a global company can be quite substantial. Rolls-Royce, for instance, has a group of highly talented photographers who take still and moving images both in the studio and on location. Government departments and similar agencies also sometimes have photographic departments.

Working as a staff photographer can be interesting and stimulating, with lots of variety. I know one photographer who has been on the staff of the same company for 40 years – and is still enjoying it and finding it challenging.

Pictures are taken for a wide range of uses, including company reports, brochures, press releases, advertisements, websites and newsletters. It can also be satisfying to be part of a team – some photographers find the solitary life of being a freelance doesn't suit them. Companies vary in the degree to which creativity is encouraged or suppressed. Some are traditional in their approach while others are looking for more original work – which gives photographers free reign to put their passion into practice.

To be successful as a staff photographer you need to be versatile and flexible – a jack of all trades and master of most of them.

GROUP DYNAMICS
In-house photographers often cover a wide range of subjects, including people.

That's because you might be called upon to photograph anything and everything. you need to be practical and organized. You may also need some of the business skills of the self-employed photographer, as increasingly photographic departments are run as 'cost centres' responsible for their own budgeting – and expected to deliver a profit to the organization.

How do you become a staff photographer? Entry requirements are variable, but both commercial companies and government departments favour professional qualifications as well as practical picture-taking skills, so it may be necessary to go to college if you want to follow this route into the profession.

■ Police scenes of crime/ forensic photographer

Being a forensic photographer is not for the squeamish. As if having to take pictures of road traffic accidents, cot deaths, industrial accidents, victims of murder, child abuse, rape or assault were not enough, a photographer has to be present at every postmortem. As the pathologist strips away the skin, flesh and bones to determine the cause of death, he directs the photographer to take certain pictures as evidence. It can also be stressful. As one police photographer once told me: 'I always get a twinge in my tummy every time I get a murder call. You don't get a second bite at those.' So you have to be fairly tough to do the job, but over time you do get used to the grim realities.

Police photographers are also trained in forensics and fingerprints, and need to be alert at the scene of a crime, where they are looking for and recording fingerprints, shoe prints, tyre and skid marks, signs of forced entry and so on. There's no room for creativity, though. Police photography is all about reproducing for the court what you see with your eye. It's a record shot – nothing more. Most of the time a standard lens is used. Wide-angle and telephoto lenses are avoided unless absolutely necessary – because then it could be claimed the photograph is distorted.

The route into becoming a scenes of crime/forensic photographer varies according to where in the world you live. In some countries they're now recruited as civilians, while in others they have to be serving officers. Pay is generally good, often with a pension and other benefits thrown in. Crimes happen 24/7, so police photographers normally work a shift system, and may be called out at short notice in the middle of the night.

As well as technical skills, police photographers need good interpersonal skills and sensitivity, since they will often find themselves dealing with victims of crime, who may be distressed.

It's a valuable, important job and – perhaps surprisingly given the subject matter – demand for positions is high.

■ Medical illustrator/ photographer

In most countries you need to have professional training and qualifications to become a medical photographer – or medical illustrator as it's sometimes known. Typically you need to have studied anatomy, physiology and biochemistry in addition to photography, and have an understanding of how diseases originate and how they manifest themselves. You'll find medical photography hard going if you don't have an aptitude for science and an interest in it.

Nor is it a job for those of a sensitive disposition. Medical photographers have to record the progress of operations and procedures, so you see everything the surgeon does, and you may also have to attend and photograph postmortems. In addition, pictures are taken of everything from patient care to hospital workers, so people skills are extremely important.

Some of the work can be technically challenging. You need to be able to employ a variety of specialist techniques, including micrography, thermal imaging and endoscopy. Often there is no chance of a reshoot, so you must get things right the first time. Attention to detail and a meticulous approach are essential, including keeping detailed, accurate records of date and time.

Not surprisingly, therefore, you need formal training to get into this area of photography, which normally means attending college. Happily, age is not a barrier in most countries. It's possible to follow the required study later in life if you're looking to switch careers. However, given that it's such highly skilled work, and that the educational requirements are so high, I've always been astonished at how poorly paid it is compared with other parts of the profession.

Museum photographer

Many museums have large in-house photographic departments, which handle everything from record-keeping to shooting pictures for brochures and posters – as well as sometimes taking in work from publishers and advertising agencies. The majority of the work is studio-based, but there is a lot of variety in the subject matter. It's a steady, solid, safe job, usually with a reasonable salary and a pension, so demand for positions is strong.

Museums often place great emphasis on technical ability, and applicants will be expected to be able to carry out most photographic tasks competently. People are also expected to be able to work with others as a team, and fit in with established practices.

The good news is that there's usually no age limit. They get people fresh from college, retiring from the forces, or returning from having a family. Hours are rarely long, and the pay is reasonable.

Scientific photographer

If you're interested in science and photography, this is for you. Many government departments, research establishments and universities employ scientific photographers to record experiments and provide research data

MEDICAL ILLUSTRATION
As well as taking pictures of patients and operations, medical photographers are also sometimes called upon to illustrate concepts.

MILITARY
PHOTOGRAPHY
If life in the military
appeals, there are
opportunities for those
wishing to pursue
photography.

to accompany reports and papers. It's often highly skilled work, requiring strong scientific knowledge – and some employers insist upon photographers in this field having a science degree.

Special techniques such as infrared, time-lapse, ultraviolet, thermal imaging and micrography may be employed in addition to standard photographic techniques.

■ Military/forces photographer

During peacetime as well during periods of war, the military is constantly looking for ways of giving a positive impression of itself, and has a well-oiled and effective public relations machine. As part of that, most branches of the forces have staff photographers taking pictures that are used for publicity purposes. Many are what are called 'local boy stories', which are placed with local newspapers and are designed to sell the armed forces at a local level. In most countries you need to 'sign up' with one of the forces to become a military

photographer, and training in photography is given to those who have the interest and aptitude. Pay for photographers in the forces is often on the same scale as for other enlisted men and women.

■ Theme park photographer

Go to any theme park and the chances are that at some time during your visit a photographer will approach you and take your picture – giving you the opportunity to pick up your print later at a moderate price. It's one of the ways in which these attractions add to their profits.

This is one area where your interpersonal skills are really more important than your photographic capabilities. In some similar situations – such as on cruise ships – you would be expected to sell the picture there and then, taking payment on the spot. Payment for this kind of work is often made on a commission basis, so you need to be reasonably pushy if you're to earn a decent living.

SPECIALIST AREAS

■ Schools and graduation

Most of us have a collection of photos from the period when we were being educated. As well as individual portraits, often taken once a year, there are pictures of the whole class or school, along with shots of sports teams and various clubs. In addition there may be graduation photographs.

Most, if not all, of these pictures will have been taken by a professional. And when you consider the number of schools and colleges there are, you can see that it's big business. It's not an especially creative sphere, but it can be reasonably lucrative.

How can you get involved? Well, one way is to approach local schools and colleges and ask if you could go along and take some pictures of the students. Nursery, kindergarten and 'mums and tots' groups are also worth targeting. They may, of course, have someone who does it already. Most do. But if you persevere, you may find one that doesn't – which will allow you to get a foot in the door.

Obviously you'll need to have some pictures you've taken to show them. If you haven't done any work of this kind before, one option is to photograph the children in your family, or those of friends or colleagues. Many will be more than happy if you let them have some prints in return.

School pictures tend to be of two main types: simple head and shoulder portraits and large groups. The portraits are easy to shoot. They're typically lit with one or two studio flash heads and have a plain or 'old masters' background. The pictures you show them should obviously be typical of the ones you plan to take. You'll also need to work out a pricing structure that gives the school or college a proportion of the takings. You don't normally charge a 'sitting' fee – but that's not an issue if you shoot digitally, as your costs are kept to a minimum. You make your money from the various 'packages' you offer. At the budget end this might be just one 10 x 8 and two 5 x 4s, rising to several larger prints at the top end.

The marketing philosophy of school and college photography is to have a relatively low price that generates a high volume of business. To succeed, therefore, you need to shoot lots of pictures. When taking head and shoulder portraits, for instance, you may have less than a minute to get the sitter settled and take the photograph. You also need to have an accurate and reliable system for matching the names to the faces.

Photographing the whole school at once, though, is technically much more difficult and can require expensive seating to do it correctly. It is therefore best left to companies that specialize in this area. Many of these companies have exclusive rights to take pictures at the larger schools and colleges, and that can be a barrier to others wanting to get involved.

If that's the case in your area, another option is to approach one of the companies to see if you can work for them. Some have employees, but many use freelances on a regional basis as and when required.

GRADUATION TIME
Graduation photography is big business, with graduates of all ages wanting a picture to record their achievement.

■ Natural history photography

Many amateur photographers enjoy natural history photography, taking pictures of everything from insects, birds and wild animals to flowers and trees. But while it can be satisfying to capture subjects of this kind it can be challenging making a living out of them. That's because the number of markets available is smaller than in some other areas of photography.

NATURAL ORDER
Natural history photography is one of the more difficult areas to earn a living from.

The principle outlets for pictures of animals and plants – greetings cards and calendars – were discussed in the previous section on publishing and both can bring a worthwhile return for those who can produce material of the right quality.

Magazines that focus purely on natural history in general are few and far between, but there are some which have a specific focus, such as gardening and birdwatching. The secret

of success in natural history lies in becoming known for something in particular – such as eagles or orchids – so that when a publisher wants material of that kind you're the first person they contact. And once you have a comprehensive coverage of your chosen area you may be able to secure a commission for a book on the subject.

For all these reasons, the easiest way to market your images is through a picture library that specializes in natural history. But to be accepted you will have to produce work of the highest standard, since the library will already have contributors whose work is selling, and who may be among the best in their field.

THE BEAUTY OF NATURE
Greetings cards and calendars can provide a market for some natural history photographs.

■ Car photography

Car photography has to be one of the most glamorous areas of the profession. It can provide the opportunity to travel to exotic locations and produce some truly memorable images – while getting paid handsomely for it. But, as always, the more desirable the work is the more competition there is for it – and the more talented and determined you need to be to break into it.

Pictures of cars are taken for two distinct markets: editorial and advertising. Many photographers start out shooting editorial – that is, magazines – and then progress to advertising, which tends to be better paid. As with many areas of photography, there's a Catch-22 situation. You'll find it hard to get commissioned if you can't show published tear sheets, and you can't get the tear sheets if no-one will commission you.

One way to get started is with smaller circulation magazines that focus on a specialized area of the market, such as a classic or cult car brand. If you can show them some pictures you've taken yourself – perhaps by seeking out an enthusiast at a car show and supplying some prints in exchange for taking the shots – they may be willing to commission you. If they like what you do on your first shoot, you could become a regular contributor, which will enable you to build up a collection of published photography.

Magazine work tends to be mainly on location, so you'll need to be willing and able to travel – which can rule out car photography for part-time freelances. The profile of leading car photographer Martyn Goddard on the following pages gives some idea of what's involved.

Some advertising work is shot on location, but there is almost always some studio photography involved as well. This is certainly not for amateurs or enthusiasts. You need a huge drive-in studio with dozens of lights and the skill and expertise to use them – often against the clock.

THE WHEEL THING
It's not easy to get a foot in the door of professional car photography because there's so much competition.

PROFESSIONAL PROFILE:
Martyn Goddard, car photographer

'Finding a good location is the most difficult part of car photography. Everywhere I drive I'm always on the lookout for potential locations – good roads for panning, good roads for tracking, great views. I have loads of maps and road atlases covered in notes and marks. I also take snapshots sometimes and keep a diary. I'm not meticulous about this, but I do like to remind myself of spots worth using in the future.

'Locations go through fashions. One minute it's beaches, the next moorland or cities. I used to shoot without any planning – I'd just turn up somewhere and take pictures. But you can't do that now, especially in Britain. It's much easier in the USA and other European countries, but in Britain I always make sure we've got permission to shoot somewhere in advance. The last thing you want is someone chasing you off their land, especially if you have the client with you.

'Keeping the car pristine is vital, so I always carry sponges, buckets and chamois. Photoshop now gives us the flexibility to remove blemishes, but you still need to start out with a clean car. You also need to be very careful not to scratch the car. This isn't such a huge problem with new cars, but

when you're shooting a classic that's someone's pride and joy, it's a different matter. I remember photographing one of Rowan Atkinson's cars and he wouldn't let anyone touch it but himself. This meant he had to clean it himself, but he didn't mind – if anyone was going to scratch it, it would be him.

'Usually when I do an editorial car shoot there will be no more than four people – me, an assistant, the

ACTION STATIONS
Being able to capture the thrill of a fast moving car requires advanced techniques.

DESERT
Car photography can take you to some fascinating and photogenic locations.

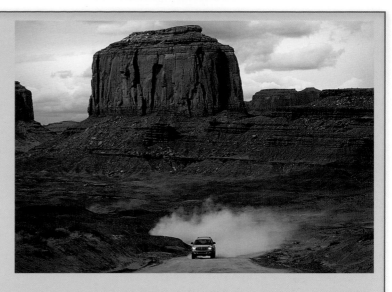

driver/owner and a journalist. I prefer it that way, because the more people you have involved the more problems you face.

'The quality of light is crucial when you're photographing a car. I prefer to work at dusk, when the sun has set, because the sky becomes one huge light source and you get this wonderful seamless, reflective light that reveals the shape and subtleties of the car. I refer to it as liquid light – it can make even the most boring car look wonderful. It also reveals the slightest blemishes – I can spot a tiny dent a mile away. On editorial jobs I have to get the shots no matter what – it doesn't matter how bad the weather is or what time of day it is because usually we only have the car for that day then it has to go to someone else. I can't assume there will be a great dusk, so I make sure I get banker shots earlier in the day, then if conditions are good later, so much the better.

'Contrast is the biggest problem in sunny weather so I often have to use fill-in. I'm not a great believer in flash, but if you're shooting in the middle of the day there's often no option. There's also a trend at the moment for lighting cars with flash against a dark sky, so I'll have to invest in some more powerful flash units – I use a couple of Norman guns at the moment.

'A typical car shoot lasts from, say, 7am to 9.30pm and I would expose maybe 700 frames, taking a series of different pictures – statics, action, interiors, details. The interiors and details are fiddly and take ages to set up – especially if I'm working inside a cramped sports car.

'Panning shots are popular. To get the car sharp and the background blurred you need to be shooting at around 1/30sec. I do that first, to get the banker shots, but then I'll experiment with speeds down to 1/4 sec. The hit rate is lower, but the results can look stunning. The type of panning shot I take depends on the car. If the side view is the best then I'll do a side-on pan and keep the car sharp, but if the front end is the best I tend to pan on a bend so only the front of the car is sharp and the rest is blurred.

'Tracking is another popular technique – this involves hanging out of a car window – having made sure the door is locked – then shooting a car that's travelling alongside or behind me. I also clamp a camera to the side of a car to get action shots. I used to use Manfrotto clamps but they never worked that well. Then I saw these guys using suckers to carry sheets of plate glass, so I contacted a glazing supplier and managed to buy some of the suckers. They're perfect, and being made of plastic the arms are lighter and less likely to damage the side of the car.

'Going digital has really streamlined my car photography because I can check progress as I go. For example, I can now get a panning shot in 15 frames, before I'd shoot two or three rolls of film. I did a four-car tracking shot in the USA recently and had it in ten frames. This saves a lot of time.

'I can also use Photoshop to clean up images – removing lamp posts, wires, a crane recently that we couldn't avoid. I'm not into doing masses of digital work, but if it can improve a shot, all the better.'

■ Fine art

The days when individuals and companies decorated their walls primarily with prints by well-known artists have long gone. These days there's demand for a much wider range of imagery, including fine art photography. What constitutes 'fine art'? It's hard to say. Go into a gallery, poster shop, or the picture department of a large store, and you'll find a wide range of subject matter on offer, from landscapes to abstracts to city views to flowers – many of them in black and white. What they have in common is an aesthetic quality based on the artistic use of photography.

If you shoot pictures of the kind you see, how could you begin selling your work as 'fine art'? Well the easiest way is probably to make a submission to some of the companies that publish posters and prints of this kind. That way you don't have to get involved in the expense of producing them yourself. The downside of licensing an image to a publisher is that you probably won't make much money – unless it's a big seller and you've got a royalty arrangement.

If you want to make some serious cash, you'll need to publish your own fine art prints. But doing so means you carry more of the risk – and could even lose money on the deal. To get a reasonable unit price you may need to have a high volume of prints made. And if the subject matter doesn't appeal you'll end up selling them off cheap. There are various ways of marketing your own fine art prints. Selling direct means you get the maximum return, since there's no middle man. So you might approach businesses in your area, and if you're lucky some will be looking for images to brighten up their boardroom or offices. Hotels often use photographs in bedrooms and corridors, so they're worth trying as well. Framed prints, ready to hang, are more likely to be bought by businesses than unframed prints.

It's also worth contacting art galleries and gift shops in your locality, but of course they will want to take a cut – sometimes quite a sizeable one – and you'll need to factor that into your costings. If you're entrepreneurial by nature you might even consider opening your own gallery.

If you want to reach a wider audience, there's nothing to beat the Internet. Setting up your own website and publicizing it will bring you customers in cyberspace, and you can also offer your wares on auction sites such as eBay.

This is a growing market, and those shooting the right kind of pictures should be able to grab a share.

■ Beauty and glamour

Pictures of beautiful women and handsome men are always in demand, because as we all know 'sex sells'. How often have you seen an advertisement for a dull, uninspiring product featuring an alluring temptress or hunky beefcake? When it comes to cosmetics, they need to be even more flawless. Who could imagine the fashion pages of a magazine without dazzling models?

Photographers who can produce stylish beauty and glamour pictures will never be short of work – whether it's shooting lifestyle work or commercial images. Getting to that stage, though, can take time and effort.

First you have to develop the skills of posing, lighting and working with models. Initially that may mean working with amateurs trying to get into the modelling

BEAUTY FOCUS
Beauty photography requires the ability to produce stylish and eye-catching pictures of models.

FINE ART There's a growing market for fine art photography – but you need to produce images that really stand out.

profession. Ask around and you will often find that family and friends know someone who fits into that category. At this stage you will normally be working on a TFP (time for prints) basis. You supply images that the model can use in her portfolio in exchange for the session. If possible, get the model to sign a release form, which allows you to sell the pictures through a library or direct to clients – and she might be famous one day!

Once you've got a decent portfolio and feel confident of your abilities, you can start charging wannabe models to produce pictures for their own promotion. It's also worth contacting model agencies to offer your services for 'test' shoots. Getting in touch with local hairdressers and beauty salons can also pay dividends – they may need pictures taken for advertisements or window posters.

If you want to pursue the stock route, perhaps alongside an existing job, you can hire models by the hour from agencies in most cities and many large towns. If you're going to produce lifestyle images that sell you need models who are attractive. It's no good using the 'girl next door'. You also need to keep up with the latest styles, so you need to be reading magazines such as *Vogue* and *Cosmopolitan*.

■ Documentary photography

In documentary photography – also known as reportage and photojournalism – an event, situation or person is recorded in a picture essay – a collection of images that may be accompanied by text but convey their meaning directly. The intention is often to express a point of view and raise awareness of a particular issue. Because of this, many younger image makers dream of becoming documentary photographers, but the outlets for such work are very limited. Beyond a handful of high profile magazines such as *National Geographic*, and a niche area of book publishing, the only substantial market is the supplements of the national newspapers – and the competition for the space is intense.

You will need to be extremely determined to succeed in this area, as well as having a talent for capturing 'the decisive moment' many times over in different situations.

■ Theatre and dance photography

For anyone interested in the arts, photographing theatre productions can be a dream come true. And photographs of plays, dancers, performances, actors and musicians are always required – by both the players and the venues promoting the event. You may not find it easy to make a living by specializing in this area (see Richard Campbell's profile overleaf) but it could be an enjoyable way of generating some of your income.

If this area interests you, the obvious way to start is by approaching venues and players direct, to ask if they need

DRAMATIC CONCLUSION
Theatres and performers have a regular requirement for pictures to promote themselves.

any promotional pictures taken for press releases, flyers, posters and the like. You'll need to have some existing theatrical images to show them, but you can usually build up a portfolio by going along to dress rehearsals of shows on an unpaid basis or attending photocalls.

The main challenge technically is the lighting on stage, which is often multi-coloured and extremely contrasty – so care needs to be taken with exposure and white balance settings.

It can also be worth offering to photograph some of the players in return for prints, taking pictures of dancers, actors and musicians for their own promotional cards as a way of building up a business.

■ Sports photography

Go to any sports event and you'll see hundreds of amateur photographers taking pictures. And the chances are many of them would love to do it professionally. Maybe you're one of them. If so, you might be wondering if there's a way you could make some money from the pictures you come home with. The honest answer? Probably not. The problem is that most amateurs can't get close enough to the action – professionals have a privileged position right in the heart of things. This is especially true of major events such as the Olympics, Superbowl or Wimbledon. And few enthusiasts can afford the extremely expensive telephoto lenses that are required to fill the frame with the subject.

If an amateur does take a fantastic picture, where are they going to sell it? Most newspapers and magazines either have their own photographer or source their sports pictures from agencies. You would need to have an exclusive, newsworthy picture to be able to sell it easily to the press. You might be able to place some sports images with a photo library – particularly if they could be used to illustrate concepts such as 'achievement'

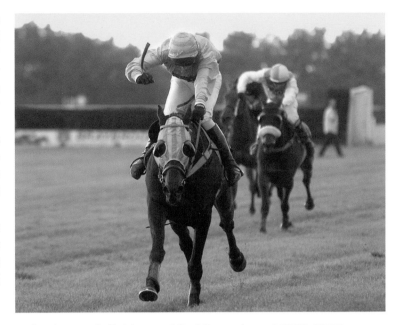

or 'endurance'. But beyond that it can be difficult to break into professional sports photography, even if you have the required qualities of patience and fast reactions.

■ Underwater photography

There's not a huge demand for underwater photography, but those who are skilled in this area normally do pretty well because there's not a great deal of competition. It goes without saying that you need to be able to swim and dive expertly. You will also require specialist equipment that allows you to take pictures underwater. This may be waterproof housing for your digital SLR or a camera that's designed specifically for subaqua use.

Most underwater photography is of natural history subjects, such as fish, corals and plant life. It requires skill to get attractive results even when the water is clear, and particularly so when it's murky. Focusing can be tricky, and you often need to get in close to your subjects.

Beyond the obvious subject matter, underwater photography is also sometimes used for fashion and glamour – bringing an unusual treatment to something that can often be clichéd.

RACING AHEAD
The best way to get started in sports photography is to shoot speculatively.

PROFESSIONAL PROFILE:
Richard Campbell, theatre photographer

Although it constitutes only around 10 per cent of his work, Richard Campbell has a passion for the theatre. His background in film and TV means that he has long associations with the acting profession, and as well as visiting the theatre as a paying customer when time permits, he also loves photographing stage productions.

'I started doing theatre photography after spending six months on set shooting stills for a BBC production called *Life Support* with Richard Wilson,' explains Richard. 'It was great fun, so I decided to capitalize on the experience by contacting a few theatres. As luck would have it, the Citizens Theatre in Glasgow were looking for a photographer. I've been with them now for about five years.

'There are two uses for the work I do – press releases and reviews in the short term and as archive material in the long term. The thing about theatre is that once a theatre production ends, photographs provide the only visual record of it so they have great historic value and will eventually become part of the Scottish Theatre Archive.

'This is one of the things that attracts me to theatre photography. Much of my corporate work has a short lifespan – it appears in a brochure or report and after a few months or a year it ends up in the bin. But at least I know that my theatre pictures will be around for a long time and have some worth in the future.'

When he first started working for the Citizens Theatre, Richard worked exclusively in black and white. He would attend a production, shoot maybe ten rolls of film, drive home, develop and contact them that very night and have prints ready for the papers the next morning.

'Often I would be up until 2am getting the work done,' he remembers. 'But then the theatre employed a new publicity head who wanted me to

shoot colour. The idea of processing and printing my own colour film didn't appeal, and there were no labs in the city that could turn it around quickly, so the decision was made to go digital. The people at the theatre were sceptical at first but once they saw the quality I could achieve they were converted – it was a real eye-opener.

My life is also easier now because as well as being able to preview shots if necessary, I can quickly download the images on to a computer, email them, burn them on to CDs and everyone has what they need the next morning.'

Richard shoots 200–300 pictures per production, and admits that it's exhausting work because he may have a viewfinder pressed to his eye and be constantly

GO FOR IMPACT
With theatre photography the aim is to produce pictures with bags of impact that can be used as posters or flyers.

DRAMATIC EXPRESSION
You need to be attentive when shooting in the theatre to catch the perfect moment.

me and concentrate on their lines.

'The key with theatre, like any specialist area of photography such as wildlife or sport, is knowing your subject. I never photograph a production without either seeing it or at least reading the script, because I need to understand the play, the characters, the relationships between the characters, what the director is trying to achieve, and so on, if I'm to take good pictures.

'Once I'm on stage, it's just a case of moving around discreetly and not getting in anyone's way so that the play can run smoothly. I only use one lens – a Sigma 20–40mm zoom, which roughly equates to 30–60mm on my digital SLR. Because I'm up there in the thick of it, I don't need anything longer – often I shoot from close range at the wider end of the zoom.

'The main technical problem of theatre photography is dealing with the huge contrast range between actors that are brightly lit against dark or black backgrounds. If you leave your camera to its own devices it averages everything out, which results in the actor's faces burning out. To avoid this, I usually work in program mode with –1.5 stops

moving around – as well as concentrating on the production and making sure he gets the shots.

'When I first started out I'd be down at the front with my camera and 200mm lens on a tripod. Some theatre photographers still work that way, but I don't. Instead, I take my pictures at the last dress rehearsal, which is usually on the afternoon of the day the production goes live.

'The benefit of doing this is that I can get up on stage, move around and work from close range while the play is in full swing. Some directors are a bit touchy about this, but at the Citizens they're fine because they know I will get better shots. It's also good experience for the younger actors because I provide a distraction, and they have to learn to ignore

dialled into the exposure compensation. Experience has taught me to recognize situations where I need more or less compensation, but generally this formula works.

'Switching to digital didn't really overcome this because in a way I now have to be more careful with exposure than I did shooting black and white film. If I burn out the highlights, there's no information in them to retrieve, so instead I prefer to underexpose a little. It's the same with lighting. Because theatres tend to use mixed lighting you can't try to get rid of one cast without affecting another. Obviously, it's never going to be natural because theatres are artificial environments, but my aim is to record a fair representation of what it was really like.'

THE WRITE STUFF

Magazines, as we observed earlier, offer one of the largest markets for the freelance photographer. And while many accept images on their own, to illustrate existing or planned articles, others prefer, and sometimes only consider, complete packages of words and pictures. Such magazines tend to be specialist in nature – on photography, railways, fishing, woodwork – or devoted to a particular locality or region. Having detailed knowledge of a subject, and the ability to express yourself in words as well as pictures, can dramatically increase the opportunities open to you. Also, getting paid for both means a better financial return on your time and effort.

◼ Getting accepted

Many photographers, however, never think of writing articles to accompany their images because they don't believe they would be good enough. One of the reasons they became photographers in the first place is that they're better at expressing themselves visually. But anyone who can describe their experiences and interests with enthusiasm and clarity should have no difficulty in putting together a feature that has the potential to be published.

Don't worry if your spelling isn't quite up to scratch. Most word processing packages these days include a spell check that will sort that out for you. And most magazines have a sub-editor whose job it is to knock 'copy' into shape, providing the ideas are interesting and relevant to the magazine's readership. It doesn't matter

how skilled a writer you are if you don't have anything interesting to offer.

That said, you'll certainly improve your chances if you brush up on your grammar and syntax. There are plenty of inexpensive books that explain the essentials of good writing in an accessible and practical way. Following just a few key rules regarding the use of apostrophes, capital letters, commas and so on, as well as elements of style such as varying your sentence length and using simple words, will enhance the quality of your writing enormously.

One of the most important things is to write in a way that comes naturally. Avoid pompous, pretentious language you would never use in normal conversation. Occasionally sentences like this appear in print:

The vehicle was apprehended as it proceeded down a rural thoroughfare.

when what the writer really meant was:

The car was stopped as it went down a country lane.

◼ Carrying out research

Every magazine has its own tone and personality. Many are chatty in the language they use. Others are more formal. So before you start to write an article, carry out some research. Gather together a selection of titles that serve the market that interests you and analyse them carefully.

The first thing, of course, is to check whether they publish word and picture packages or whether they prefer to source them separately. Having established that the magazine is open to illustrated articles, you should then establish their typical length, whether it's all continuous text or if there are any separate 'box-outs', and whether it's written from the author's point of view ('I always put down fertilizer before

A PORTRAIT OF WHITTLESEY

In Words and Pictures by
Steve Bavister

Eighteenth century Harrington House

IN RECENT YEARS the cathedral city of Peterborough has grown enormously in size, spreading out in all directions in order to accommodate its rapidly growing population which now approaches 155,000. This expansion threatens to engulf and devour near neighbours and take away their previously independent character.

One place that could all too easily be swallowed up in coming years is Whittlesey, the quiet market town that sits some six miles east of Peterborough along the A605.

In the early 19th century, however, the two places were of comparable size and population. In 1811, for instance, the number of people living in Whittlesey was 4,248, only 169 fewer than the 4,417 then resident in Peterborough.

A century later the situation had changed dramatically: Peterborough's population had risen to 33,574 while Whittlesey's had meandered slowly to a total of 7,587 and today, Whittlesey is only up to about 14,000.

The name Whittlesey has stood the test of time remarkably well, having remained largely the same give or take a change in spelling, for over 1,000 years. The first documentary evidence of its existence comes in a 10th century Anglo-Saxon chronicle where it was referred to as Witeslig - meaning 'Witel's Island'. Witel was an Anglo-Saxon landowner and the place was then quite literally an island.

Although it's almost impossible to imagine it now, given the solid and reassuring permanence of our modern roads and housing estates, up until the draining of the fens in the 17th century much of the area was permanently submerged with just a few isolated islands such as Whittlesey forming stepping stones across the great watery expanse.

Visit Whittlesey today and you'll find a friendly place where everybody seems to know everybody else and strangers are warmly welcomed. Your first visual impressions may not be immediately favourable though and it's undeniably true that it's not as pretty as other places you might care to call upon. But then one should never judge a book by its cover and as you turn the pages of Whittlesey and get to know it better so you begin to appreciate the pleasures it has to offer.

The place to start is the market square, the very heart of the town. Here you find the Buttercross - an open-sided square market raised on four large Tuscan columns fashioned from Ketton

Seventeenth century Grove House

stone, all covered by a large conical Collyweston slated roof. This imposing and attractive building, erected in 1680, has been the centre of Whittlesey life for over ten generations. Nowadays it performs a more mundane function - protecting those waiting for a bus to arrive from the elements.

The year 1715 marked a turning point in Whittlesey's history. That year it was granted the right to hold a weekly market and three annual fairs - raising its status from village to that of town. There's still a weekly market that sets up shop behind the buttercross every friday offering an appealing selection of goods at attractive prices.

From the Buttercross you see several buildings of interest, including the three-story Georgian post office, the seventeenth century Harrington House and the eighteenth century Vinpenta House.

Other notable places to visit are The Wilderness in London Street and Grove House near The Bower which Oliver Cromwell is said to have visited.

No matter where you go in the town you'll see, towering high above you, the spire of St Mary's church. Rising 150 feet into the air, it is widely regarded as being one of the most splendid spires in Cambridgeshire.

The present church dates from the thirteenth and fourteenth century - an earlier building having been destroyed when the timber and thatch village of Whittlesey was totally consumed together with all forty-four residents by a great fire in 1244.

In addition can also be found the fourteenth century church of St Andrew's which although attractive in its own right is bound to pale in comparison with its illustrious neighbour.

The Hero of Aliwal

Given the size of the town, you'll probably be surprised at how many public houses you come across. The number now is nothing to what it used to be though. It's said that at one time there were 52 pubs - many of which have now disappeared. They even ran out of ideas for what to call their watering holes! This is how the Letter A public house, a pretty seventeenth century thatched building now an artist's studio, got its name.

Most unusual pub names have a story behind them and the story of The Hero of Aliwal is the story of Whittlesey's most famous son.

Lieutenant General Sir Harry George Wakelyn Smith was born in 1788 in St Mary's Street at a house now known as Aliwal House. He was educated locally, joined the army and became an officer. He was hailed The Hero of Aliwal for the successful part he played in the Battle of Aliwal during the nineteenth century Sikh-British wars, returning in triumph to Whittlesey on the 30th of June 1847.

A poster announcing that event is just part of the Harry Smith memorabilia to be found in the Whittlesey Museum on Market Street. This small but well organised archive also boasts a variety of displays as well as local records. One thing you'll find there is a collection of old postcards showing street scenes, many from the early 1900s. Compare them to the town today and you come to realise how little things have really changed in the last hundred years. In the museum you'll also see a mysterious straw bear. This relates to a local fenland tradition that flourished in Whittlesey at the end of the nineteenth century. The 'bear' is a man dressed in straw who dances through the town on the Saturday before plough sunday - which is the first Sunday after Twelfth Night.

This practice is thought to stem from pagan times and the placating of Corn Gods, and is believed to have been stamped out by police because they regarded it as a form of begging. It was revived in 1979, and is now a highly popular event. The date of the next Straw Bear Festival is the 11th of January 1992.

Public House sign commemorates a well known village name

Whittlesey Museum - a goldmine of local archive material

planting the seeds') or it's addressed to 'you' ('You should always put down fertilizer before planting seeds'). Often the two will be combined.

This research is essential, not optional. If you write an article and then try to find a market for it you're almost certain to get rejected, because it won't match a magazine's needs.

The next step is to contact the editor or commissioning editor, to check whether the idea is of interest to them. Either send a brief email with a synopsis of what you have in mind or give them a call. If they like the idea, but you've never written for them before, it's unlikely they'll give you a firm commission. Instead, they'll probably say they'd be interested in seeing it. You can expect no more at this stage. The only option is to write and submit it speculatively. Once they've actually published your work you can expect a more positive response.

They may, however, feel it doesn't fit with their approach or content, or they may just have accepted or published something similar from another contributor – in which case it's back to the drawing board. You need either to pitch the suggestion to another magazine or come up with some different ideas for the one you've just approached.

■ Planning and preparation

Sooner or later you'll find a magazine that expresses interest in a feature you've proposed. That's when the real work begins. But, unless you're really clear about what you want to say, don't start writing immediately. Spending some time first in planning and preparation will mean you come up with an article that reads well. As an editor, I have most often rejected contributions because the ideas seemed to jump around, rather than being organized and clear.

One simple way of coming up with a logical structure is to list on a large sheet of paper all the things you want to cover. Don't try to put them in any order at this stage. Just get them all written down. Then, and only then, should you think about the best sequence. What needs to

WORDS AND PICTURES
Being able to illustrate articles with high quality images makes it easier to get them published.

MIND & BODY

Taking control of your emotions

By Amanda Vickers and Steve Bavister

Although we would hate to admit it, many of us experience emotions we'd rather not have - flying off the handle at the smallest thing or wracked with guilt over something we did.

Such 'negative' emotions may be inconvenient or even debilitating, but they often have a purpose, even if we're not aware of it consciously. They let us know what's going on for us at a deeper level. If, for example, you've got an exam coming up and feel panicky, the underlying message may be a warning that you haven't prepared well enough.

Most of us have an emotion that comes up time and again and makes life a misery. If that's true for you, there's something you can do about it. While it may feel as if emotions just happen to you, in fact you always have a choice about how you respond to a situation or person.

Think of a recent time when you lost control of your emotions and were unhappy with the outcome. What emotion would you like to have felt instead? In your mind's eye picture yourself back then acting in a different way. If things seem to work out better, step into the movie as yourself and experience it again. The next time you're in a similar situation, it may turn out different. This kind of visualisation works because our brains use the same neural pathways for what we imagine and what we remember.

An even better way of improving your lot is to focus on emotions you'd like to have more of - such as happiness, joy or even bliss. It sounds unlikely, but acting as if you are happy actually makes you happy. What this means is that you can have more good feelings in your life just by imaging them. We do not need to be victims of our emotions, we can make choices about how we feel.

"Acting as if you are happy actually makes you happy"

Want to learn more about how to control your emotions? Book a place on Infinite Potential's 'Taking Control of Your Emotions' workshop on Saturday 29th March. Contact Stamford Arts Centre on 01780 763203 for details.

be said first? How would you like to end? Spend a few minutes trying out different sequences until you come up with one that seems to flow.

Then you can start the writing itself. If you're knowledgeable on the subject, or describing a personal experience, you may be able to write it 'out of your head'. But often you'll need to do some research, using the Internet, reference books or magazines, to fill in any gaps.

Once you're happy with what you've written, set it aside and come back to it a few days later. Then look at ways you can make it better. Treat it as a first draft – not the finished product. What else could be added to make it better? Is there any part that doesn't quite work? Continue to polish it until you can't think of any way it could be improved.

If you're confident of your grammar, spelling and syntax, now is the time to send it. If you're not, ask friends, work colleagues or members of your family to read through it and point out any errors that you can rectify before it goes.

■ File formats

If you're supplying the images on a CD or DVD, the easiest way to send the article is to add it to the disk – accompanied by a hard copy so it can be read without any need for the recipient to open up the file or print it out.

Traditionally, magazines have used Apple computers, and many still do, but they can usually read files from Windows-based machines. The program most widely used by magazines is Microsoft Word, but most can work with files produced in other popular word processing packages. If you send your article in some weird and wonderful format they may not be able to access it.

■ Sticking at it

Writing is a skill like any other, and the more you practise the better you'll get. Don't expect to be an instant expert. Read lots of articles in a range of publications to get ideas of different ways to express things – and you'll soon be selling illustrated articles on a regular basis.

WINNING COMPETITIONS

Although it could never be considered freelancing in the traditional sense, there's potentially a lot of profit to be made from entering photographic competitions. Hundreds are held every year, with prizes as lucrative as cars, foreign holidays and hard cash. Someone has to win them, and there's no reason why it shouldn't be you. Some photographers earn a significant amount each year by entering every photo contest they come across.

Once you start looking you'll see picture-taking competitions everywhere you go. They're a staple of photographic magazines, often running on a monthly basis, usually with the chance to win a top-of-the-range camera or lens. Other magazines, both specialist and general interest, host photo contests, sometimes as one-offs and sometimes on a regular, annual basis. Many different organizations also stage photo competitions with a view to getting publicity. These include travel companies, product manufacturers, picture libraries and charities. To set you on the road to success, here's a list of ten 'rules' for winning photographic competitions.

◼ Ten rules for winning competitions

RULE 1: Be constantly on the lookout for competitions. You never know when they might turn up. You'll see them advertised in shopping malls, mentioned in magazines, promoted on product packaging and publicized on television and radio. You can also be more proactive in finding them via Internet search engines. Type in 'photo competition' or 'photographic competition' and you'll be presented with links to hundreds of different sites. Use the advanced search option, and limit your search to sites updated over the last three months, and you're more likely to find contests that are still running.

RULE 2: Read the rules carefully. Then read them again, just to make absolutely sure you're clear about every aspect. Then follow them to the letter. You can't afford to have your images rejected because they don't meet the criteria specified. If they're asking for prints, what are the maximum and minimum sizes? If digital files are required, what size and resolution? Are you required to send reference prints? What's the theme of the competition? Must the pictures have been taken in any specified location or within any particular time frame?

RULE 3: Whenever possible shoot specifically for the competition. Only use existing material if it absolutely fit the brief. Don't send in something that's 'nearly' what they're asking for. And even if you do have a picture that seems to be suitable,

PICTURE QUALITY
This winning image from the Travel Photographer of the Year Competition (www.tpoty.com) shows how good you need to be to win a major competition.

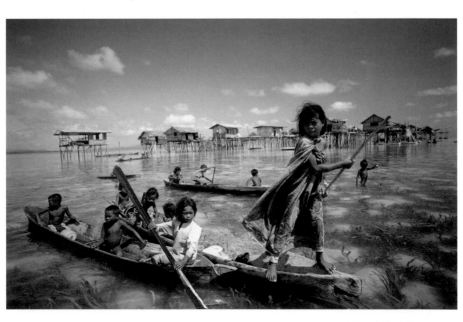

STAINED GLASS
Pictures need to be vibrant and technically perfect to make it on to the shortlist.

VISIONS OF SCIENCE
One of the winning images of the Visions of Science Competition 2005 (www.visions-of-science.co.uk)

it's still worth taking the time and trouble to come up with something better. So take the competition seriously. Treat it as if it were a paid commission from a client. Give yourself a creative assignment, and set yourself a date to deliver the images ahead of when you need to post them. This may seem a strange way of working, but it really produces winners.

RULE 4: Make sure your entry doesn't have any technical faults. To be worth submitting, pictures need to be correctly exposed and accurately focused. If the quality isn't up to the mark they will go straight on the rejection pile.

RULE 5: To get yourself on to the winner's rostrum you need to come up with something special. So avoid the dull and mundane. I have been involved in judging dozens of photo competitions, and this is where most entries fall down: 80 per cent of entries are technically OK, but an enormous proportion of that 80 per cent are dull, dull, dull. I find myself wondering why someone bothered to take the picture in the first place, let alone why they thought it might stand a chance of winning. So interpret the competition theme in an original way if you want to impress the judges. Produce some really creative ideas that fit the brief – but forget the ones that come to mind first. Everyone will have thought of them. Be imaginative and push back the boundaries if you want to get noticed.

RULE 6: Actually submit your work. This may sound obvious, but a lot of photographers never get round to it. Or they leave it to the last minute and then send in second-rate images. Make sure you know when the closing date is and send your pictures in good time.

RULE 7: Presentation matters – so make your entry as attractive as possible. If you're entering a print make sure it's bright and clean, not tatty and dog-eared. Send prints at the maximum size allowed. Enprints, at 15 x 10cm (6 x 4in), don't show the quality of the image or the appeal of the subject matter. A4 (210 x 297mm/8¼ x 11½in) or 25 x 20cm (10 x 8in) entries are normally allowed – sometimes larger – so have your picture blown up to those sizes. If you're making inkjet prints yourself, take care they are of high quality, with no 'banding' or colour cast, and that they have a full range of tones, with no burned-out highlights or blocked up shadows,

RULE 8: Put your contact details – name, address, phone number, email address – on everything you send in: entry form, prints, CDs, DVDs, index sheet, covering letter and digital image. During the judging process items sometimes get separated.

RULE 9: Beware competitions that require you to sign away your copyright – check the rules carefully. If they say that the copyright in all images entered is assigned to the company running the competition, don't enter. This is an unscrupulous way of getting lots of images for next to nothing However, you should expect a clause saying that winning entries may be used for publicity and PR purposes without payment – this is standard practice and perfectly acceptable.

RULE 10: Keep a competition diary. Some competitions come round at the same time every year, so you can shoot with them in mind whenever you take pictures, rather than waiting until they're announced.

NON-PICTURE-TAKING WAYS

In the main I've focused in this book on picture-taking ways of making money. But there are other ways of profiting from photography, some of which I'd like to consider now.

FADED GLORY
Many people have old pictures they'd like restored. Anyone capable of breathing life back into them can earn a decent income.

■ Working in a camera shop

I spent four years working in a camera shop and enjoyed every minute of it. Most of the people who get into this kind of work are enthusiasts, and it's easy to see why. You get to handle lots of different cameras, including the latest models as soon as they come out, and you get to talk about photography all day long. Retail employment doesn't suit everyone, of course, and it's not the highest paid occupation around, but helping customers take better pictures and choose the right gear can be extremely satisfying.

■ Restoring old photographs

Many people have old photographs that have been handed down in their family, that are cracked, faded, torn or creased, and that they would like to have restored to their original state. Anyone capable of breathing life back into them can earn a useful income. And it's not particularly difficult. All you need is a quality scanner, a computer and some image-editing software. Simple enhancements, such as improving contrast, bringing back colour and removing cracks, can be done in just a few minutes. Trickier problems, such as removing stains or replacing missing parts of the picture, can take much longer, so it's best to charge by the hour rather than give a price per print, or you could soon find yourself out of pocket. Start by practising on some old photographs of your own, so you have something to show potential customers, and you'll soon be able to estimate reasonably accurately how long it will take you. Obviously, the more restoration you do the faster you'll get.

Repairing cameras

Those with a natural talent for figuring out why things work and finding ways of fixing them might consider repairing photographic equipment. It pays reasonably well, and can be extremely satisfying. It's not, however, an occupation you can just walk straight into. You need a solid understanding of mechanics and electronics, which is something you only get by undertaking relevant training followed by supervised experience. If the idea appeals, try contacting the service centres at some of the leading manufacturers to find out what their entry requirements are.

Teaching photography

Have you ever thought of teaching photography? Many of those involved in the hobby or profession – depending on whether they take pictures for pleasure or profit – have a thirst to learn more. And you don't have to be an expert in every area. You might have specialist knowledge of a particular subject, such as landscape or portraiture, that you could pass on.

One good place to start is running an evening class – ask your local college if tutors are required. Or you might put on your own seminars, advertising them locally and/or through national photographic magazines. Another option is to work with people on a one-to-one basis, charging by the hour.

Working at a photo library

Working at a photo library is something I've never done, but I've certainly thought about it a number of times, figuring it would give me some inside information about the kinds of images buyers are looking for. I know a couple of people who went from being picture researchers to being extremely successful stock photographers – so I figured it might be a route to fame and fortune. That was in the days when libraries housed millions of transparencies in plastic sheets in hundreds of filing cabinets, and legions of picture researchers were required to interpret the client's often vague requirements, finding and sending images to them. Now that most images are sourced online by the clients themselves, the libraries require fewer staff, and opportunities at the creative end of the business are restricted – but it could still be an interesting way to earn a living.

Leading photography trips

If you like to travel, are well organized, and are good at helping others take better pictures, why not consider running your own photography trips? There's quite a number of companies and individuals who do this successfully already, and the potential for more to get involved. Many offer photographic holidays at an all-inclusive price that covers travel, accommodation, meals and tuition. Often the groups are relatively small, between six and ten people, and the locations should naturally always be photogenic, such as the Grand Canyon, the Venice carnival and the Lake District in northern England. If you get the economics right, you can make a decent living doing something extremely enjoyable.

Becoming a photographer's agent

If you enjoy photography, but are better at business than taking pictures, one option to consider is becoming a photographer's agent. This involves promoting a photographer – or, more often, several photographers – getting them work and getting them well known.

The agent takes a percentage of all the jobs that are booked, which can be significant sums with leading photographers and prestigious commissions. To be successful you need skills in marketing and promotion, and the ability to sell effectively over the phone.

BUSINESS MATTERS

Once you start making money from photography, even if it's only selling a few pictures to magazines or shooting the occasional wedding, you are running a business. And that means you have certain legal and financial responsibilities. Their precise nature depends upon the country you live in, but the principles are broadly the same around the world. Normally you are expected to:

- tell the relevant government department that you have started trading
- keep detailed records of the money you earn and expenses you incur
- pay tax on any profit that you make by the due date

If what you are earning from photography is only small scale, and most of your income is coming from your day job, you may think it's not worth disclosing the change in your circumstances to the authorities. This is unwise. Government departments such as the IRS in America or the Inland Revenue in the UK have the right to investigate anyone failing to declare earnings – and the power to issue penalties if they're judged to be acting fraudulently. So get things off on the right footing. The moment you make your first sale let the authorities know.

If you expect to make more sales, this can be a good time to engage the services of an accountant. Yes, they will charge you for their time and advice, but this is money well spent, since their knowledge of what can and can't be claimed means you will almost certainly recoup the amount you pay out.

Your accountant will also advise you on the records you need to keep, what you can and can't claim, and the best way for you to do business – should you be a sole trader or should you set up a company. There are advantages and disadvantages of each, and which you go for will depend upon your particular circumstances.

Practical matters

You should also consider opening a separate bank account – and may need to if you are trading under a name that is different from your own. It's easier if you keep your business and personal finances separate, and your accountant will almost certainly prefer it that way – though in many countries there is no legal requirement to have a business account, as long as your record keeping is accurate. In the early days you may not have many transactions, just the occasional sale and purchase – in which case it's better to do your own book-keeping and pass everything to your accountant at the end of the year to produce a profit and loss account.

One of the secrets of making money as a photographer is to claim every kind of expense you legitimately can. As a rule of thumb – and once again it varies according to where you live – anything that's essential for the business can be claimed. This includes camera, lenses and other equipment; your computer, scanner, printer and associated items such as printer cartridges and inkjet paper; business premises; traveling expenses, by car, rail, airplane or bus; all stationery costs, including pens, folders, papers and envelopes; postage expenses; insurance; telephone bills; office furniture; meals while you're out; and – I could go on and on. Your accountant will soon tell

you if something isn't claimable. What is of crucial importance is that you keep a receipt for everything you're claiming, or it may later be disallowed.

At its simplest, a book-keeping system involves summarizing, on a monthly basis, all your sales and all your costs. I still write it all down in a couple of specially designed accounting books, but many people these days prefer to use a computerized system.

The way I work is to issue an invoice for every sale I make, sending one copy to the client and keeping the other in my file. On the invoice you need to include all relevant details: what the invoice relates to, how much it's for, and of course the client's name and address. I give each invoice a unique code, a combination of letters and numbers, which identifies it and makes it easy to keep track of things. Some people do their books every week, which is ideal if you have the time. When I'm busy I may not get round to writing everything up for a month or two.

However, I do make sure I send out invoices as early as possible – sometimes the same day that I did the work. You will find that some companies are slow to pay, and the sooner you send the invoice the sooner it can be chased. Most photographers don't enjoy this part of the job, but it comes with the territory – and once you've done it a few times it does get easier.

If you get to the stage of working full time, you'll need to manage the ups and downs of photography. Whatever sphere you work in you will inevitably have busy and quiet periods. To maintain an even spread of income across the year it's essential to save money when times are good for when times are lean. You should also set aside sums on a regular basis for tax; as your turnover increases so you can expect a sizeable bill from the revenue.

You will also need to invest money in health care, insure your equipment, and perhaps protect your income should you be unable to work because of illness or for some other reason. And, since we live in an increasingly litigious society, it's essential to take out Personal Indemnity and Public Liability insurance in case anyone gets injured or killed. If something happens to another person as a result of your actions, they could sue and the cost of meeting the claim could wipe you out financially.

Keeping track

As well as keeping track of your finances, you also need – if you submit work speculatively – to keep track of where you sent what. So make sure you have a book in which you log every submission made – how many images there were and what they were of. And take great care you don't send the same images to rival publishers at the same time.

Marketing and promotion

Whether you plan to be a full-time professional or a part-time freelancer, being able to market yourself effectively is essential to success. If potential customers don't see your work, or worse, don't know even know you exist, you'll never make a sale or be given a commission, no matter how skilled you are with a camera. At the end of the day it's not all down to the quality of the pictures you take. Average photographers who are good at promoting themselves usually do better than colleagues who shoot masterpieces but hide their light under a bushel.

But how do you let picture buyers know what you do? Well, the kind of marketing and promotion you undertake will depend to a degree on what kind of photography you're involved in and your target market. If you're a specialist architectural photographer, for instance, you'll have a

lot of wastage handing out flyers in your local shopping mall. But that would be potentially a good approach if you were a portrait photographer with a studio in the area. And there would be no point at all if your aim was to get your work published in magazines. So you need to think clearly about your target market, and the best way of communicating with them.

Submitting images

The best approach with publishing companies is often to send them a CD/DVD of images which they can hold on file and use as and when necessary. This works particularly well with magazines, which often work to short deadlines, and may look first at what material they've already got at the office when seeking to illustrate. Files should be high resolution 300dpi TIFFs. Also include a reference sheet that shows thumbnails of the images, so the editor doesn't have to load the disk to find out if the images are suitable.

Ringing around

Many people get nervous at the thought of telephoning buyers of photography and telling them what they do, but there's no reason to feel that way. As long as you're sensitive to their situation, asking whether it's a convenient time to speak, and calling back another time if it's not, there shouldn't be a problem. Most buyers are happy to receive calls from potential contributors – as long as the conversation doesn't go on too long. What's important is that you plan what you're going to say and avoid waffle. Have a short 'elevator pitch' ready so you can get your message across in just one or two sentences, such as:

- "Hi, I've got lots of images of your town and the surrounding area should you ever need them for brochures etc." (to local design agencies)

- Good morning, I'm a commercial photographer and I see you produce a catalogue each year... I'd like to show you some examples of my work.' (to a manufacturing company)

- "Hello, I'm an experienced yachting photographer and I wonder if you're looking for contributions?" (to a yachting magazine)

- Good afternoon, I'm just ringing to let you know that my portrait studio is offering free sittings until the end of the month (to members of the public)

The worst thing that can happen – the worst thing – is they say they're not interested. So then you call the next person. It's a numbers game. It doesn't matter how many people say 'no', you're only interested in how many say 'yes'.

Keep clear, detailed records of your conversations. You may sometimes have to ring several times before you have any success – so it's important to know what you discussed last time.

Emails

Email is another good way of contacting prospective clients, and many prefer it because it's less intrusive. They can send replies when they're not busy, and generally it takes up less of their time. Email is also ideal for part-time photographers who find it difficult if not impossible to make telephone calls during the working day. Messages can be sent and replies picked up in the evening or at weekends. And while emails are not as personal as telephone calls, they do give you the opportunity to attach low-resolution image files so the recipient can assess immediately the quality and style of your work. You can also include a hyperlink in your email that takes the prospective client direct to your website.

As you build up a list of contacts, and ultimately regular customers, it's worth sending them emails from time to time detailing any new pictures you've added to your files, describing any interesting shoots you've done recently, or discussing any new service you're offering. Consider producing a monthly email newsletter that keeps you in the minds of your clients.

Do take care, though, when compiling your mailing list that you don't fall foul of anti-spam or data protection legislation. The last thing you want is to send out 'spam', so always give recipients the opportunity of opting out of future mailings.

Networking

Networking is another useful way of meeting potential clients – people are often more willing to buy from those they've met in person. If you're a wedding and portrait photographer, get involved in your local community and socialize at events and parties. People will remember your name, and when they're looking to get married they're likely to get in touch.

If you're a commercial photographer, go along to meetings where you'll come into contact with business people in your area, such as the owners of small to medium-sized companies, who will require pictures taking from time to time.

The great advantage of networking is the lack of 'hard sell'. When you're chatting with someone what you do comes up naturally. You'll be able to tell them what kind of photography you do and hand them a business card.

Promoting your services

As good as they are, networking telephone calls and emails will only get you so far. Even if you work round the clock, there's a limited number of people you can contact. So at some point you will probably need to advertise. That way you can promote yourself to thousands of potential customers at one time. But think carefully where you advertise. You can easily spend lots of money and get little return. Consider what publications your target market will read, and draw up a shortlist of possible titles. Then check the cost for each size of advertisement. Don't ever pay the price that's published – you should be able to negotiate a discount, which may be significant if you're a shrewd negotiator.

Wedding and portrait photographers should consider all the local newspapers and regional magazines. Commercial photographers should think about publications read by business people. Telephone directory 'yellow pages' can also be an effective medium, because it's still a common way for people and companies to find a photographer – though it's increasingly being replaced by the internet. Advertising is not an effective route to making money for most stock photographers and those interested in selling to magazines.

Well designed flyers can also be effective in getting you known, and if you do a targeted mailing can make good financial sense. A simple postcard, for instance, is sometimes all you need to promote yourself, especially if you have a website. Make it eye-catching, so it gets noticed among a mass of other mail, and give the recipient a number of different ways to respond to you – email, text, phone, letter – to maximize take-up.

Website/online portfolio

Having a website is essential. Not only does it allow picture buyers searching the internet to find you, it gives them an opportunity to see what kind of work you do and assess its quality and suitability for their needs. Or, if you contact a potential customer in another way, you can direct them to your website, where you will have

listed the kinds of things you do, where you are based, any qualifications you have, and so forth.

Unless you really know what you are doing, don't be tempted to design your website yourself. While it's not difficult to learn the basics of HTML coding in a weekend, and even easier putting together a website using a software program such as Microsoft FrontPage, it can easily look amateurish, which may then reflect on your services and lose you work. It's a worthwhile investment commissioning a talented web designer to produce a site that gives a professional image. But before you make contact, spend some time thinking about how you would like the pages organized, and what should be on each. Take a look at the websites of other photographers, so you know what works and what doesn't. When you're clear about what you want, it's easier to brief the designer.

Most people coming to your site will be interested in seeing examples of your work and finding out how much you charge, so make it easy to find your online portfolio and rates. Pages must also load fast, since most people don't have much patience when surfing the web. This can be an issue when you have lots of images on your site, so make sure the resolution for each image is optimized for internet use.

The world wide web is now the first port of call for many people looking to engage the services of a photographer, so it's essential that your pages be found by the leading search engines, such as Google, Yahoo and MSN. Most website designers know how to structure a site to maximize the likelihood of them being picked up by the 'spiders' that roam the internet gathering information. Also, think about the word potential customers will type into the search engine. There's no point spending time and money creating a fantastic site if no-one can find it.

Relationship marketing

Whatever sphere of photography you're involved in, your aim should be to build long-term repeat business. You want customers who come back time and again, and who recommend you to other potential customers. So make sure the service you offer is as good as it can possibly be – and professional at all times. Go the extra mile when it comes to satisfying customers and eventually you won't need to advertise, you'll get all your work by word of mouth.

It's also a good idea to build up a detailed database about each of your clients. Get as much information as you can. The more you know about your customers the better. That way you can contact them with offers that relate to their particular needs – such as a discount on a portrait sitting on a child's birthday, an anniversary shoot for a couple whose wedding you photographed, or a reminder for a commercial client that he's due some new pictures of his premises.

Create a professional image

While at the end of the day it's the quality of your photography that counts, you also need to present a professional image in everything you do. Even if you're only a 'one-man-band' selling a few pictures here and there or carrying out the odd freelance commission, it's worth developing a consistent style for your communications. To save money you might be tempted to do it yourself – it's easy enough if you have access to a computer. But unless you've got experience it can end up looking cheap and amateurish – and that can put off potential customers. So it's worth commissioning a graphics specialist to come up with some concepts and designs for you, including a logo and a corporate type style, that look more creative and professional . You need to make sure the design can also be used on your website and incorporated into your emails.

As an absolute minimum you'll need business cards, headed paper and compliments slips. Have them printed on quality paper stock – at least 100gsm in weight, but ideally heavier. Avoid standard inkjet/copier paper, which is typically only 80gsm, feels flimsy and gives an unfavourable impression. There are other things you might also consider having printed, including labels and cover sheets for CDs/DVDs, personalized envelopes, and invoice sheets.

Whatever you do, don't put 'Professional Photographer' on your literature. That 'professional' is a dead give-away – to many buyers of photography it actually says 'amateur'. Have you ever seen a card saying Professional Accountant, Professional Dentist or Professional Attorney? Exactly. If in doubt, just put 'Photographer'. That implies that you're professional. If you think that's too vague, make it more explicit what you do – such as Commercial Photographer, Freelance Photographer or Wedding Photographer.

Understanding copyright

Whenever you supply pictures – whether they've been commissioned or shot speculatively – make sure the rights you are granting are made crystal clear. As far as possible, do not sign away the copyright on any of the images you have taken – or you will suffer financially.

The law of copyright varies around the world, but the principles are broadly the same. When you take a photograph it automatically becomes your copyright – that is, you have full ownership and control over how it is used. That only changes if you assign the copyright to someone else in writing. When that happens, they can do whatever they want with it.

The duration of copyright also varies around the world. In many places, including the UK and the USA, it persists until 70 years after the death of the photographer. In some other countires, such as Canada, copyright lasts for 50 years after the photographer's death.

Protecting your assets

These days many photographers think of their images as assets which they are looking to protect and exploit. By licensing them for specified periods, uses and geographical locations, they are able to maximize their return.

Generally, when a picture is sold for use in a magazine or on a calendar the fee paid is for it to be published just once – with the copyright remaining with the photographer. The fee is normally agreed 'by negotiation'. Once it's been published you can sell the rights again – or at the same time to a non-competing market – as long as you have not been asked to grant 'exclusive' rights for a fixed period. This often happens in the calendar and postcard market, where you may not be free to sell an image for anywhere from one to three years.

Copyright for social and commercial photographers is different, since the pictures have been commissioned. In each case the photographer, as 'author' of the images, owns the copyright, but is limited in how they can be used. To circumvent this problem, many photographers produce a written contract they ask their customers to sign which allows the pictures to be used for a range of purposes. Wedding and portrait photographers, for instance, may wish to use pictures they've taken for promotional purposes. And commercial photographers may wish to use images for stock after an agreed period. To avoid any misunderstandings, make you have a written statement of what rights have been granted for every picture. It may also be worth considering putting 'watermarks' in digital images to prevent your copyright being abused.